Sport & Action

10 9 8 7 6 5 4 3 2 1

ISBN: 978-2-940378-26-5

Art Director Jane Waterhouse
Design by JCLanaway
Lighting diagrams by Rob Brandt

Reprographics in Singapore by ProVision Pte.
Tel: +65 6334 7720
Fax: +65 6334 7721

Printed in China by SNP Leefung Printers Limited

A Note on the Diagrams
The three-dimensional diagrams in this book are based
on information supplied by the photographers. Naturally
the diagrams should only be taken as a guide, as it is
impossible to accurately represent the enormous variety
of photographic equipment that is available, while using
an accessible range of diagrams, nor is it possible to fully
indicate lighting ratios and other such specifics.

The World's Top
Photographers'
WORKSHOPS

Sport & Action

Andy Steel

Contents

Introduction

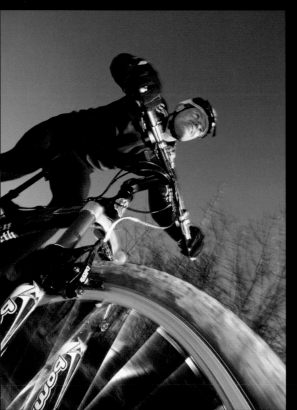

What makes a great action shot? It's a simple enough question but there's no simple answer—you could argue subject, setting, and timing are the three main elements that turn themselves into a single arresting moment but, ultimately, it is the skill of the photographer that captures the perfect moment—and the viewer's imagination.

Almost anyone can pick up a modern camera and press the shutter button, but flick through the pages of this book, and you'll see it is only the true professional who is capable of recording the most memorable and unique images, time after time.

For this reason, the sports–action photography community is today rich with inspiration and artistry. It has also become the most competitive and exciting arm the industry has ever seen.

The World's Top Photographers' Workshops: Sport & Action is the definitive guide to this illustrious photographic medium, which aims to help readers master the correct techniques and methods from some of the very best in the business. The contributors are comprised of world-famous action photographers, including previous Nikon Press Awards winners and industry leaders, with names such as Tom Jenkins, Bob Martin, and John Gichigi, who share with us their personal insights from some truly illustrious careers and acclaimed shots.

It is they who take readers into the core methods of sports–action photography, right down from the equipment and lighting techniques needed for profitable work, to the enthusiasm and creativity required by those wanting to reach the very echelons of picture-taking.

This book seeks not only to bring about the technological know-how and timing needed to succeed in such fast-paced situations, it also helps to guide keen amateur photographers toward finding their inspiration to capture the perfect action shot.

In the end, though, it is the pictures—105 in all, by many of the greatest action photographers ever to peer through a lens—that tell the tale, in page after page of some truly arresting images.

Andy Steel

Left:
Front-of-bike view
Seb Rogers

Below:
Ladies' Final, Wimbledon
Bob Martin

Right:
World Masters Swimming Championships, Crystal Palace
Tom Jenkins

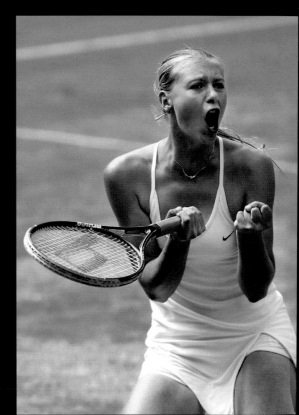

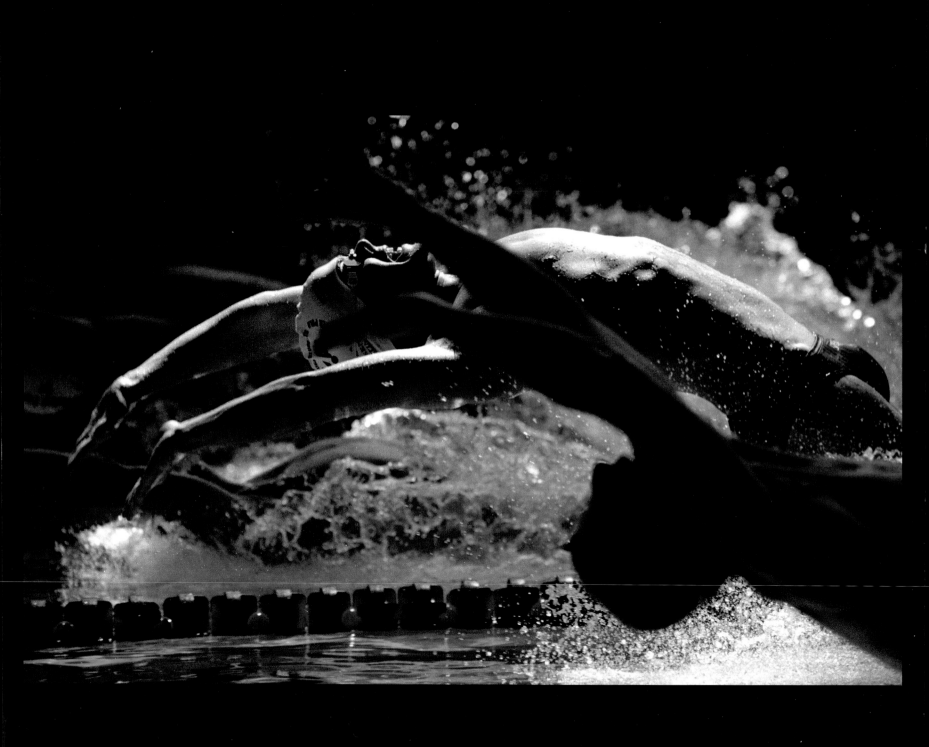

Introduction

Formula 1

This Formula 1 enthusiast has captured some of the most famous faces and cars in the sport's modern era, from Alain Prost and Ayrton Senna to Michael Schumacher and Fernando Alonso. His passion for the world's most glamorous sport seems to be never ending, having been in and around the paddock's elite division for almost 13 years. As a youngster, Charles Coates wanted to become a racing driver, but his hopes were dashed when he grew to 6ft 7in— too tall for a professional driver. After landing a darkroom job with LAT Photographic, he grasped his opportunity and progressed through the ranks, finally realizing his ambition as a top-flight Formula 1 photographer in 1994.

Now working as a freelancer, Coates still has an image sales contract with LAT Photographic, which has become part of Haymarket Publishing. It produces some of the world's leading motor racing titles which include *F1 Racing*, *Autosport*, and *Motorsport* magazines. In addition, he has spent several seasons looking after the photographic needs of the high-profile Renault F1 team.

Charles Coates

AS: What was your first-ever camera?

CC: The first camera I actually used was my father's classic German Voigtländer, with hard leather case, which had a fixed 50mm lens. The first SLR I bought was an Olympus OM-10, with 24, 50, and 80–200mm lenses. I started shooting action shots and motor racing as an enthusiast during weekends; I could only afford one roll of film per meeting, so this particular camera gave me a thorough grounding because I couldn't afford to make any mistakes.

AS: What have been your greatest photographic achievements to date?

CC: Becoming an F1 photographer to realize a boyhood dream. But I feel most privileged to have done my one and only job with the late, great Ayrton Senna. I photographed him racing at the Williams F1 HQ in Didcot, just a couple of weeks before he died at the San Marino Grand Prix in 1994. He signed a picture for me with the words "Dear Too Tall."

AS: Is it fair to say that, like many successful photographers, you had a "lucky break" at some stage?

CC: Because I grew so tall it was obvious that my best chance of working in motorsport was to combine it with my love of photography. I persistently wrote letters and made phone calls to established agencies, and I eventually got a job as a "darkroom scumbag" at LAT Photographic.

AS: Why did you decide not to pursue other types of photography, such as portraits or fashion, for example?

CC: F1 is the pinnacle of motor racing and the fast-paced photography that accompanies it is unparalleled. The world's greatest drivers race in the most technically advanced cars at some of the most fascinating circuits on earth. Why would I want to do anything else?

Mark Webber, San Marino Grand Prix
"For me, the San Marino Grand Prix at Imola always signifies the start of spring. After the streets of Melbourne and the intense heat of places like Malaysia and Bahrain, it is always a nice beginning to the European season. A sensible temperature, fanatical crowd, with flowers and trees bursting into life, create a special atmosphere. This picture of Mark Webber in the Williams, cresting the Aqua Minerale chicane, captures this feeling, I think. Technically it was a hard shot, because the car appeared suddenly, so anticipating its track position was vital. Shot with a very long lens, there is enough movement across the frame to enable very slow shutter speeds to work effectively."

CAMERA: Canon EOS 1S MKII
LENS: 600mm with 1.4x converter
ISO: 100
APERTURE: f/4.5
SHUTTER SPEED: ¹/20 sec
LIGHT CONDITIONS: bright sunshine
WEATHER CONDITIONS: dry

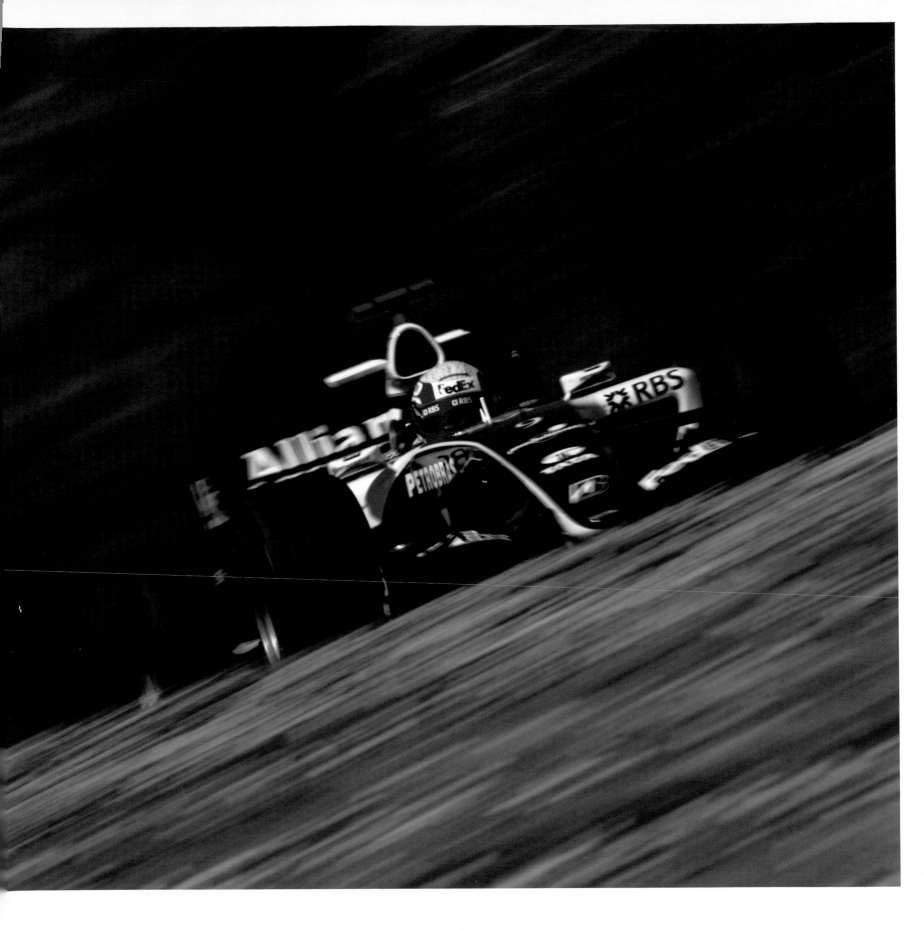

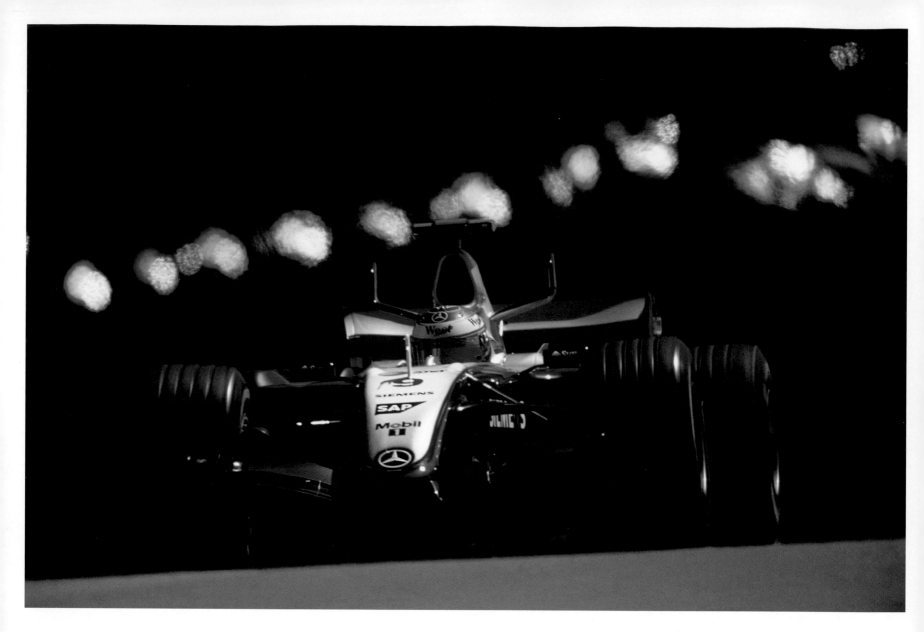

**Kimi Räikkönen,
Monaco Grand Prix**
"There are few more spectacular places to watch and listen to F1 than by the tunnel at Monaco as the cars exit. Räikkönen in the McLaren emerges from the blackness into bright sunlight at about 170mph—an incredible sight. The lights from inside the tunnel in the background give a nice effect. Shooting through a small gap in the safety fence, at an awkward height and angle, made this quite a tricky shot to pull off. For this reason I took the photograph at a slightly faster shutter speed than usual."

CAMERA: Canon EOS 1V
LENS: 600mm
ISO: 100
APERTURE: f/6.3
SHUTTER SPEED: 1/800 sec
LIGHT CONDITIONS: bright
 sunshine
WEATHER CONDITIONS: dry

AS: Do you shoot what you want or do others generally define what's required of you?

CC: It's a bit of both. Experience tells me when a client wants solid, sponsor-friendly pictures, and when I am able to try my hand at something more unusual. I consistently shoot both, but I prefer the latter.

AS: Where are you mostly based? Where are your most popular locations?

CC: From the US to Bahrain and Japan—and everything in between! While the F1 season is in full swing, my trips abroad vary from nearly a week for races like Australia and Brazil, to about four days for most European Grand Prix.

AS: What things do you enjoy most about your job?

CC: It is essential to love the sport. Seeing things like Mika Hakkinen slicing past Michael Schumacher at Spa in Belgium a few years ago, using a backmarker as a foil, makes my job very special. Working with some of the top drivers is an experience not many others can lay claim to. I enjoy the times when I'm out on the circuit—somewhere like Monaco really brings a special feeling. I am inches away from the cars and drivers and, because I was a fan before I became a photographer, I still hold every moment dear.

AS: From a technical aspect, what are the most difficult things about your job?

CC: The hardest conditions are when it's raining and dark and I'm trying to keep everything dry. It was worse when I was using an analog camera—changing film in the rain was always a nightmare. With digital I don't have to do that. I never know if I have a winning shot until my pictures are edited, but there are times when conditions come together perfectly for spectacular shots. Finding these conditions is the most difficult thing, especially when you need to find a unique angle other photographers haven't got.

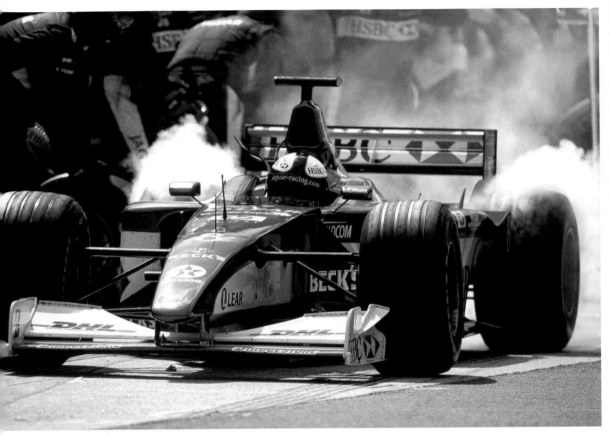

Luciano Burti pit stop, Silverstone

The Jaguar team practices its pit stop routine in preparation for the Grand Prix at Silverstone. "After being stationary for six or seven seconds, Luciano Burti lights up his rear tires and rockets away from the pits. The urgency of the situation, as clouds of tire smoke are left in his wake, is well captured using a 600mm lens from the relative safety of the pit wall. Although this picture was shot using a high shutter speed, the dynamic movements by the mechanics as they change four tires and refuel, means that pit stops also lend themselves very nicely to slow shutter speed photography."

CAMERA: Canon EOS 1N
LENS: 600mm
ISO: 100
APERTURE: f/10
SHUTTER SPEED: 1/250 sec
LIGHT CONDITIONS: bright sunshine
WEATHER CONDITIONS: dry

Charles Coates

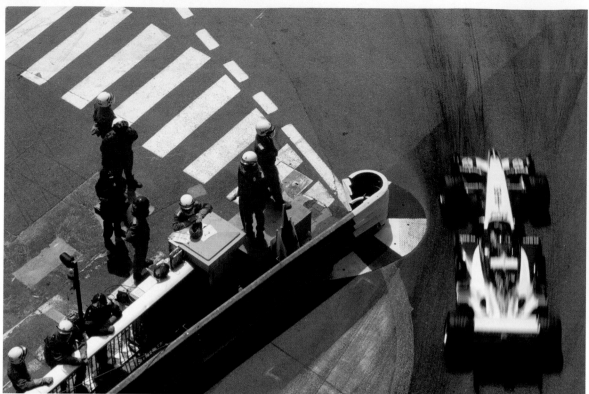

Williams car, Monaco Grand Prix
"Monaco offers unrivaled photographic opportunities and is therefore a special event. This picture was taken from a road overlooking the harborside chicane. The marshals seem oblivious to the Williams as it hurtles past literally inches away. By using a relatively slow shutter speed and focusing on the marshals, the car's movement is very apparent."

CAMERA: Canon EOS 1V
LENS: 70–200mm
ISO: 100
APERTURE: f/20
SHUTTER SPEED: 1/60 sec
LIGHT CONDITIONS: midday, overhead light
WEATHER CONDITIONS: dry

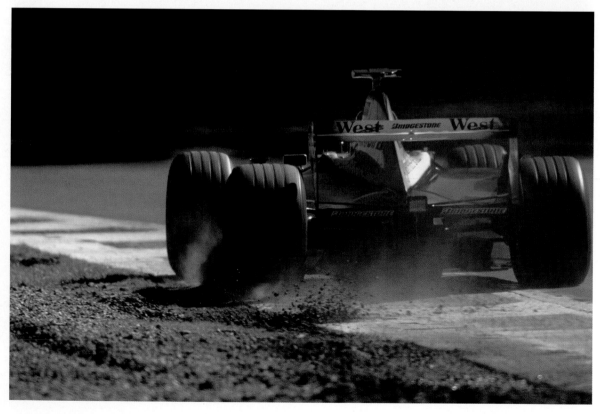

A McLaren kicking up the dust, Monza
The second chicane at Monza, during a morning practice. "It's a good spot for action photographs—with high kerbs the cars become very unsettled, with wheels in the air, sometimes all four. On the exit of the corner, the rear tires run wide into the gravel traps, kicking up dust and stones, which can create spectacular images. By sitting on the floor and hoping not to get peppered by too much flying gravel, a low angle is perfectly achieved."

CAMERA: Canon EOS 1V
LENS: 600mm
ISO: 100
APERTURE: f/7.1
SHUTTER SPEED: 1/500 sec
LIGHT CONDITIONS: bright sunshine
WEATHER CONDITIONS: dry

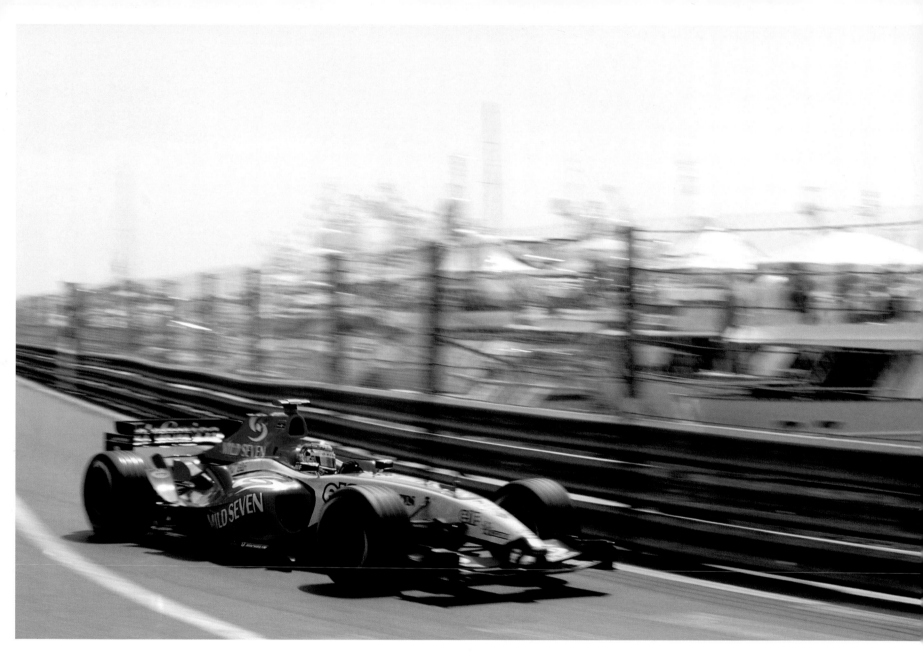

Jarno Trulli flies through Tabac corner at Monaco
Jarno Trulli going past the yachts in Tabac corner, during an early morning practice session. "This is a wonderful place to watch racing cars, with drivers working hard to stay in control on the narrow, bumpy circuit. Behind the barrier on the far side of the track, the yachts are moored in the harbor, housing fortunate spectators watching from their decks. Standing literally inches from the cars, a relatively short lens can be used, along with a careful choice of shutter speed. Too fast and the car can appear static; too slow and the boats become an unrecognizable blur."

CAMERA: Canon EOS 1V
LENS: 70–200 mm
ISO: 100
APERTURE: f/20
SHUTTER SPEED: 1/80 sec
LIGHT CONDITIONS: bright sunshine
WEATHER CONDITIONS: dry

Charles Coates

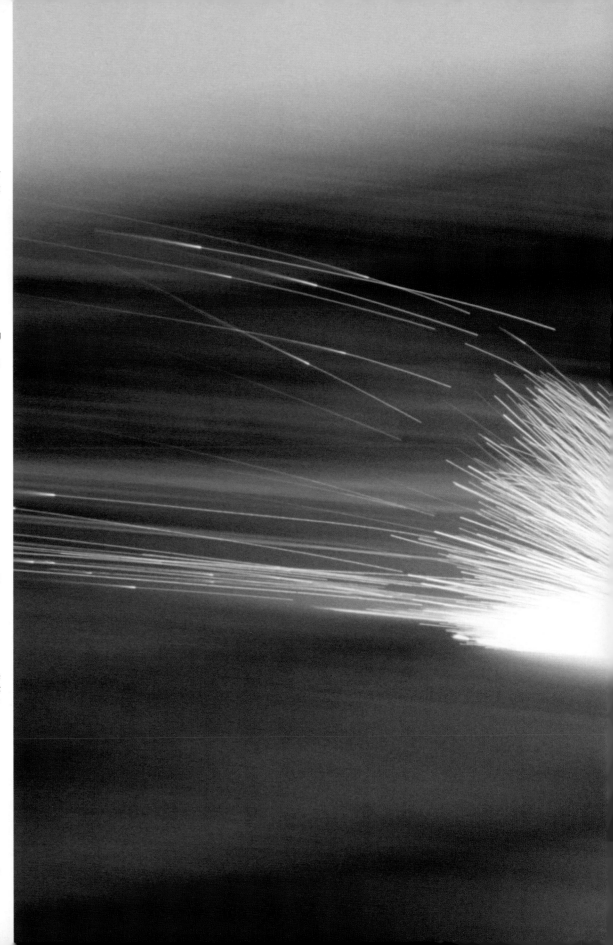

AS: Which race circuit do you like to work at the most?

CC: Monaco, because it offers so many different photographic positions compared to most circuits, and there is more scope for getting unique pictures. It is hard to explain but the absolute buzz of being so close to the action always makes it special: standing in the tunnel, with the roar of the engines, is just incredible.

AS: How would you describe your personal technique or style of photography?

CC: I like to shoot at slow shutter speeds, sometimes down to ⅛ sec; I think this method better conveys the feeling of speed and movement, especially when the cars are engaged in battle. The effects can be dramatic. Cars creating sparks make stunning pictures, but these days cars do not spark as much as they used to, when in the late 1980s and early 1990s they had titanium skid plates. My favorite picture is a shot of Senna, during his first Williams test at Silverstone, in winter 1994.

Ayrton Senna, Silverstone
This photograph captures the first time that Ayrton Senna had driven the new 1994 Williams Renault, at the end of a freezing cold test day. "As Senna powered down the start/finish straight, between the snow-covered verges, I noticed the car had bottomed out over one particular bump, causing a huge shower of sparks. I ran to the pit wall for his next lap hoping that the same thing would happen again. It did. The low shutter speed, taken at ⅟15 sec, accentuates the explosion of sparks coming from the rear of the car to give a very dramatic effect."

CAMERA: Canon T90
LENS: 50mm
ISO: 100
APERTURE: f/8
SHUTTER SPEED: ⅟15 sec
LIGHT CONDITIONS: natural/dusk
WEATHER CONDITIONS: dry

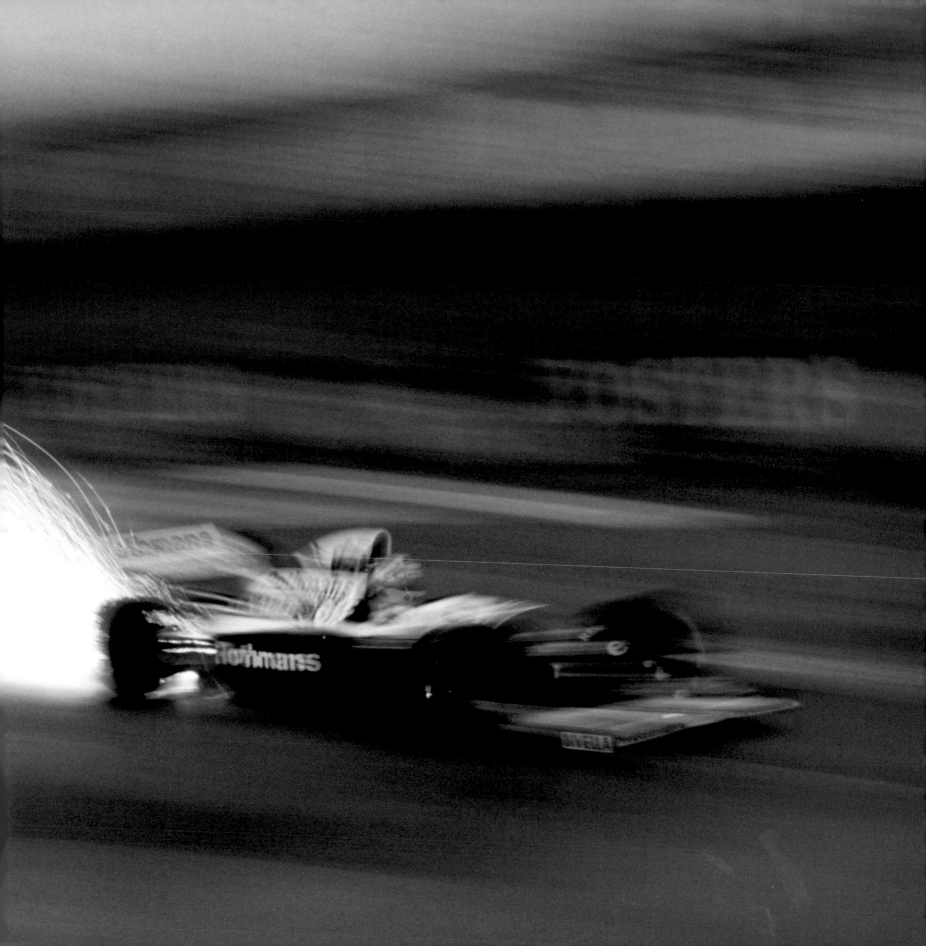

AS: What's in your kit bag? Which camera system do you use and why?

CC: I use a Canon EOS 1Ds MKII. I own two bodies, which sports agencies adore because I can shoot RAW files as well as high-resolution JPEGs. LAT Photographic sends a technician to all the races, who takes my cards, does the editing, and wires them electronically to the agency. I've used Canon gear all my career to date because it is the best in the business. Canon also provides a loan and repair service at many Grand Prix circuits, which is extremely useful. My gear takes one hell of a battering.

AS: What are your favorite and most used lenses/focal lengths?

CC: I take numerous lenses along to each race to be sure of covering all the action, regardless of the conditions throughout the weekend. For pit work I use a fast 135mm f/2 lens, but I also have a 50mm f/1.4, 17–35mm f/1.4, and 14mm f/2.8. For action shots I mainly rely on a 600mm f/4, often used with a 1.4x converter, as well as a 300mm f/3.8. But I have to be careful of heat-haze if I use the converter, because images can lose crispness, especially when the cars are traveling at high speed.

AS: What types of pictures do you find the most difficult to take?

CC: One change I have seen over my F1 career is the more limited access for photographers, both trackside and in the pits. This can be challenging. For me, experience and understanding of the sport lend a huge advantage, such as knowing intuitively when and where incidents and accidents are most likely to happen. But it's getting harder.

AS: Which do you prefer, digital or film, and why?

CC: The development of the digital camera has put a great amount of emphasis on speed and convenience without the expense of quality. But I will always have a certain love of film, even though it sounds old-fashioned. Original transparencies on a lightbox still look amazingly sharp and rich in color. Digital can also lead to laziness!

Heidfeld and Sato crash, Austrian Grand Prix
"The restart, after a safety car period of a Grand Prix, is always a dangerous time. The second corner at the A1 Ring is notorious for accidents. With these two facts in mind, I decided to shoot the restart of the 2002 Austrian Grand Prix with a 600mm lens (rather than the less risky option of a 300mm or 70–200mm zoom), hoping for a dramatic incident. It happened—German driver Nick Heidfeld lost control of his Sauber and speared the Jordan of Japanese driver Takuma Sato. The impact lasted for a split second, creating scattered pieces of race car in all directions. My longer lens captured the violence of the incident perfectly."

CAMERA: Canon EOS 1N
LENS: 600mm
ISO: 100
APERTURE: f/6.3
SHUTTER SPEED: ¹⁄₅₀₀ sec
LIGHT CONDITIONS: bright sunshine
WEATHER CONDITIONS: dry

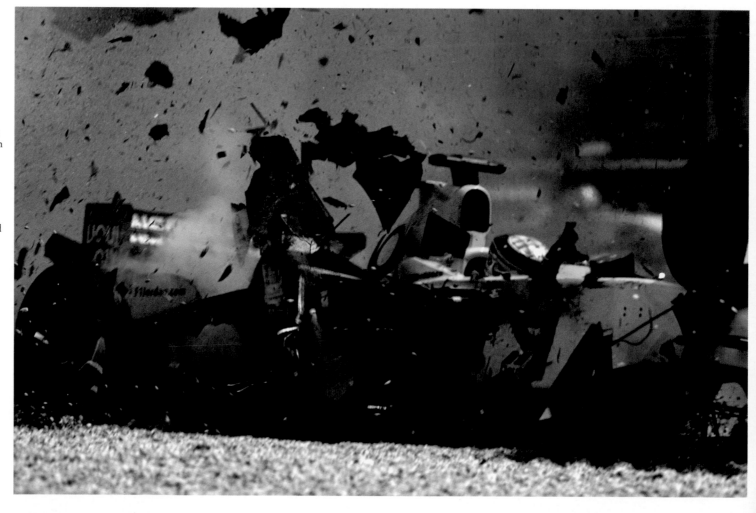

AS: How much of your work is manipulated using imaging software?

CC: Just the basics, like curves, to enhance the image rather than change it. I do not overuse Photoshop, and I hate stitched images. The camera should be used as a tool to create the image, above all else.

AS: Where do your ideas for innovative pictures come from?

CC: It is vital to think about the end result. It's fine having pictures of the right cars and drivers, but can you actually see them on the newspaper and magazine covers the following day? Is the photograph clear? Is the background cluttered? All these factors generate ideas for my pictures and they are important. It's hard to preplan too much and I often take inspiration from other photographers' work.

AS: What does the future hold for you?

CC: I want to carry on doing what I do, but I also enjoy travel photography, just as much as when I'm on the F1 circuit. I like the contrast in style. Each year I take a month out to travel, to places like Morocco or India, and it's very important because I need to forget about F1 at times. To go freely where I want without a press pass and marshals screaming at me makes a lot of sense.

Start line accident, German Grand Prix
The first corner at Hockenheim has been the scene of numerous accidents in recent years, often involving local hero Michael Schumacher. The 2001 Grand Prix was one such case. Brazilian Luciano Burti, driving a Prost, was launched into a series of horrific somersaults, wiping out Schumacher's Ferrari in the process. "Accidents are one of the few times that I hit the autofocus button on the back of my camera and, on this occasion, it worked superbly. I was able to record the full sequence of the accident, which happily resulted in no serious injury."

CAMERA: Canon EOS 1V
LENS: 300mm with 1.4x converter
ISO: 100
APERTURE: f/7.1
SHUTTER SPEED: 1/500 sec
LIGHT CONDITIONS: bright sunshine
WEATHER CONDITIONS: dry

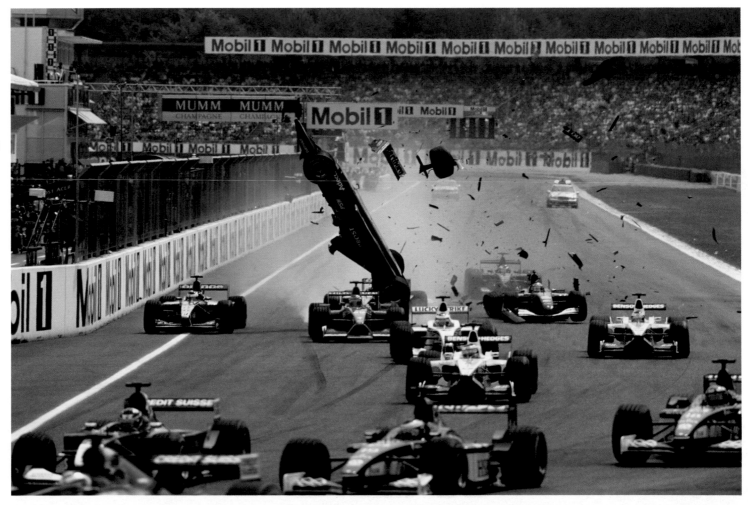

Charles Coates

Michael Schumacher celebrating, Indianapolis
"Winning is something that Michael Schumacher grew accustomed to over the years and he remains a photographer's dream when it comes to celebration pictures. While other drivers, who have achieved a fraction of his success, can appear dull on podiums and during victory laps, Schumacher, to his huge credit, celebrated every addition to his incredible record, almost as though it was his first. Despite the crash helmet covering his face, a long lens and the relatively slow speed of the car enabled me to photograph quite an intimate moment."

CAMERA: Canon EOS 1V
LENS: 600mm
ISO: 100
APERTURE: f/6.3
SHUTTER SPEED: ¹⁄500 sec
LIGHT CONDITIONS: bright sunshine
WEATHER CONDITIONS: dry

Top 10 Tips for Success

1) Anticipation

Try to anticipate where the action is most likely to happen. As with all sports, a knowledge of the subject is very important. On any circuit, there are always corners with a history for action and incidents (the first corner at Hockenheim, Germany, and the daunting series of turns at Eau Rouge in Spa-Francorchamps, Belgium, are good examples) and by spending time at such places, the chances of taking spectacular images are greatly increased.

2) Concentration

It is crucial when shooting a fast action sport like F1 to maintain concentration and remain focused at all times. A dramatic incident can happen at any moment, even when a corner or race may appear uneventful for long periods. A car can break, catch fire, or crash in a split second. There is no worse feeling than missing a shot and knowing it is impossible to rewind time.

3) Experiment with slow shutter speeds

Try experimenting with slow shutter speeds—the results can be surprisingly dramatic. For a sport such as motor racing, reducing the shutter speed can help to convey the feeling of speed, so I use many different speeds, from $1/1000$ sec to as low as $1/10$ sec. When shooting like this, it's crucial to be extremely smooth with your actions to avoid camera shake, so using an image stabilizing facility on any lens can help.

4) Camera technology

Make use of the facilities that modern camera technology can offer, but be careful not to become over reliant on them. Autofocus and image stabilizing are probably the two most useful aids. Autofocus can be activated by a button on the back of the camera, thus enabling me to use manual focus for the majority of my shots, but giving me the option to use it in the event of an incident. Image stabilizing can be a real help when shooting at slow shutter speeds.

5) Learn from other photographers

Don't think you're ever too good to learn from other photographers. Sometimes inspiration can be gained by observing other people's work, perhaps from outside the field of motor sport.

6) Don't overuse Photoshop

A good photographer will always shoot a decent picture, however, nowadays, a bad photographer can almost create a decent picture. I appreciate the tools are there to be used and skillful appliance of them can enhance a very good picture to make it superb. But I find it frustrating when I see images being made that have never really existed.

7) Vary your lens choice

Most photographers have a favorite lens. I personally like the 600mm and I can be guilty of overusing it. On modern Grand Prix circuits the 600mm, often used with a 1.4x converter, is now crucial for most action photography because of the distance to the track. However, by mounting a different lens, perhaps a 14mm for example, a corner can take on a very different look. Suddenly the crowd in the grandstand, trees beyond, and the sky can become as important as the car itself.

8) Try backlit photography

Conventional thinking says that the subject should be lit directly. This isn't always the case and some of my most striking, often moody shots are taken facing into the light. Early morning and late afternoon, when the sun is low, are great times to do this. Winter testing, when the cars start early and run almost until nightfall, are when some of the best backlit pictures are taken. It's sometimes surprising how much darker an image can be shot than your camera may be telling you.

9) Find unique angles

Strive to find a position away from the crowd. It can be easy to stand with other photographers, assuming that this must be the best position for the best shot. It isn't always true. The most satisfying pictures are often the ones that nobody else has taken. Spend time trying to source new angles—they're always there.

10) Enjoy the shoot

Believe in your ability, experiment with shots, and enjoy the experience. Almost anyone can take a good action photograph. The hard part is consistently taking good ones. The convenience of digital photography and the relative lack of expense in comparison to film means that it has never been easier to experiment.

Charles Coates

Workshop

Michael Schumacher winning the Monaco Grand Prix
The victory lap after the 1999 Monaco Grand Prix in Monte Carlo. Michael Schumacher has just won, with teammate Eddie Irvine behind him in second position. As they come down the hill from Casino Square, arms aloft in celebration, the marshals wave the different colored flags in acknowledgment of a fine drive. The backlit conditions dramatically emphasize the colors.

Specification

CAMERA: Canon EOS 1

LENS: 600mm

ISO: 100

APERTURE: f/9

SHUTTER SPEED: 1/500 sec

LIGHT CONDITIONS: afternoon sunshine, backlit

WEATHER CONDITIONS: dry

Essential Equipment

- Two 35mm Canon EOS 1Ds MKII camera bodies
- 14mm f/2.8 lens
- 50mm f/1.4 lens
- 17–35mm f/1.4 lens
- 135mm f/2.8 lens
- 300mm f/3.8 lens
- 600mm f/4 lens
- Lens hoods for all lenses
- Aquatech lens covers
- Flashgun, but not too often
- Three Lithium-ion batteries
- Ten 2GB CF cards
- Chamois leather cloth
- Cellphone
- Wet weather cape

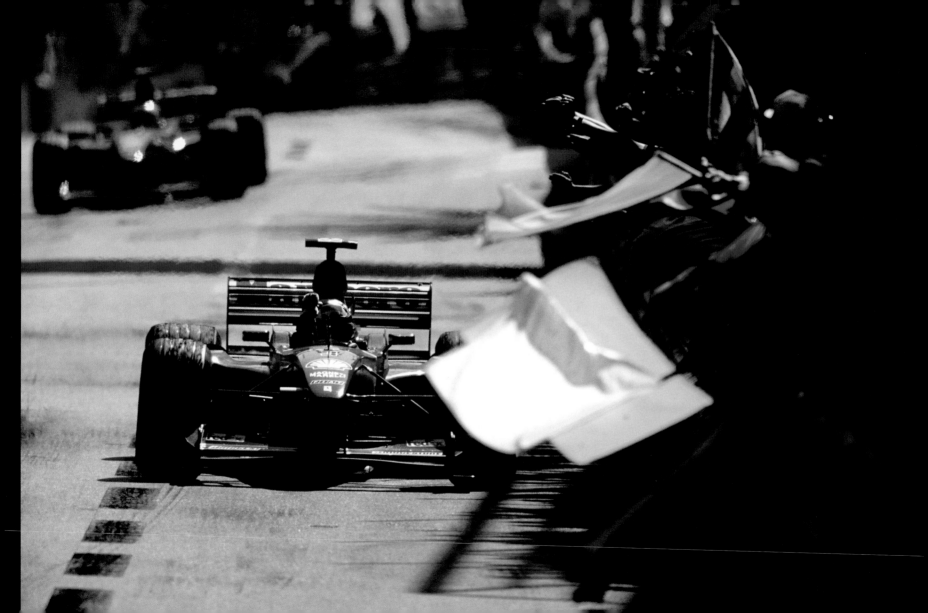

John Gichigi

Boxing

Kenyan-born John Gichigi, known as "John G" within the sports photography world, has brushed shoulders with the biggest and best names of the boxing hierarchy, and is firmly established as one of the world's premier action photographers. But his heavyweight status didn't come easily. Gichigi worked diligently to graduate as an architect from the University of Westminster, where his course had a strong photographic bias. At this time he was also boxing at amateur level. His interest in boxing made the sport a natural subject for his photography, while his knowledge as a participant enabled him to anticipate the movements of the fighters.

During the mid-1970s Gichigi was employed by photo agency Allsport, after completing a postgraduate photography course at Kingston College. He now shoots for worldwide giant Getty Images. His lust for the sport remains unabated. If you talk to Gichigi about a certain fight or fighter, you can expect to learn more and know what you're hearing is true. After all, he's been there, seen it, and done it.

John Gichigi

AS: What was your first-ever camera?

JG: A 35mm Praktica LTL. I bought one because it was the same affordable camera we were taught with at college. It was also the first SLR I had used which offered manual exposure control, metering options, and the ability to change lenses.

AS: What have been your greatest photographic achievements to date?

JG: Photographing Lennox Lewis vs Evander Holyfield, who fought each other twice. The first contest had an amazing buzz about it because none of the top pundits knew who was going to win. The anticipation level was just incredible.

AS: Is it fair to say that, like many successful photographers, you had a "lucky break" at some stage?

JG: Gaining employment with Allsport. The agency had photographers who were specifically assigned to boxing and they would always produce the goods. When I started I was considered second or third in the pecking order, but I helped out when I could and shot bouts in my spare time.

AS: Why did you decide not to pursue other types of photography, such as portraits or fashion, for example?

JG: I studied all photographic genres at college but I loved action shooting and geared myself to follow this path. I still have unfinished portrait projects I wish to undertake, however, because this type of photography is my second love.

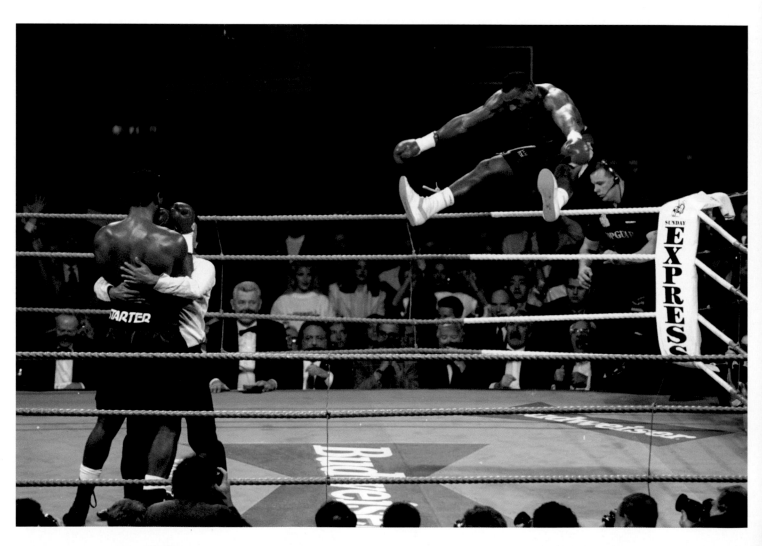

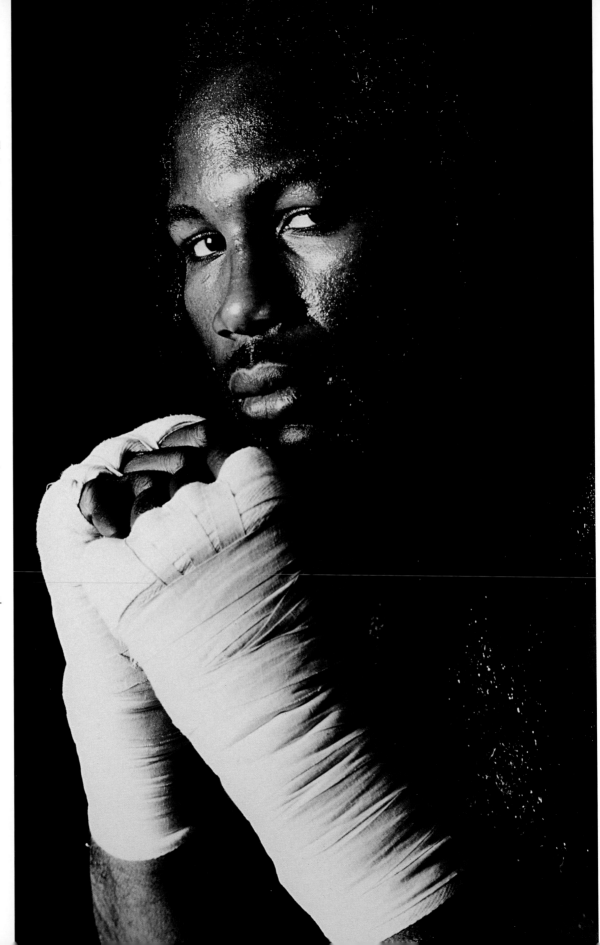

Right: **Lennox Lewis**
Portrait of the former Undisputed
World Heavyweight Champion,
Lennox Lewis, taken inside the
Lennox Lewis Boxing Academy.
To gain access to Lewis, Gichigi
had to go through about six
months of negotiations. "The
session was on-off about four
times, before he eventually let
me photograph him. This was
an exclusive shoot for me and
it's one of my favorite shots."

CAMERA: Nikon D1X
LENS: 80–200mm
ISO: 100
APERTURE: f/8
SHUTTER SPEED: 1/250 sec
LIGHT CONDITIONS: single
 Elinchrom flash with softbox

Left: **Oliver McCall vs Lennox
Lewis, Wembley Arena**
Oliver McCall jumps for joy
after his TKO win over WBC
Heavyweight Title holder
Lennox Lewis. Gichigi was only
one of two photographers to
capture the exact scene, despite
the fact that 50 other
professionals were in the arena.
The image brought him the
Runner-up Prize in the
prestigious Reebok European
Image of the Year 1994
competition, and it was also
used in every newspaper report
on the day after the 2am contest.
"I rarely shoot from balcony
positions but I'm glad I did on
this night. I was able to capture
both fighters in the same
frame—the joy and anguish
of victor and vanquished."

CAMERA: Nikon F5
LENS: 80–200mm
FILM: Fuji 800
APERTURE: f/2.8
SHUTTER SPEED: 1/500 sec
LIGHT CONDITIONS: tungsten

AS: Do you shoot what you want or do others generally define what's required of you?

JG: I have complete control over what I decide to shoot. I know what Getty wants from me, but essentially I control it. I am given a brief—in particular for more commercial demands—but at ringside I make the final decisions.

AS: Where are you mostly based? Where are your most popular locations?

JG: I have traveled to virtually every big bout in the UK, Ireland, Germany, Denmark and, of course, Las Vegas in the US. Even after all these years I still get excited about covering any fight, from small halls to major arenas, such as Madison Square Garden in New York.

AS: What things do you enjoy most about your job?

JG: I have a natural aptitude for cameras and I continually find myself wanting to take pictures. I also love boxing and the continued evolution of the photography that accompanies it.

AS: From a technical aspect, what are the most difficult things about your job?

JG: Deciding which approach is going to work with the best available light when I get to the venues; one of the main skills a sports photographer needs is the ability to adapt to lighting conditions. Some boxers and the way they maneuver are extremely difficult to read. Some fighters are very quick; others fight with their hands around their waists and move in an unorthodox way. I've learned where to direct my camera lens and anticipate when they might connect with a good punch, but anticipation is still a challenge after all these years!

AS: Which venue do you like to photograph fights in the most?

JG: The MEN Arena is a great venue for light and space. It is big enough for the crowd to be farther from the ring, giving the images a black background, which allows the available light to be concentrated on the fighters.

AS: How would you describe your personal technique or style of photography?

JG: I'm always looking for pictures where someone's landing a punch on the face. That's never easy, because you've only got a split second to react. Many fighters try to mask when they're going to throw a big punch, but I'm able to see this through experience of watching the same people fight.

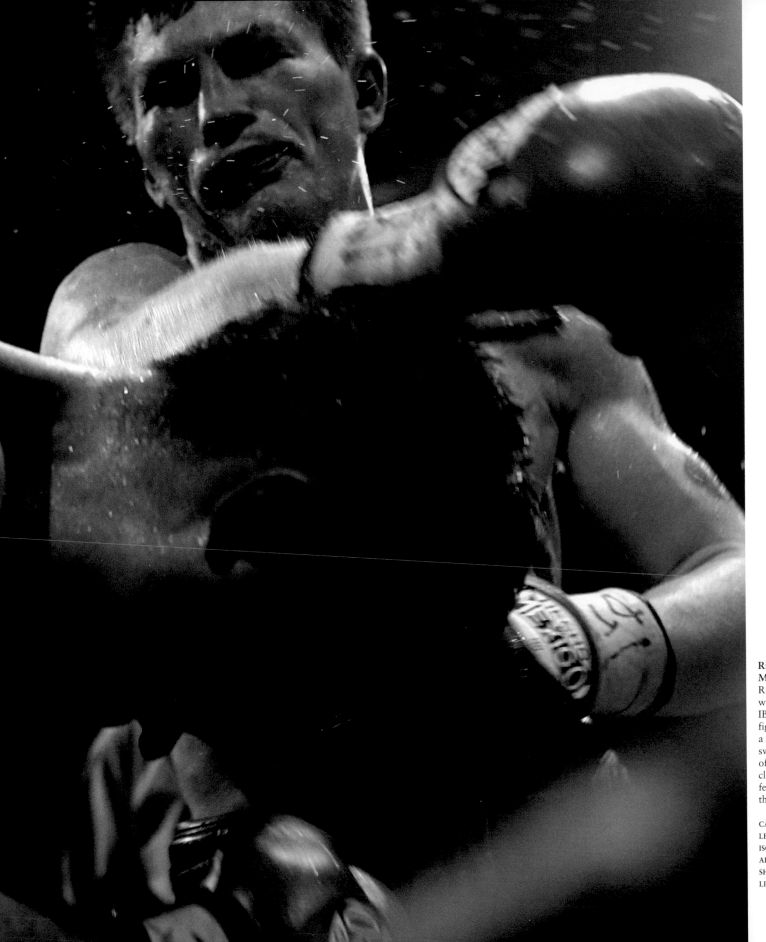

Ricky Hatton vs Kostya Tszyu, MEN Arena
Ricky Hatton fights up close with Kostya Tszyu during the IBF Light Welterweight Title fight. Hatton has attacked with a right cross, creating a hail of sweat, which adds to the drama of the punch. "Being up this close allows me to capture the ferocity and determination of the fighters," says Gichigi.

CAMERA: Canon EOS 1Ds MKII
LENS: 24–70mm
ISO: 800
APERTURE: f/2.8
SHUTTER SPEED: $\frac{1}{500}$ sec
LIGHT CONDITIONS: tungsten

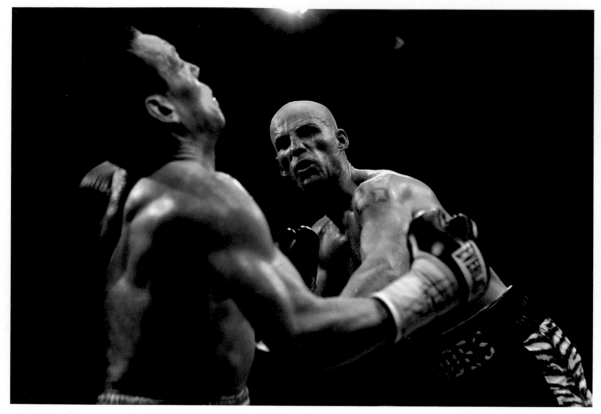

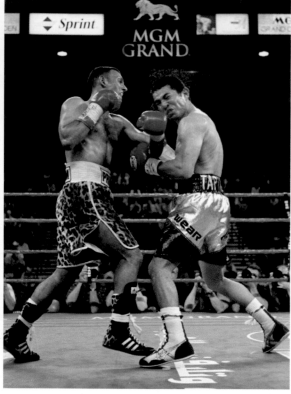

Above:

**Gary Lockett vs Ryan Rhodes,
Millennium Stadium**

Gary Lockett (left) is hurt by
a left cross during the WBU
Middleweight title fight against
Ryan Rhodes. The fighters were
right next to Gichigi, with his
lens poking through the ropes.
"I had to be quick to evade
being hit by the boxers,"
he chuckles.

CAMERA: Canon EOS 1Ds MKII
LENS: 24–70mm
ISO: 800
APERTURE: f/3.2
SHUTTER SPEED: 1/640 sec
LIGHT CONDITIONS: tungsten

Above right:

**Prince Naseem Hamed vs
Marco Antonio Barrera,
MGM Grand Garden Arena**

Prince Naseem Hamed (left)
lands a sharp uppercut against
legend Marco Antonio Barrera
at the MGM Grand Garden
Arena in Las Vegas. Gichigi
remembers: "The lighting was
very even—commonplace in
American arenas—which
enabled me to shoot with a
high shutter speed. I don't think
Hamed ever recovered from this
particular fight."

CAMERA: Nikon D1H
LENS: 28–70mm
ISO: 800
APERTURE: f/4
SHUTTER SPEED: 1/640 sec
LIGHT CONDITIONS: tungsten

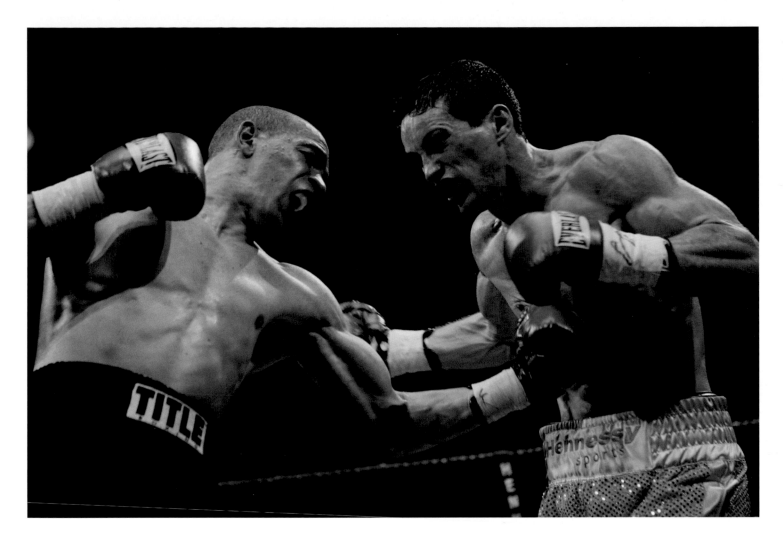

Billy Corcoran vs Carl Johanneson, York Hall
Carl Johanneson (left) connects with a body shot against Billy Corcoran during the British Super Featherweight fight at York Hall. Lighting was very good at this venue and this enabled Gichigi to use an aperture and shutter speed combination of f/3.2 and 1/800 sec at ISO 800.

CAMERA: Canon EOS 1Ds MKII
LENS: 24–70mm
ISO: 800
APERTURE: f/3.2
SHUTTER SPEED: 1/800 sec
LIGHT CONDITIONS: tungsten

AS: What's in your kit bag? Which camera system do you use and why?

JG: I need a fast 35mm camera to capture the action. Although I was a Nikon die-hard for about 20 years—I used a Nikon D1H for much of that time—nowadays I use a Canon EOS 1Ds MKII. This camera offers two key functions I need for successful sports shooting—speed and picture quality.

AS: What are your favorite and most used lenses/focal lengths?

JG: My ringside workhorse is a 24–70mm lens, which takes care of everything right in front of me to the other side of the ring. If I think someone's on the verge of getting knocked out, I'll change to a 16–35mm lens, which frames the victor as well as his opponent on the canvas.

John Gichigi

AS: What types of pictures do you find the most difficult to take?

JG: Experience can mean making something difficult look easy. I can tell by looking at a boxer's face what sort of condition he is in and how long he has got to go before the fight will be stopped. If I think someone's going to get knocked out, I really focus on body language, which at times can be challenging.

AS: Which do you prefer, digital or film, and why?

JG: I was brought up on film but now I am fully digital. The best thing about shooting digital is that I can see my pictures as I go along, and correct my timing if it is needed. That way I am able to offer a wider range of pictures from the same bout.

AS: How much of your work is manipulated using imaging software?

JG: Agency regulations mean I am not allowed to manipulate my images—it is called editorial integrity. However, I can edit simple things such as cropping and slight lightening and darkening.

AS: Where do your ideas for innovative pictures come from?

JG: Before a fight I think about the kind of images I want to achieve, often by looking at previous bouts I have covered. Action photography means you seldom have control over the outcome, but you can control what is in front of you through your choice of angle or lens, to achieve a different picture to other competing photographers.

AS: What does the future hold for you?

JG: I still want to cover boxing at the highest level, but I would also like to do more features on the boxers themselves. This would enable me to fulfill my portraiture needs.

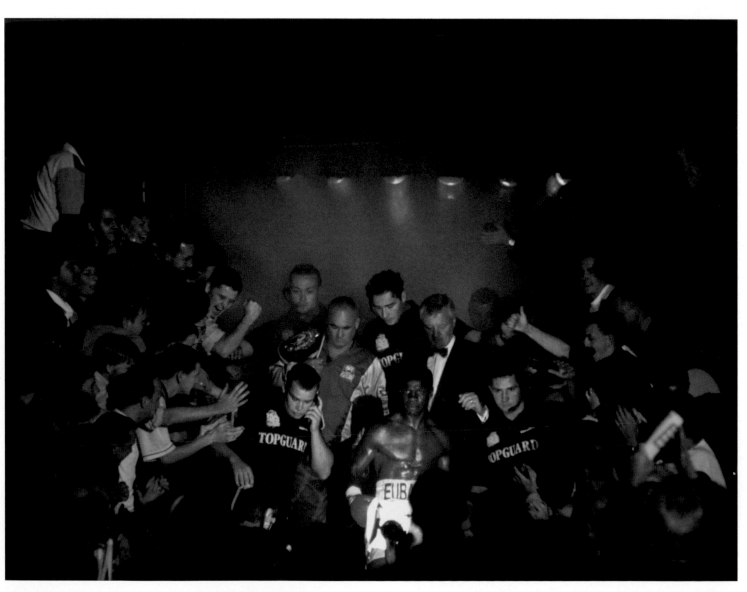

Chris Eubank enters the arena
Eubank is cheered by fans as he approaches ringside; the fighter always made a flamboyant entrance and Gichigi captured the moment with perfection. A lot of elements in this image came together to provide a unique photograph—the tungsten lights above, the fans' reaction, the security around the fighter, the team—while the TV cameraman provides the lighting for the boxer's stance. "As Eubank came down the steps to defend his title against Sam Storey, quick reactions allowed me to capture his entrance before he disappeared down into the steps… I think I had just two frames left on my roll of film in which to pull off the perfect shot."

CAMERA: Nikon F5
LENS: 80–200mm
FILM: Fuji 800
APERTURE: f/2.8
SHUTTER SPEED: ¹⁄₂₅₀ sec
LIGHT CONDITIONS: tungsten

**Acelino Freitas vs Barry Jones,
Doncaster Dome**
Exhausted fighter Barry Jones
is counted out during the Super
Featherweight bout against
Acelino Freitas. The referee
always plays a big part in any
boxing match—here he
illustrates his important role
by counting out Jones. The
referee has already reached a
count of seven, yet the boxer
still has his head down and
has pushed his gumshield out
in resignation.

CAMERA: Nikon F5
LENS: 28–70mm
FILM: Fuji 800
APERTURE: f/2.8
SHUTTER SPEED: $^1/_{500}$ sec
LIGHT CONDITIONS: tungsten

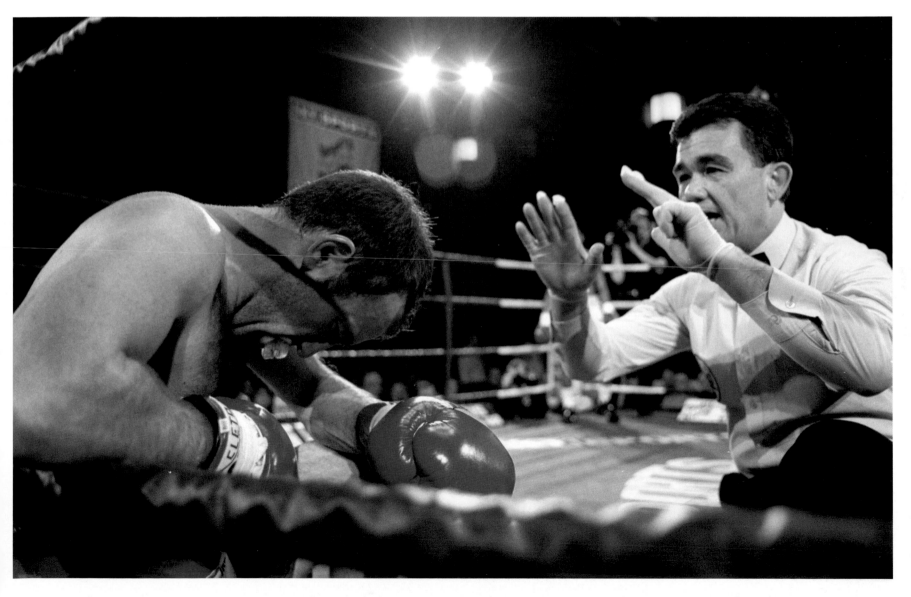

John Gichigi

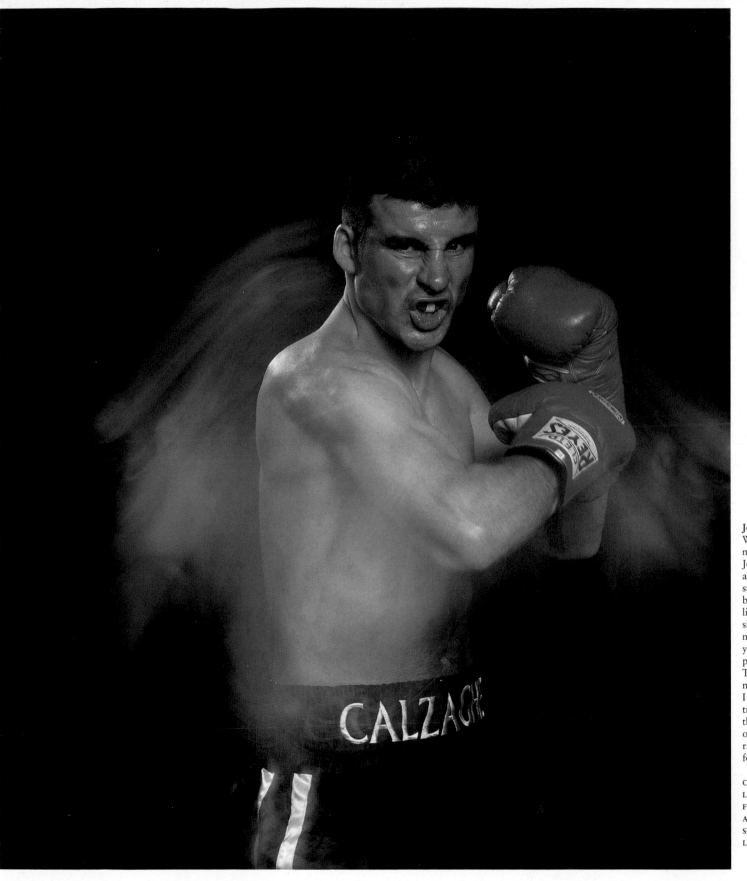

Joe Calzaghe
WBO World Super-middleweight Champion Joe Calzaghe pictured during a feature shoot. "We hired a studio and used a black background with tungsten lighting to provide the correct shooting conditions for the motion blur. If you look closely you can see Calzaghe's face printed either side of his body. This was shot using a Bronica medium-format camera; I got Calzaghe to punch first, triggering the flash, and then weave into the glare of the tungsten lights from right-to-left, during a long four-second exposure."

CAMERA: Bronica GS1
LENS: 150mm
FILM: Fuji 100 transparency
APERTURE: f/8
SHUTTER SPEED: 4 sec
LIGHT CONDITIONS: single Elinchrom flash and two tungsten lights

Top 10 Tips for Success

1) Buy a camera you are comfortable with

When you purchase a 35mm SLR camera, make sure it is from one of the leading manufacturers, such as Canon or Nikon. These cameras are the industry standard and have been designed to take a lot of punishment, such as knocking into other photographers, poor weather, and the sheer volume of pictures the camera has to cope with. Importantly, choose a camera that is CompactFlash-compatible (CF), which today is used by most sports professionals. Flash card size is also important—I would choose anything from 1–4GB because camera file sizes are getting bigger each year. Up until around 2005, 256MB and 512MB cards were quite common, however, now I would choose a card with a bigger capacity. But don't put all your eggs into one basket: I would rather shoot on two 2GB cards than on one 4GB card, just in case it became corrupt or was lost.

2) Bring the right accessories

A competent digital camera is just the tip of the iceberg. You will also need to bring these items:
*A good lens hood is essential because overhead lights are very strong and often you shoot straight into them.
*A chamois leather cloth for cleaning lenses, because specks of sweat and blood fall onto your lens which, if not removed, can be detrimental to image quality.
*Batteries must be at peak performance to cope with fast-paced, continuous shooting. Boxing happens in spurts; you won't want to miss any pictures through such a simple mistake.
*Keep a selection of lenses at hand, so that you can change quickly as the fight develops. Some boxers will be far-ringside or right next to you, so at least two appropriate lenses such as 16–35mm and 24–70mm are ideal.

3) Get the best possible seating position

In boxing photography, this is essential. Get to the arena early to get the best possible position—scout for it before the start of the fight. In major fights these are preassigned, but your position will determine the range of pictures you can get.

4) Be aware who is ringside

Look out for sports personalities and celebrities who are ringside because they can be very animated and engrossed in the fights. I have seen well-known faces going absolutely crazy. They lose their guard and it makes for wonderful pictures.

5) Keep your eyes on the boxers at all times

You can be sure the minute you take your eyes off the fighters, one of them will throw the split second power punch and you'll miss the action. In a dull fight you need to be able to capture every moment, because of the lack of good photo opportunities. Also, 50 percent of the time is spent with the referee in the way, or fighters facing the wrong way, so there is no clear shot all of the time. I'm forever calling out to the referee "can you please keep moving!" I appreciate he has to do his job, however.

6) Get the lighting just right

There are typically less important bouts on a fight card before the main event, so it's essential to take test shots during these to fine-tune your color balance and shutter speed/aperture combination. I always set these manually because automatic exposure can fool the camera's metering system, such as a referee's white shirt set against the dark ambience of the crowd. I tend to manually set my color balance to tungsten because I know I will get a consistent balance throughout the fight. I like to avoid cold and warm color ranges. Always carry a flash in case of power failure or very low-light levels in small halls.

7) Shoot in JPEG file format

I always shoot in high-quality JPEG—the biggest available JPEG file—because RAW is generally too slow for fast action photography. It takes the camera too long to transfer the image to the image card. JPEG format is appropriate for 90 percent of requirements; however, sometimes shooting in RAW is required for the occasional high-quality production, such as a poster campaign.

8) Choose the correct ISO and shutter speed balance

There is a fine balance between the ISO setting and the shutter speed required to freeze the action. I use the slowest ISO setting to give me the fastest required shutter speed possible, which is usually about 1/500 sec. Images can produce a lot of "noise" at higher ISO settings (noise is pixels in the wrong place in an image), such as ISO 800, so the picture quality suffers a lot.

9) Learn the movements of the fighters

Use the first couple of rounds to study the movements of the boxers. This is time well spent because it will help you get better images as the fight progresses. Your anticipation will also improve.

10) Prepare for the unexpected

In boxing, more than most sports, a fighter who looks down and out can produce a knock-out punch from nowhere. You cannot write anybody off, as you can with other sports, where one team who is 4-0 down is seldom going to win. I've seen guys with dislocated arms produce one throw of the dice to knock out their opponents, so be prepared.

John Gichigi

Mike Tyson vs Brian Nielsen, Parken Stadium

Mike Tyson knocks down opponent Brian Nielsen during the World Heavyweight Title fight. Tyson spectacularly won the bout when the referee stopped the fight in the seventh round, after Tyson had lifted the 252-pound (114.3kg) Nielsen off his knees with this punch. This picture is a great example of being in the right place at the right time, with the right equipment at hand. Gichigi was the only photographer to capture the image of Nielsen falling mid-air from the knock-out punch—his ideal seating position aided him because the referee was blocking out the other photographers' viewpoints. "Toward the end of the round I wanted to change film, so I was shooting sparingly, but I could see that Tyson had weakened his opponent and was about to knock him out. So I waited a little longer to capture the knockout."

Specification

CAMERA: Nikon F5

LENS: 17–35mm

FILM: Fuji 800

APERTURE: f/2.8

SHUTTER SPEED: 1/500 sec

LIGHT CONDITIONS: tungsten

Essential Equipment

- Two 35mm Canon EOS 1Ds MKII camera bodies

- 16–35mm f/2.8 lens

- 24–70mm f/2.8 lens

- 70–200mm f/2.8 lens

- Lens hoods for all lenses

- Flashgun

- Two spare Lithium-ion batteries

- Six 1–2GB CF cards

- Chamois leather cloth

- Laptop computer

- Cellphone

- Water bottle

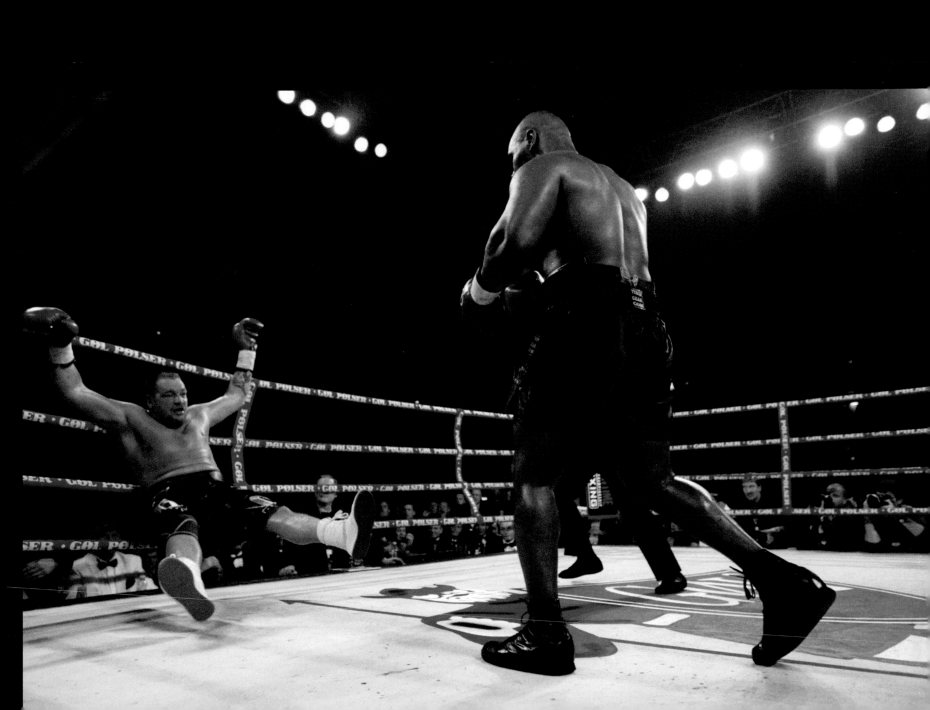

Jed Jacobsohn

Baseball

Jed Jacobsohn developed a penchant for photography at a very early age, when he watched his father, a keen amateur, taking pictures in his spare time. Marrying this with his love for baseball, which he "always played as a kid," Jacobsohn joined a photography program at Berkeley High School in California where he spent three summer vacations starting in 1992, working for renowned photo agency United Press International. Here he mastered the art of E6 image developing and black-and-white printing, while in his spare time building up a stunning portfolio of top baseball teams, such as the San Francisco Giants.

Thereafter Jacobsohn landed a full-time job as staff photographer with sports agency Allsport in Los Angeles, in 1995. Getty Images acquired Allsport in 1998, the same year Jacobsohn won a World Press Photo Award, during which time he photographed boxing, basketball, US football, and winter sports, in addition to his number one vocation, baseball.

Interview

AS: What was your first-ever camera?

JJ: I started using a Pentax K-1000 at high school, but the first SLR camera I actually purchased was a Nikon F2, and thereafter a Nikon F3.

AS: What have been your greatest photographic achievements to date?

JJ: Winning the World Press Photo Award in 1998 for my picture of Evander Holyfield's ear, after Mike Tyson had bitten off part of it. More recently, however, my best achievement is having my image of the Boston Red Sox published on the cover of *Time* magazine, when the team won the World Series in 2004. It's a pretty rare thing for a sports photographer to have an image on the cover of such a politically biased magazine, especially with such an iconic team.

AS: Is it fair to say that, like many successful photographers, you had a "lucky break" at some stage?

JJ: Absolutely not. Hard work and perseverance bring luck.

AS: Why did you decide not to pursue other types of photography, such as portraits or fashion, for example?

JJ: I am a baseball man through-and-through and it will always remain my first love; I am in love with the sport. There are just so many different moments in any given game. Photographically there are not just hard, impact moments in which players move at a fast pace, but also a lot of subtle and emotional opportunities.

Boston Red Sox vs New York Yankees, Fenway Park
Alex Rodriguez of the New York Yankees warms up while the Stars and Stripes flag is draped for the singing of the national anthem, before the start of game three of the American League Championship Series at Fenway Park. The perspective in scales makes this image interesting, in addition to the featured player, who is a future Hall of Fame star. "I'm always trying to find a different angle at any event I go to and I think this image encompasses that ethos very well."

CAMERA: Canon EOS 1Ds MKII
LENS: 400mm
ISO: 800
APERTURE: f/2.8
SHUTTER SPEED: 1/640 sec
LIGHT CONDITIONS: night/ tungsten

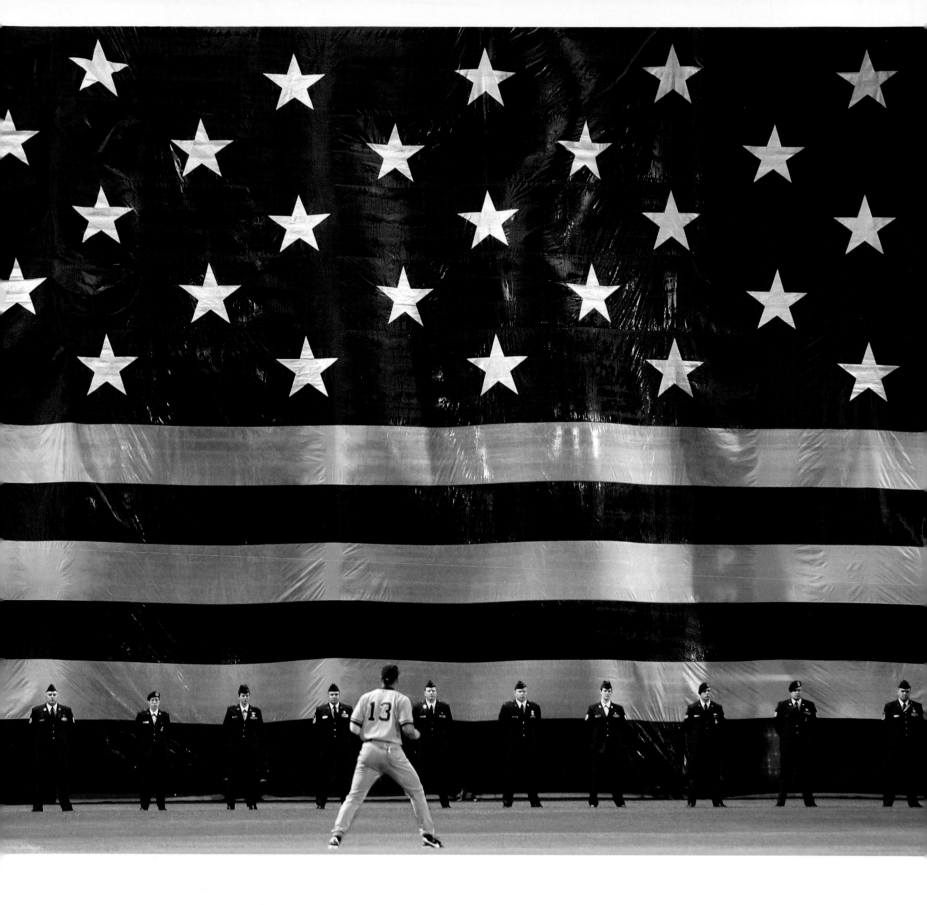

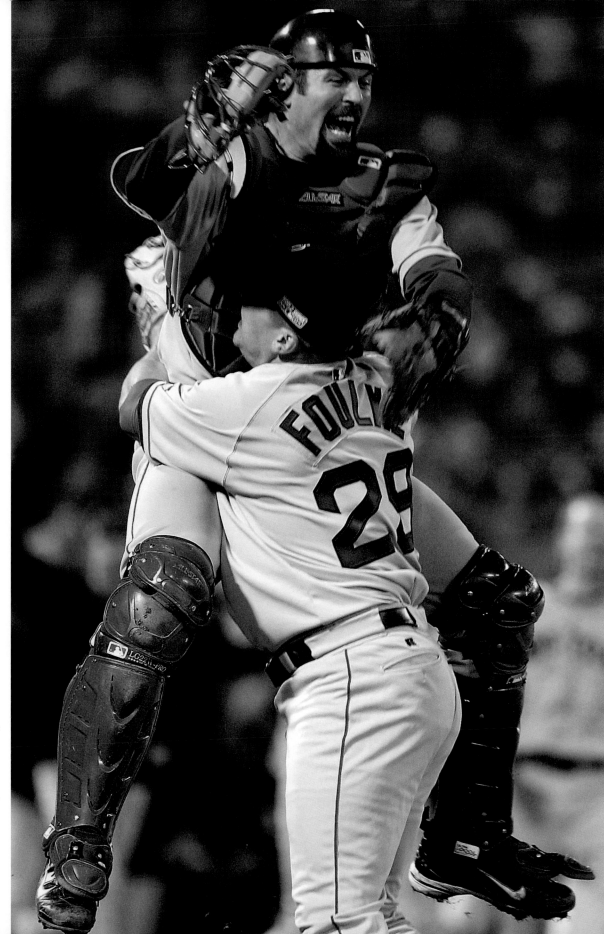

St. Louis Cardinals vs Boston Red Sox, World Series, Busch Stadium

Jason Varitek and Keith Foulke of the Boston Red Sox celebrate after defeating the St. Louis Cardinals 3-0 in game four of the 2004 World Series at Busch Stadium in St Louis. "This was a monumental moment in baseball history, so the pressure was there to capture a moment that would sum up the joy and relief of the Red Sox finally winning the World Series again, the last time being 1918. Usually there is a 10-second moment when pitcher and catcher come together before a pile of players arrive. Luckily, in this instance, they jumped in my direction."

CAMERA: Canon EOS 1Ds MKII
LENS: 300mm
ISO: 800
APERTURE: f/2.8
SHUTTER SPEED: ¹⁄640 sec
LIGHT CONDITIONS: night/
 tungsten

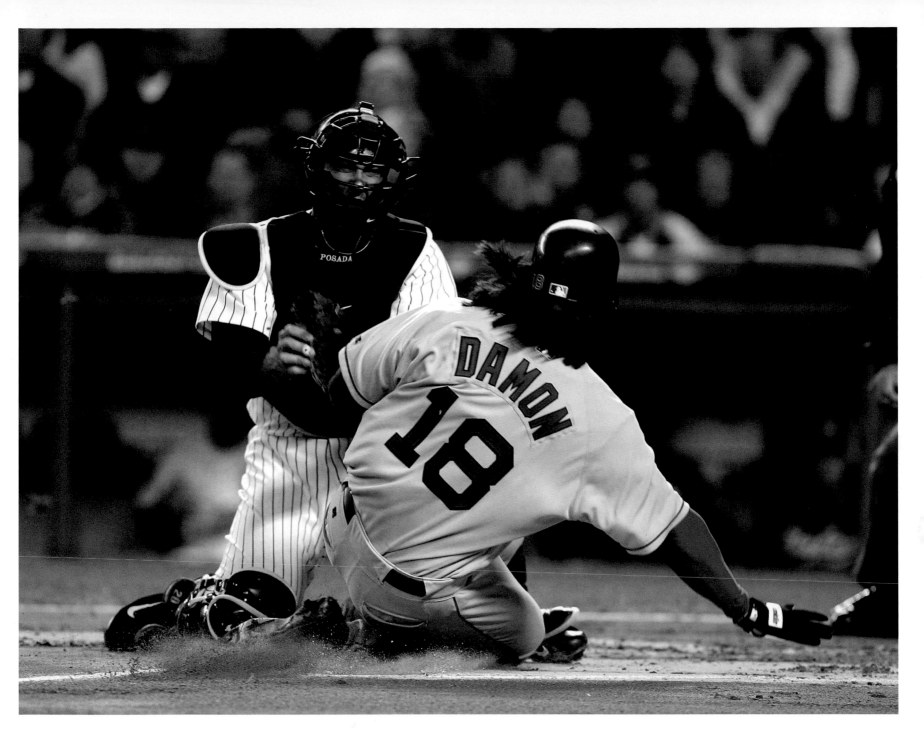

New York Yankees vs Boston Red Sox, Yankee Stadium
Johnny Damon of the Boston Red Sox is tagged out at the "home plate" by catcher Jorge Posada of the New York Yankees, in the first inning during the American League Championship Series in Yankee Stadium. "The rivalry between the two teams is unmatched by any in US sport; the desire for them to beat one another up is always there—especially in play-off time."

CAMERA: Canon EOS 1Ds MKII
LENS: 300mm
ISO: 800
APERTURE: f/2.8
SHUTTER SPEED: ⅟₆₄₀ sec
LIGHT CONDITIONS: night/ tungsten

Jed Jacobsohn

AS: Do you shoot what you want or do others generally define what's required of you?

JJ: It's a mutual thing. Experienced photographers shoot what they like to shoot because they know the teams and they know how to read the game. Getty Images has every faith in my ability to get the best shots during a game, in particular ones that will sell.

AS: Where are you mostly based? Where are your most popular locations?

JJ: I'm based in the Bay Area in California, either in Oakland, Berkeley, or San Francisco, but of course I do have to travel to wherever I am assigned to shoot. It's hard to leave here because I grew up here.

AS: What things do you enjoy most about your job?

JJ: No disrespect to those who do, but I don't have to go into an office and sit in the same seat five days each week; I go to major sporting events and I get paid for doing something I enjoy. I also get to be around lots of other people enjoying themselves and I am able to show this through my photography. It's an extremely satisfying way to earn a living.

AS: From a technical aspect, what are the most difficult things about your job?

JJ: Technical things aside, being able to switch off my emotions is difficult, especially when I'm at a baseball match and my team is playing. Moreover, security at stadiums in recent years has risen to the point where it has become almost prohibitively hard in comparison with just a few years ago. Restrictions on where photographers are allowed to go within most venues is beginning to limit the range of pictures they can get. Skills now aren't just with a photographer's ability to take good pictures, but also with their ability to negotiate good seating positions.

AS: Which venue do you like to photograph in the most?

JJ: The San Francisco Giants' stadium is ideal because of the photographic positions that are provided. They're pretty varied and I can think of dozens of positions that I can shoot from to get a unique perspective on any game; obtaining action shots other rivals do not get is very significant, especially in today's busy market. Some other stadiums are very limited. It's nice to have options to fully exploit my technique and equipment.

AS: How would you describe your personal technique or style of photography?

JJ: I try to capture sports stars and what they do in a unique manner. I don't just look for peak-action moments; I try to look for a different angle on that particular moment. I don't look for the obvious and I always try to tell the story of a game as it unfolds.

AS: What's in your kit bag? Which camera system do you use and why?

JJ: A Canon EOS 1Ds MK II which, although provided by Getty Images, is a 35mm system I would buy anyway, simply because it's just so good.

AS: What are your favorite and most used lenses/focal lengths?

JJ: I use my 400mm f/2.8 lens more than any other, sometimes with a 1.4x converter.

AS: What types of pictures do you find the most difficult to take?

JJ: A very tough question to answer; ultimately difficult pictures depend on the stadium, the facilities it offers photographers, the weather, and of course, the available light.

AS: Which do you prefer, digital or film, and why?

JJ: For me, the ease and convenience of digital is much better than film, particularly for fast action photography. But the quality of film—in some circumstances—is still better. There is also something romantic about film photography and I think it will always be this way.

AS: How much of your work is manipulated using imaging software?

JJ: No images are manipulated, except for only the slight use of levels and unsharp mask in Photoshop. A good photographer takes good pictures with his or her camera—not because they know how to use a computer better than their rivals. I cannot stress this point enough.

AS: Where do your ideas for innovative pictures come from?

JJ: Above all from the sport itself and from the use of light as it appears on the field of play. Gaining motivation and ideas from other photographers is also key to my work.

AS: What does the future hold for you?

JJ: I hope to continue doing the things I do, in particular shooting sport, action, portraits, and the stories that accompany them, particularly on the baseball field.

Oakland Athletics vs Seattle Mariners, Network Associates Coliseum
Bobby Crosby of the Oakland Athletics attempts to throw out Edgar Martinez of the Seattle Mariners on a base hit. "This image works because of several factors: the background is clean, the shortstop's throw caused his body to be in a very dynamic position, and Crosby happened to be the Rookie of the Year in 2004."

CAMERA: Canon EOS 1Ds MKII
LENS: 400mm
ISO: 200
APERTURE: f/2.8
SHUTTER SPEED: 1/200 sec
LIGHT CONDITIONS: day/natural

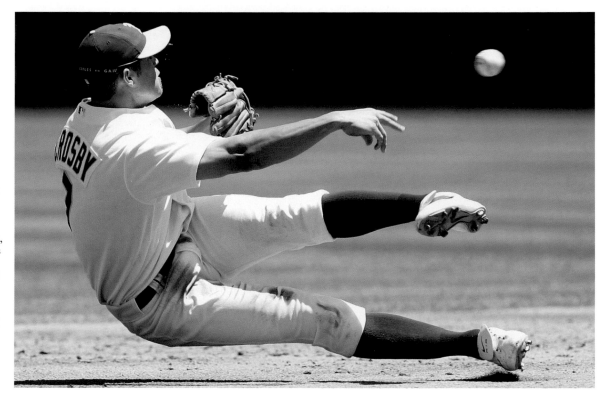

Japan vs Cuba, Petco Park
Manager Sadaharu Oh of Team Japan is thrown up into the air by teammates after defeating Team Cuba 10-6 in the final game of the World Baseball Classic (WBC) at Petco Park in San Diego. "This was the inaugural WBC and I wasn't really sure how the players would react at the end of the game. They were quiet throughout the tournament from beginning to end, but I had no idea they would react like this when they won."

CAMERA: Canon EOS 1Ds MKII
LENS: 400mm
ISO: 800
APERTURE: f/2.8
SHUTTER SPEED: 1/640 sec
LIGHT CONDITIONS: night/ tungsten

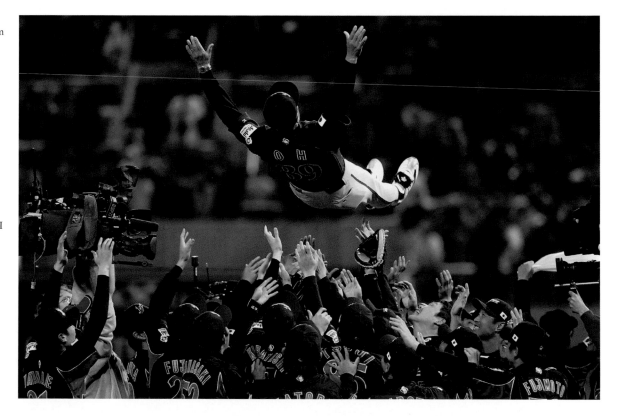

Jed Jacobsohn

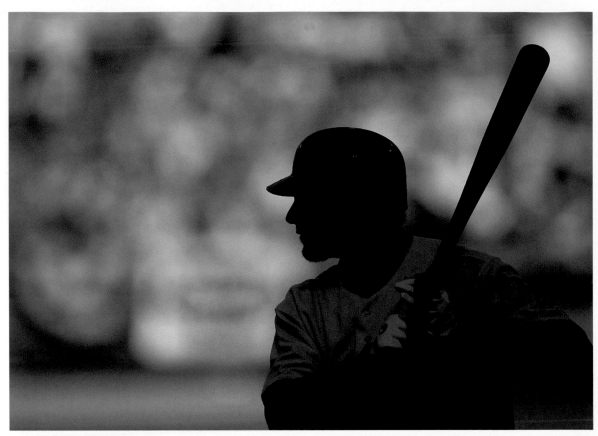

Oakland Athletics vs Chicago White Sox, McAfee Coliseum
"The one good thing about TV's big influence on Major League Baseball is that it can sometimes change the start time of the game, such as with the 5pm start to this game. As Mark Kotsay of the Oakland Athletics waited for a pitch against the Chicago White Sox, the sun was setting on the nearside field, while the sun still shone bright in the stands. I exposed for the background conditions to get a silhouette effect."

CAMERA: Canon EOS 1Ds MKII
LENS: 400mm
ISO: 100
APERTURE: f/4
SHUTTER SPEED: $\frac{1}{1000}$ sec
LIGHT CONDITIONS: day/natural

New York Yankees vs New York Mets, World Series, Yankee Stadium
Mike Piazza of the New York Mets smashes his bat from a pitch thrown by Roger Clemens of the New York Yankees in the first inning during game two of the World Series at Yankee Stadium. "The broken bat led to a confrontation between Piazza and Clemens, during which time Clemens picked up a piece of the bat and threw it at Piazza. I took this image with one of the original digital cameras—a Canon DCS 520—which was an atrocious camera that had a terrible shutter lag and produced an average image. I was actually quite surprised by the end result."

CAMERA: Canon DCS 520
LENS: 400mm
ISO: 800
APERTURE: f/2.8
SHUTTER SPEED: $\frac{1}{640}$ sec
LIGHT CONDITIONS: day/natural

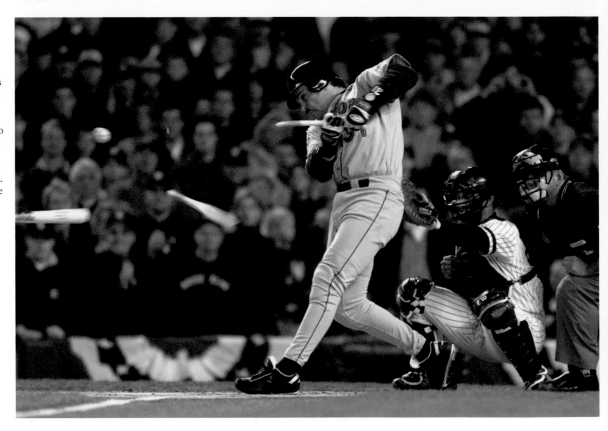

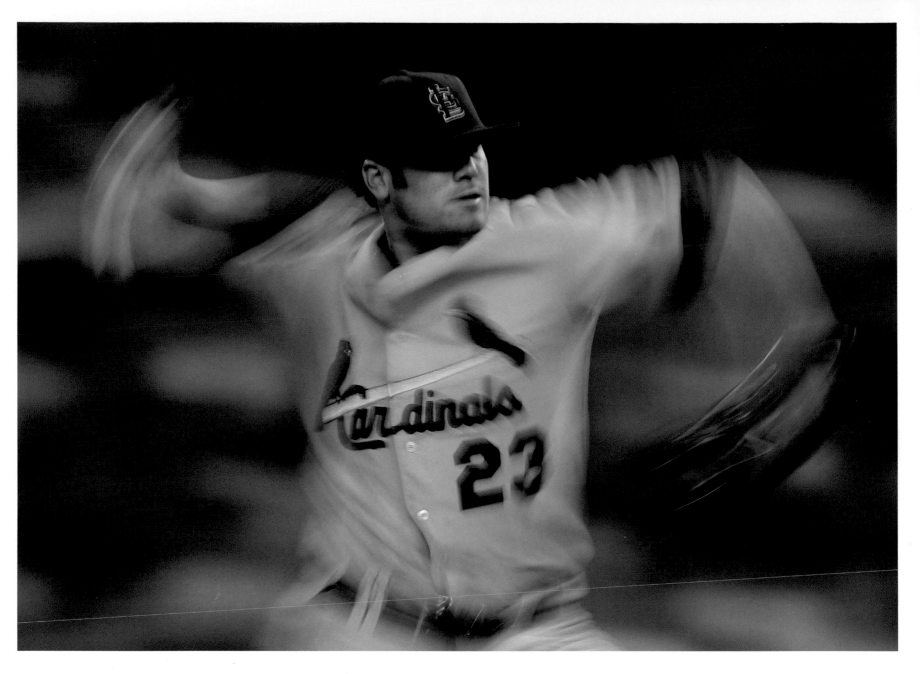

Detroit Tigers vs St. Louis Cardinals, World Series, Comerica Park
"Anthony Reyes of the St. Louis Cardinals was pitching a dominant game from the first pitch during game one of their World Series clash. Unfortunately, as a photographer, a pitching duel does not often make for compelling visual moments. This was a perfect opportunity to use some photographic effects, so I used a slow shutter speed to bring motion blur to Reyes' arms."

CAMERA: Canon EOS 1Ds MKII
LENS: 400mm with 1.4x teleconverter
ISO: 800
APERTURE: f/4
SHUTTER SPEED: 1/15 sec
LIGHT CONDITIONS: night/ tungsten

Jed Jacobsohn

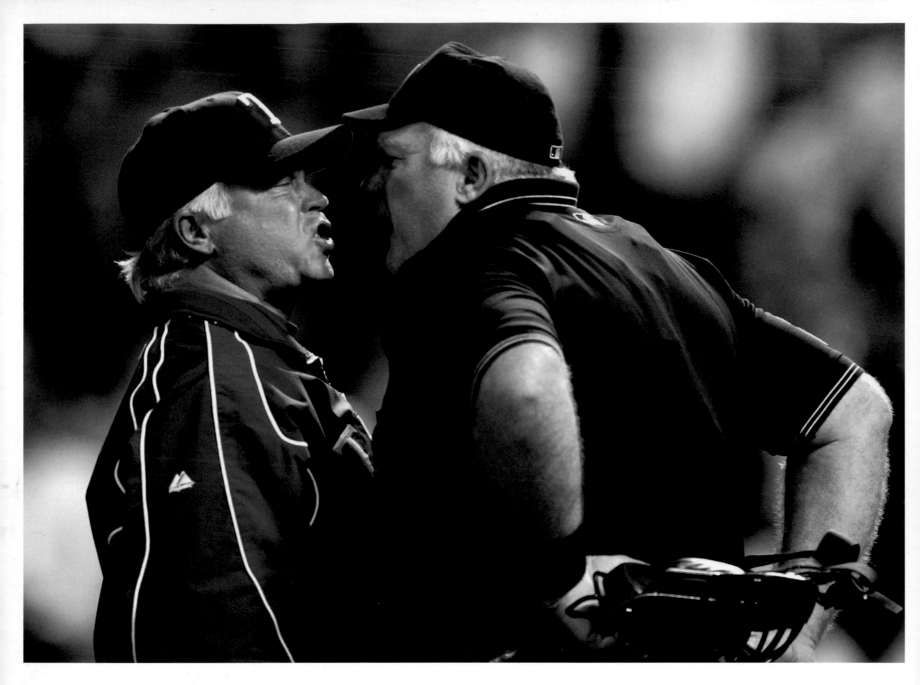

San Francisco Giants vs Texas Rangers, AT&T Park
"Buck Showalter (left), former manager of the Texas Rangers, is notorious for arguing and being a hothead. He was thrown out of the game against the San Francisco Giants for arguing balls and strikes with umpire Larry Young (right), which, technically, is illegal in baseball. I happened to be on the right side of the field for the encounter and the argument between the two men did the rest."

CAMERA: Canon EOS 1Ds MKII
LENS: 400mm with 1.4x teleconverter
ISO: 800
APERTURE: f/2.8
SHUTTER SPEED: 1/500 sec
LIGHT CONDITIONS: night/ tungsten

Top 10 Tips for Success

1) Consider the background
You could have the most incredible and dynamic moment unfold suddenly at a baseball game, but if a player, umpire, or someone similar happens to wander into the background, it can often turn the planned image from great to average. Always keep a watchful eye on the background, not just the subject in hand.

2) Adapt to available light
Work with lighting conditions that are presented to you. If you're shooting at night under tungsten conditions, keep in mind where the best artificial light may be around the stadium. During the day, work with the sun as it progresses around the stadium throughout the game. Always think about the final picture: what are the implications of shooting from a certain side of the field? For example, if you are shooting into the sun, the image can often become more dramatic and cut out any clutter.

3) Preparation
Know your subject and the sport you cover. Having knowledge of the game can lead to anticipation of when and where the action might happen. For example, if you are shooting a left-handed batter, there is every chance he will hit the ball to the second or first baseman. Anticipate and frame your lens on these types of basemen, hoping for a dramatic dive. It's also important to know who the star players are, as these often present the best sales opportunities after the shoot.

4) Correct stadium position
Position yourself in the field according to which players you are hoping to get shots of. Different stadiums have very different shooting positions. Try to explore all your options and don't be afraid to change positions throughout the game, to determine the finished product.

5) Take chances
Don't be afraid to try something different; try not to get the shot that everyone else is getting. Move to an overhead position or something similar, but always keep in mind how things may look from the angle you are shooting from.

6) Tell the story
I can't emphasize this enough: being creative is a good thing, but don't forget to tell the story of the game. For this reason I always try to take a set of pictures from which others can immediately grasp the outcome of the game—without reading the captions.

7) Make friends
Get to know the staff and players you work with. Having a comfortable relationship with security staff at any venue is a very important thing, too—I even go so far as to make prints for them after a game. In the end this will help you in numerous shooting situations and the positions you are allowed to access in future.

8) Ask for feedback
Getting other people's input on your images is very important. Too often you can become emotionally connected to an image and have a skewed view of how good it is, when in fact it's really not that good at all.

9) Do your research
Looking at old photographs and other photographers' work can often be a great way of learning. Find out who some of your favorite photographers are and study their work for ideas. Importantly, ask yourself this: what is different about their pictures to the ones you have taken?

10) Have fun
Always remember to enjoy your image-making. You are at a big sporting event taking pictures and the way you approach the game, in terms of being happy to be there, always shows on the final edit. A simple point but one that certainly makes a lot of sense.

Milwaukee Brewers vs San Francisco Giants, Miller Park

Randy Winn of the San Francisco Giants makes contact with the ball against the Milwaukee Brewers at Miller Park in Milwaukee. "I was in town to cover Barry Bonds and I had special permission to go to the roof of the ballpark to photograph the game. Unfortunately, Bonds never played, but the light was really nice and it offered a unique view of the ball park and of the game that I had never shot before."

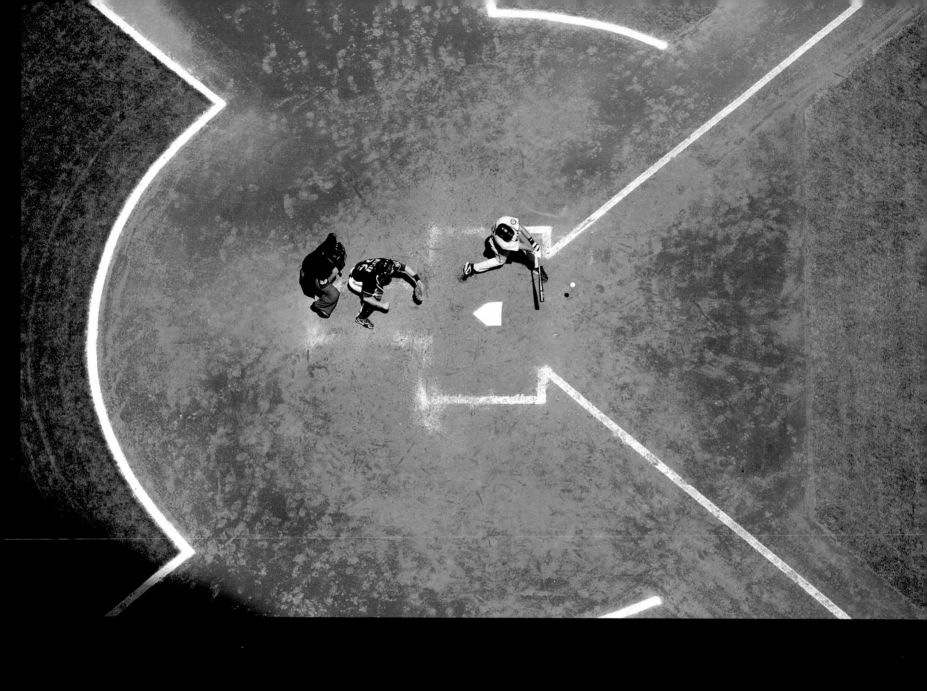

Jed Jacobsohn

Tom Jenkins

General sports

Tom Jenkins is one of the finest and most influential action photographers living today, having photographed some of the most eminent personalities of the modern sports era, borne not just from his skills behind the camera, but also his ability to build relationships with the world's leading stars. Jenkins was named Britain's top sports photographer for the second year in 2005, adding another title to his already illustrious portfolio. The *Guardian* photographer took one of the Sports Journalists' Association's top prizes, and also picked up awards for Best Olympic/Paralympic Portfolio, Best Sports Portfolio, and Best Sports News Picture.

He is the first photographer to win the award in two consecutive years since the legendary Eamonn McCabe in 1978 and 1979. Jenkins says he is "in the best job in the world" and "couldn't possibly imagine" himself undertaking any other vocation.

Tom Jenkins

AS: What was your first-ever camera?

TJ: At college I had a Canon T90 film camera and I was only allowed to shoot with a fixed 50mm lens. Later I was mugged and the T90 was stolen, so I bought a Nikon F4 with standard 50mm lens. This was my first real SLR camera.

AS: What have been your greatest photographic achievements to date?

TJ: Being named Britain's best sports photographer in 2005, for the second year, is the highlight of my professional career. I have also loved photographing the Summer Olympics [in 2000 and 2004]—there are so many different sports within the competition and each one is the top pinnacle in its genre. Emotion is very high yet the event itself isn't too commercial. As a photographer I have found it most rewarding.

The other highlight of my career has to be in Sydney, Australia, November 2003, when Martin Johnson lifted the Rugby Union World Cup for England. That day was amazing and I will never forget taking my photo of Jonny Wilkinson walking past the crowd into the tunnel at the end of the game.

AS: Is it fair to say that, like many successful photographers, you had a "lucky break" at some stage?

TJ: At some point in their life almost everyone is in the right place at the right time. That in itself is lucky but you still have to make the most of this time. Taking sports pictures has an element of luck, however, Eamonn McCabe once told me "you make your own luck."

Jonny Wilkinson, Australia vs England, Rugby World Cup Final, Telstra Dome
"Wilkinson had just kicked the winning drop goal to give England victory at the 2003 Rugby World Cup Final. But he was a reluctant hero. I was trying and failing to illustrate this properly until I saw the arms of adoring fans above the tunnel, waiting to greet him as he returned to the dressing room. Head down, his job done, Wilkinson's body language portrays someone ill at ease with the superstar celebrity status awaiting him—precisely what makes this shot so interesting."

CAMERA: Canon 1D
LENS: 20mm
ISO: 800
APERTURE: f/2.8
SHUTTER SPEED: 1/500 sec
LIGHT CONDITIONS: tungsten

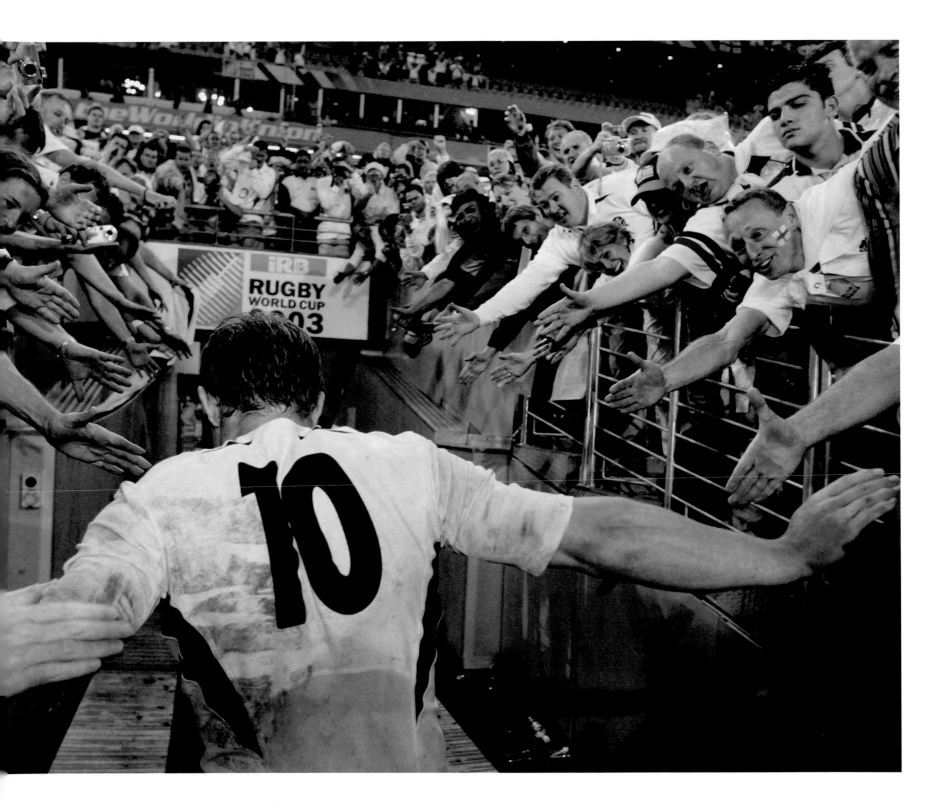

Tom Jenkins

AS: Why did you decide not to pursue other types of photography, such as portraits or fashion, for example?

TJ: I've actually done a bit of portrait work in my time. In all honesty, though, I wish I was a professional sportsman, which makes me realize I'm taking the right kind of pictures. Using a camera is a way for me to feel close to the action I am in love with.

AS: Do you shoot what you want or do others generally define what's required of you?

TJ: Working for a newspaper I am governed by certain restrictions and I have to produce specific pictures that the editors want. There's no point me going off and shooting things I may prefer because I'm not a stock agency and I'd be wasting my time. I sometimes find a story that I want to shoot, and I apply particular characteristics to it, but the majority of time I know what is expected of me.

AS: Where are you mostly based? Where are your most popular locations?

TJ: I regularly visit most big soccer and cricket grounds; Twickenham stadium for rugby and Wimbledon for tennis are also popular venues. The last place is my favorite—Centre Court at Wimbledon is a dream venue for a photographer.

AS: What things do you enjoy most about your job?

TJ: The unpredictability; my job is both frustrating and exhilarating because I never know what's going to unfold. Things can happen right in front of me one day and I'll get loads of strong pictures. The next day it might not and I'll end up with very little. I have to be quite philosophical about these things.

AS: From a technical aspect, what are the most difficult things about your job?

TJ: Shooting unpredictable, fast-moving sports with poor or little light to work with. The cold and damp is also very challenging. I really suffered when I photographed the British women's bobsleigh team, near the German–Czech border, up in the hills with my camera tucked under my jacket, to stop it from freezing up.

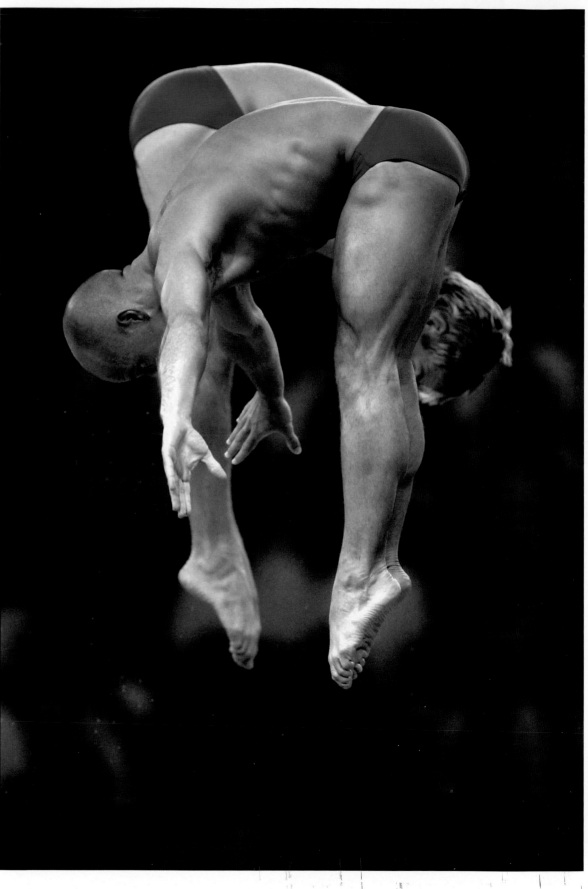

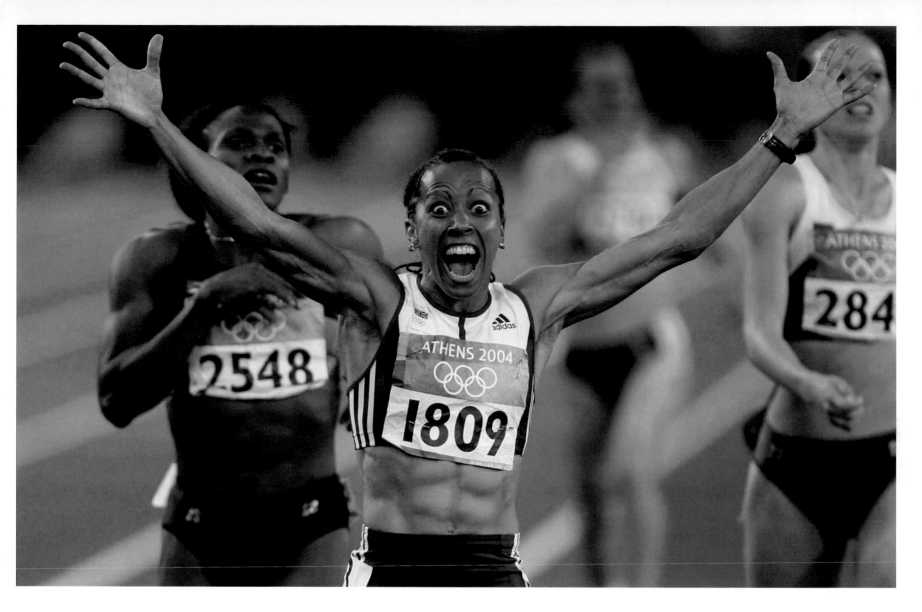

Left: **Mens' Synchronized 3m Springboard Dive Final, Summer Olympics, Athens** "This shot was all about getting exactly the right angle and waiting for the right dive. Against a clean, dark background, the pattern created by the two divers in mid-air is easy to see. This duo went on to win Britain's first medal in Athens that year."

CAMERA: Canon 1Ds MKII
LENS: 400mm
ISO: 1000
APERTURE: f/2.8
SHUTTER SPEED: 1/1000 sec
LIGHT CONDITIONS: indoor floodlit

Above: **Kelly Holmes, Womens' 800m Final, Summer Olympics, Athens** "I managed to sneak into position just around the corner from the finishing line because I had noticed, from previous races, that athletes were reacting to seeing themselves on the big TV screen above that particular bend. Fortunately, that meant that Kelly Holmes was looking right at me when she realized she had won gold in the 800 meters final."

CAMERA: Canon 1Ds MKII
LENS: 400mm
ISO: 800
APERTURE: f/3.2
SHUTTER SPEED: 1/800 sec
LIGHT CONDITIONS: stadium floodlit

Tom Jenkins

AS: Which location or venue do you like to photograph the most? Why?

TJ: I love Centre Court at Wimbledon—photographers have bags of space to maneuver, the backgrounds are very good, the court is contained into a nice size and it's all just terribly simple to work with. I also like [soccer club] Arsenal's new Emirates stadium in London—terrific for working around, with first-class photographers' facilities, and great, modern lighting.

AS: How would you describe your personal technique or style of photography?

TJ: I never go out and think I have to impose a certain style on the picture I'm taking. I go out to photograph whatever sport I'm doing in a way that I'm happy with. You can be arty and creative with fashion or portrait photography and develop a certain look, but with sport it's just too difficult to do this; I am not in control of what may or may not happen. Good pictures in sport come from capturing the unpredictability.

AS: What's in your kit bag? Which camera system do you use and why?

TJ: Along with my three EOS 1D MK II Canons, my main lens is a 400mm, but I also use 80–200mm, 24–70mm, and 16–35mm zoom lenses. I also have teleconverters, remote gear, a 580-EX Canon flashgun, and an array of CompactFlash cards, comprising 2 and 4GB sizes. The cards are a mixture of SanDisk and Lexar Media and I don't like carrying ones that have the biggest memory. I need to transmit during a game and I am constantly changing cards: I just don't need an 8GB size card.

AS: What types of pictures do you find the most difficult to take?

TJ: Ice hockey is hard to shoot because it's so amazingly quick and the tiny puck is very hard to capture. I don't think capturing celebration or emotion is always the key ingredient in any successful photograph—sometimes you need to get the ball or puck in the frame and show the sport in its simplest form. For me, sports photography is about finding a balance of action and emotion, and you can't say that one is more important than the other. Ice hockey is also hard to focus on because of the white ice reflecting artificial light. It's easier to shoot snow and ice using natural light, such as with skiing.

AS: Which do you prefer, digital or film, and why?

TJ: Digital because of the ease of transmission. Modern quality is so good that sports photography has no need for film. There is a nice romance with film that digital cannot produce, but in the sports arena digital offers the perfect medium: quality with speed.

AS: How much of your work is manipulated using imaging software?

TJ: I'm not allowed to do anything aside from basic darkroom techniques, such as lighting, darkening, and a bit of sharpening.

AS: Where do your ideas for innovative pictures come from?

TJ: Experience: watching, waiting, and knowing the stadiums and players. Knowledge of the venue is important because I know how the light on any given time of day or part of year will affect my pictures. Absorbing what other photographers are doing and combining this with the way I take my pictures is also important.

AS: What does the future hold for you?

TJ: I don't want to do anything else. I love what I do so much and if I gave it up I would miss it terribly.

Arsenal vs Manchester United, Highbury stadium

"I took this during a typically feisty Arsenal vs Manchester United game at Highbury stadium. Thierry Henry [left] had just taken a tumble in the United penalty box and the goalkeeper [right] was furious, thinking Henry had dived. The contrasting emotions of the two players make this a strong picture. Fortunately they were exactly in profile to me, so I could photograph both of them perfectly."

CAMERA: Canon 1D
LENS: 400mm with 1.4x
 converter
ISO: 640
APERTURE: f/4
SHUTTER SPEED: ¹⁄₅₀₀ sec
LIGHT CONDITIONS: overcast
 daylight

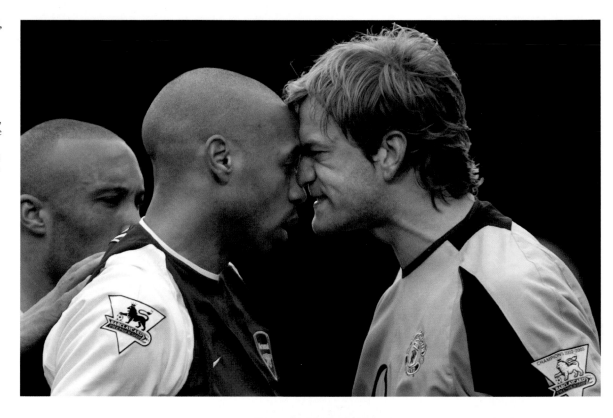

Viatcheslav Ekimov, time trial cycling, Summer Olympics, Sydney

"On the penultimate day of the Sydney Olympics the cycling time trial was taking place in a park in the city center. I thought about doing a pan-blur picture to show the speed they were going at and I found a spot under some trees where I could flash the cyclist going past. What made the colors even better was a bed of bright flowers just behind the trees. This image of Russian cyclist Viatcheslav Ekimov captured the blur and beautiful colors perfectly. Luckily for me, he went on to win the gold medal."

CAMERA: Nikon D1
LENS: 20mm
ISO: 200
APERTURE: f/16
SHUTTER SPEED: ¹⁄₁₅ sec
LIGHT CONDITIONS: flash under
 shade/trees

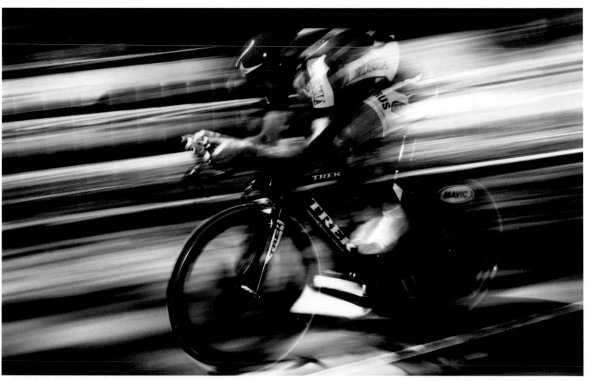

Tom Jenkins

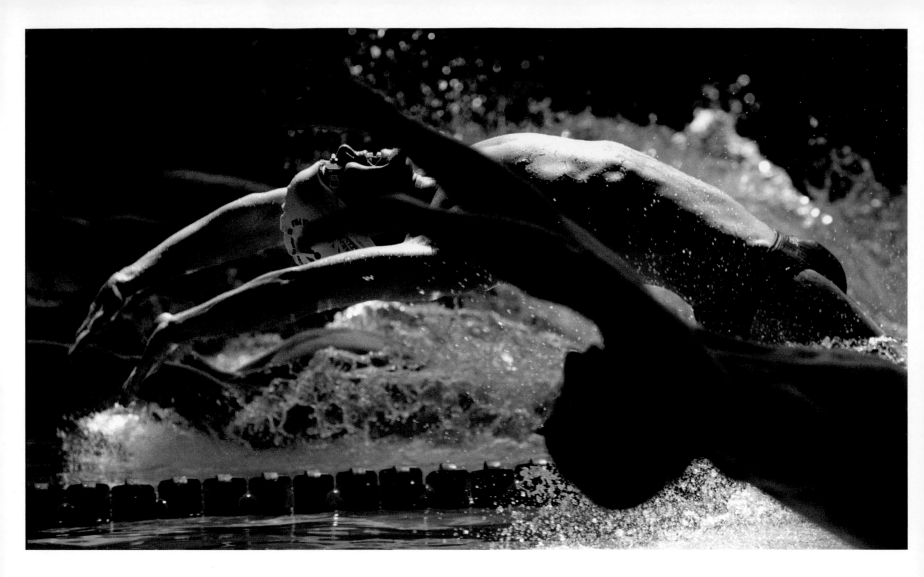

**World Masters Swimming
Championships, Crystal Palace
National Sports Centre**
"It's very unusual to get sunlight
during an indoor swimming
event, however, at the Crystal
Palace National Sports Centre
there are windows down one
side of the pool and, because
this was in mid-summer and
taken quite early in the morning,
the sun was hitting a quarter of
the pool. By midday the sun had
moved around and the light had
gone very flat. The combination
of sun on water with a dark
background makes this
picture—for me—work."

CAMERA: Nikon F5
LENS: 300mm
FILM: Fuji 200
APERTURE: f/5.6
SHUTTER SPEED: ¹/1000 sec
LIGHT CONDITIONS: sunlit
 through windows

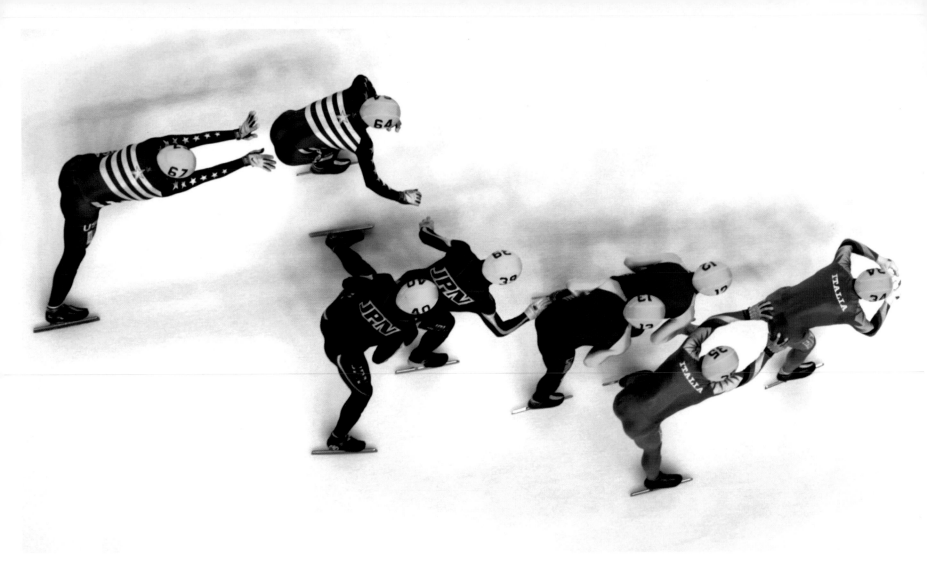

World Short Track Speed Skating Championships, Sheffield Arena
"I photographed this race in the lighting gantry high above the ice, during the World Short Track Speed Skating Championships. The picture captures the atmosphere of the relay final. I think it works well because the unusual angle makes it very graphic and slightly bizarre."

CAMERA: Nikon D1
LENS: 200mm
ISO: 1000
APERTURE: f/2.8
SHUTTER SPEED: 1/500 sec
LIGHT CONDITIONS: indoor floodlit

Tom Jenkins

Tiger Woods, Open Golf Championship, Royal Liverpool
"I captured Tiger Woods at the end of a baking summer's day during the Open Golf Championship. The final competitors go out really late and barely finish their rounds in daylight. I knew the setting sun would make a good image, so it was just about finding the right tee shots so that I could frame everything correctly. Thankfully, everything came together very nicely."

CAMERA: Canon 1D MKII
LENS: 35mm
ISO: 200
APERTURE: f/10
SHUTTER SPEED: $\frac{1}{1000}$ sec
LIGHT CONDITIONS: low sunlight

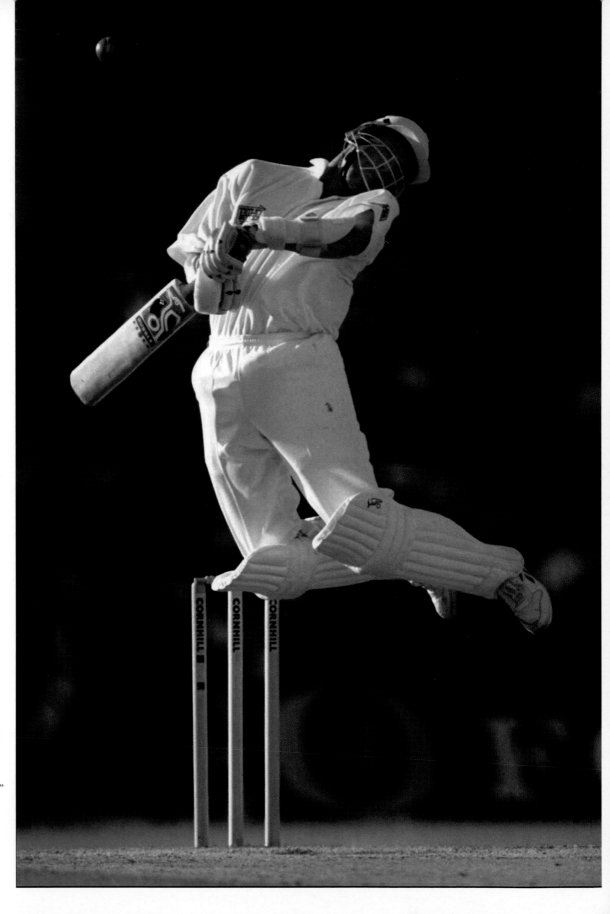

Alec Stewart, England vs Pakistan, The Oval
"During the late 1990s, before The Oval cricket stadium was redeveloped, on a sunny day, you could get a lovely dark background after about 5pm, especially if you shot straight down the wicket. England's opening batsmen were facing a very hostile spell from Pakistan bowler Wasim Akram—and he was getting plenty of bounce. My shot of Alec Stewart shows him at his most agile, trying to avoid some of the fast deliveries."

CAMERA: Nikon F5
LENS: 500mm with 1.4x converter
ISO: 200
APERTURE: f/5.6
SHUTTER SPEED: 1/1000 sec
LIGHT CONDITIONS: sunny

Top 10 Tips for Success

1) Consider your backgrounds
The cleaner and darker, the better. You want to show off the action in front of you as well as possible and you don't want to be distracted by something in the background. Look for things like dark trees or shade from buildings. If possible try to avoid nasty, garish signs and advertising boards.

2) Vary the shutter speed
Think of the images you can create using a variety of shutter speeds. Use slow shutter speeds for panning or blurring the background, to give the impression of quick movement. Try sacrificing aperture for shutter speed. Remember that you need very fast shutter speeds to freeze rapid action; if you are photographing a subject from side-to-side, remember it needs a faster shutter speed than something that is heading straight at you.

3) Prediction
Always put yourself in a good position, so that the best action may happen in front of you. By reading the game you may be able to predict when and where a crucial piece of action might occur.

4) Knowledge of the sport
It's very important to know the rules of any game, especially if it's a sport you have never covered before. There may be some unpredictable moves or decisions that make a great picture. With that key knowledge of the game you will know when and where it's most likely to happen.

5) Knowledge of the competitors
Which competitors are likely to give better pictures? A sport may have a great character and he or she may give you a better image than a poker faced competitor.

6) Vary your lenses
Don't become obsessed to the point where action pictures have to be taken on long lenses. Variety is the spice of life, so don't just whack on a huge telephoto lens and expect great pictures every time!

7) Work with available light
Sometimes the best pictures come from the hardest lighting circumstances, such as harsh backlit conditions. Such light can emphasize the sweat or grass bouncing off a soccer player, as he goes for a header or tackle. Think also of the possibility of silhouettes. And don't be put off by extreme dark. Modern cameras are remarkable and they can record images accurately in dreadful conditions; you may be able to get something very moody and charismatic from it.

8) Try different angles
Either very low or very high angles can produce different effects. By altering your viewpoint, any given image can be transformed, and something mundane can be made highly graphic, unusual, and unique.

9) Expect the unexpected
Never take a game for granted and never assume nothing will happen. The dullest match can suddenly explode with a fantastic piece of action. If you doze off for a split-second you could miss the best photography.

10) Use black and white
Sport is very colorful and this can be used to your advantage. But it can also produce wonderful gritty black-and-white images, too. Think of the results the different media can produce and use them for a variety of effects.

White Turf horse race, St. Moritz

"I took this photo at the unique White Turf horse race meeting held annually on the frozen lake at St. Moritz. The horses came round the final bend and the forest behind formed a beautiful black background. I was lying flat on the snow, so that I could make the most of the backdrop and emphasize the speed of the horses, as well as the flying snow kicked up by their hooves."

Specification

CAMERA: Canon EOS 1D MKII

LENS: 300mm with 1.4x converter

ISO: 200

APERTURE: f/5.6

SHUTTER SPEED: ¹/1600 sec

LIGHT CONDITIONS: bright sunlight

Essential Equipment

- Three 35mm Canon EOS 1Ds MKII camera bodies
- 400mm f/4 lens
- 80–200mm f/2.8 lens
- 24–70mm f/2.8 lens
- 16–35mm f/2.8 lens

- Lens hoods for all lenses
- Canon 580-EX flashgun
- Spare Lithium-ion batteries
- Eight 2–4GB CF cards
- Waterproof jacket

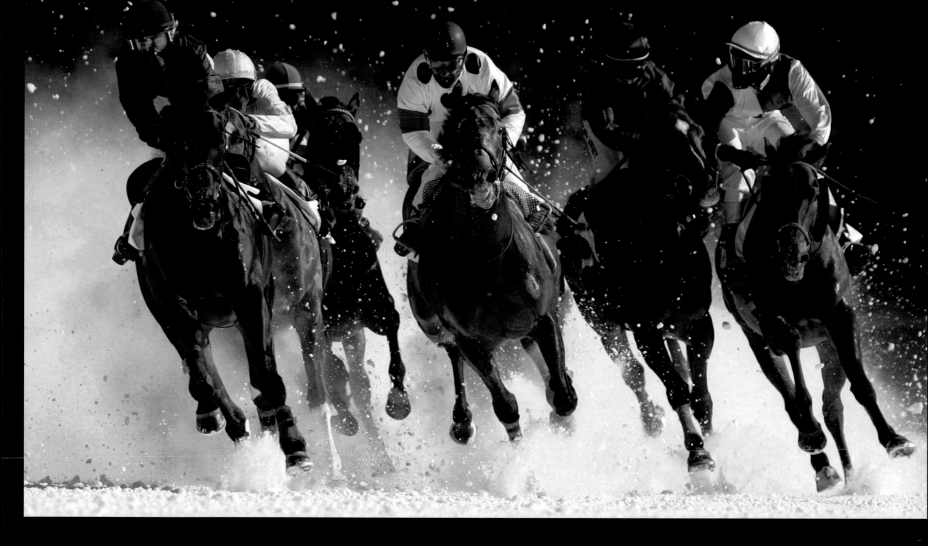

Tom Jenkins

General sports

Bob Martin is a multi-award-winning sports photographer specializing in action, graphic, and editorial pictures for advertising, corporate, and editorial clients. During a magnificent career spanning the last 20 years, he has photographed every major sporting event, from the past 10 Summer and Winter Olympics, to elephant polo and horse racing on ice. His work has taken him to the farthest corners of the globe and his photographs have been published in the world's most respected outlets, including *Sports Illustrated*, *Time*, *Newsweek*, *LIFE*, *Stern*, *Paris Match*, *Bunte*, and *L'Equipe*, as well as *The Sunday Times* and *The New York Times*.

A resident in his native England, Martin is currently the only *Sports Illustrated* staff contributor to be based outside the US. Many from within the industry recognize his picture-taking abilities as being at the very highest echelons of the profession, bringing him hitherto more than 50 national and international awards. He is a three-time winner of the prestigious British Sports Photographer of the Year competition, while, in 2005 alone, he was awarded over 23 titles, including the Sports Picture of the Year in the coveted World Press Photo Awards.

<p align="right">Interview</p>

AS: What was your first-ever camera?

BM: A Zenith E. Then I bought an Olympus OM-1 with two fixed focal length lenses: 50mm and 135mm. The first professional camera I shot sport with was a Nikon FM1; I bought a 300mm f/2.8 lens which cost just under £2,000 [$4,000 US] 20 years ago. Even back then I realized buying cheaper equipment was a false economy.

AS: What have been your greatest photographic achievements to date?

BM: Winning a combination of awards, in particular being named British Sports Photographer of the Year three times and receiving the World Press Photo Sports Picture of the Year accolade in 2005. It was also a humbling experience going to the Paralympics in 2005.

AS: Is it fair to say that, like many successful photographers, you had a "lucky break" at some stage?

BM: I wouldn't say so. I haven't had a career-defining break. I have made my luck by working hard.

Xavi Torres, Summer Paralympic Games, Athens
"I was honored to win many awards for this photograph, including The World Press Photo Sports Picture of the Year, which is the most prestigious international annual competition of press photography. I took this image from the lighting rig above the pool and the unique angle required months of planning. The rest speaks for itself."

CAMERA: Canon EOS 1Dn MKII
LENS: 70–200mm
ISO: 640
APERTURE: f/2.8
SHUTTER SPEED: $1/1250$ sec
LIGHT CONDITIONS: floodlit tungsten

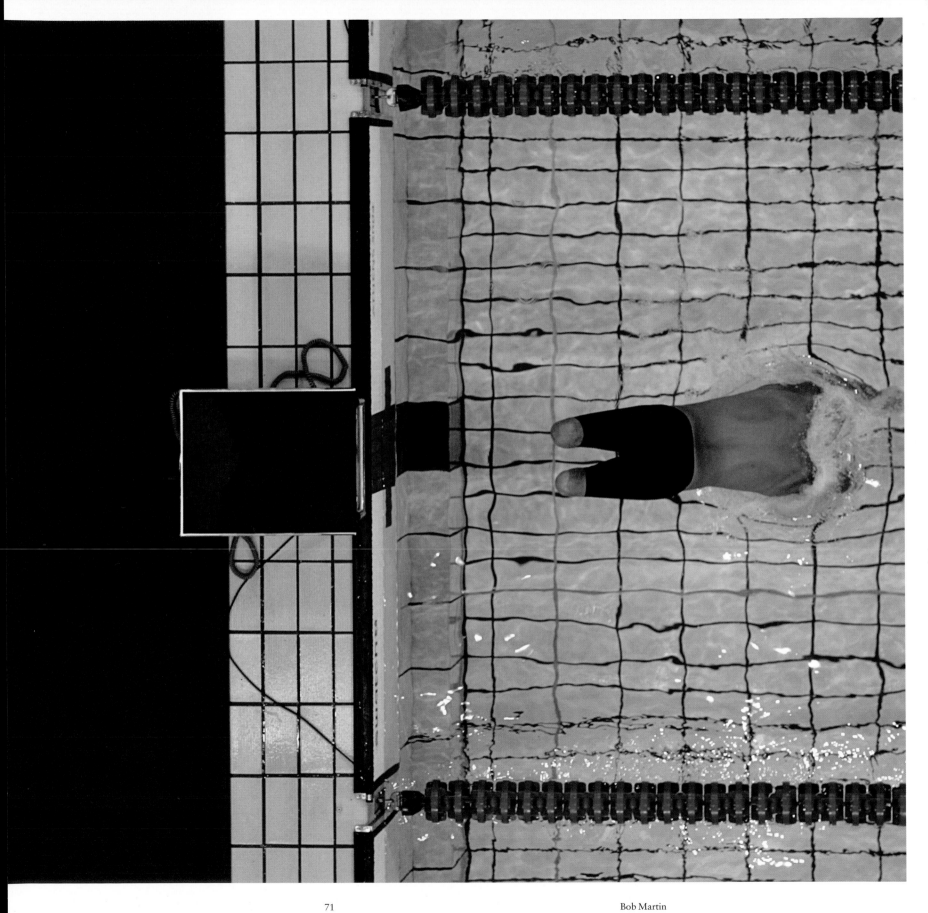

Bob Martin

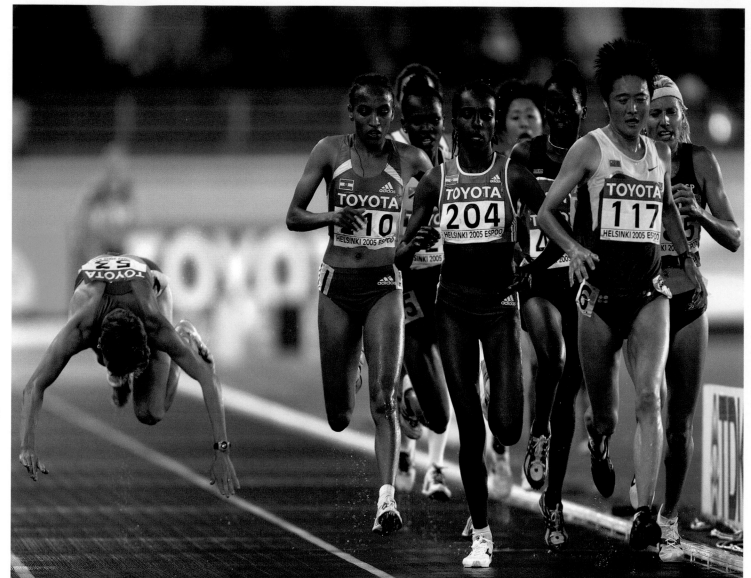

Women's 5,000m, Track and Field World Championships, Helsinki
"The 2005 World Track and Field Championships was not so great for Olga Kravtsova of Belarus. I was following the runners through the lens and, watching fastidiously, I captured the moment as she started to topple over. I was one of only a couple of 250 photographers at the finish line to record the moment."

CAMERA: Canon EOS 1Dn MKII
LENS: 400mm
ISO: 640
APERTURE: f/2.8
SHUTTER SPEED: 1/1000 sec
LIGHT CONDITIONS: floodlit tungsten
WEATHER CONDITIONS: rain

AS: Why did you decide not to pursue other types of photography, such as portraits or fashion, for example?

BM: Nobody wanted me to! Sometimes I do personality portraits of leading sports stars but they are not really my strength. I quite fancy having more of a go at wildlife one day, however.

AS: Do you shoot what you want or do others generally define what's required of you?

BM: It varies. I carry out assignments when I am commissioned but people employ me for my style. People know me for getting something different and they have confidence in my ability to get the picture they want for their business. Most of the time I am left to my own devices.

AS: Where are you mostly based? Where are your most popular locations?

BM: I've done so much traveling—so often—that I have become more interested in going to a place which gives me a buzz pictorially, rather than just going to a nice place for the sake of it. I do however like Australia and for some reason I am also in love with Scandinavia. The creativity is more important than the location.

AS: What things do you enjoy most about your job?

BM: The feeling I get every time I know I've got a really good picture. No matter where it is or the conditions that are thrown my way, photography is the one key thing I still enjoy most about my job.

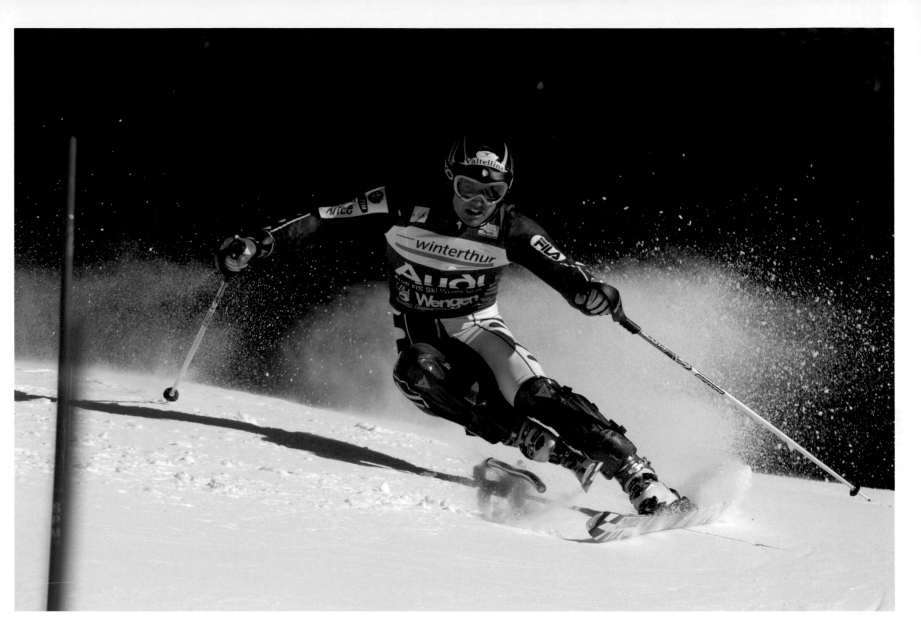

AS: From a technical aspect, what are the most difficult things about your job?

BM: Patience. I spend many days feeling bored but I have learned to persevere with boredom to achieve exciting shots.

AS: Which location or venue do you like to photograph the most and why?

BM: My highlight is the Summer Olympics every four years. Normally I have a free role and I can go to lots of different events. I have a contract with *Sports Illustrated* magazine and my career has reached the stage where they let me wander off and do what I am best at: getting something unusual. I try to avoid the men's 100m final; competing with 500 other sports photographers jostling for position is my idea of hell.

AS: How would you describe your personal technique or style of photography?

BM: I always try to find an unusual angle and I have far more fun going to a smaller event than a bigger one. I'm the type of person who might excel at the World Canoeing Championship, rather than the FIFA World Cup final.

Giorgio Rossa, World Cup Slalom, Wengen
"Switzerland's Wengen is one of the best venues on the World Cup circuit for photographers. The course is lined with fir trees at the bottom, and when the sun is out the trees give you this wonderful black background. Giorgio Rossa won the race and went on to win the World Cup Slalom in 2005. For me, the concentration on his face captures the danger and passion of the event."

CAMERA: Canon EOS 1Dn MKII
LENS: 400mm
ISO: 200
APERTURE: f/4
SHUTTER SPEED: 1/2000 sec
LIGHT CONDITIONS: natural
WEATHER CONDITIONS: bright and sunny

Bob Martin

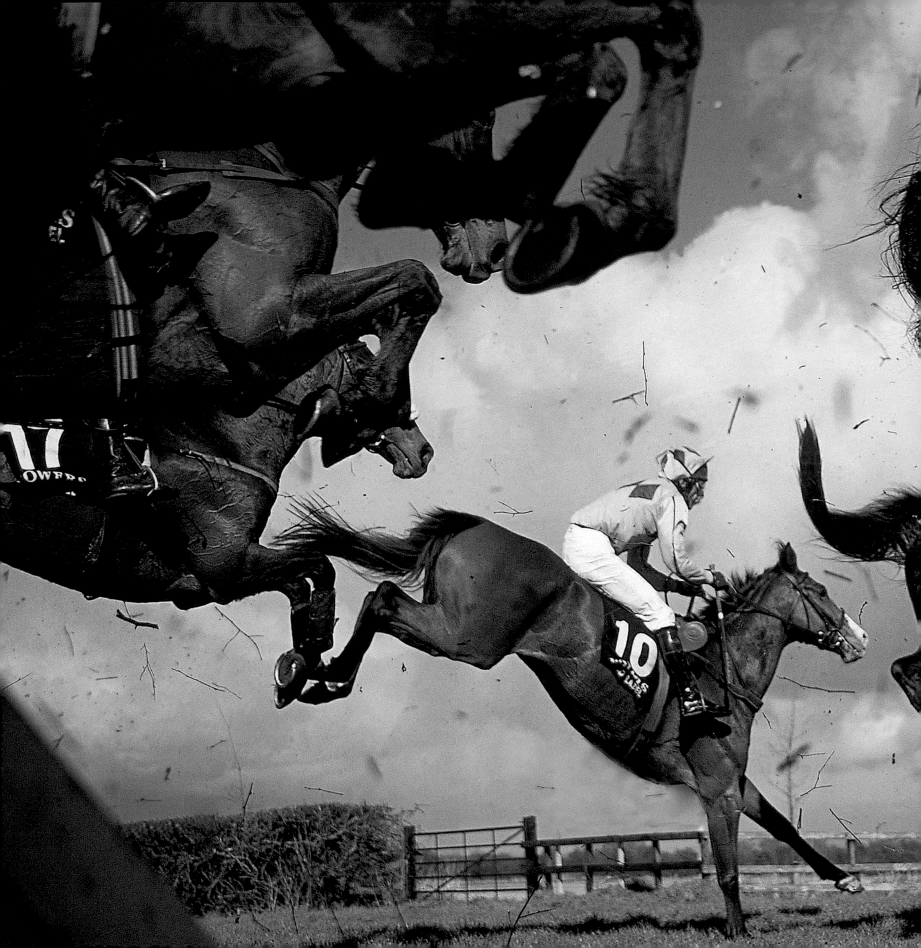

AS: What's in your kit bag? Which camera system do you use and why?

BM: I am an equipment man through-and-through and I have everything one could possibly desire. It is a false economy to buy cheap equipment so I buy the best gear because it gives me the best results. In the main I own four Canon EOS 1D MKII bodies, two 1Ds MKII bodies, four 1Dn MKII bodies; and lenses ranging from 14 to 600mm, including two 1.4x converters and one 2x converter.

AS: What are your favorite and most used lenses/focal lengths?

BM: I don't have a favorite lens but I tend to enjoy shooting in the 400–500mm focal length range. I'm a believer in using as many prime lenses as I can, with a fixed focal length.

AS: What types of pictures do you find the most difficult to take?

BM: Soccer in a stadium: you have to be in the right place at the right time, the attack can come from anywhere, you have to sit in one place, and you can't move around freely. Athletics is slightly different because it's more predicatable, which allows you to be more creative with your choice of shots.

AS: Which do you prefer, digital or film, and why?

BM: I prefer digital now but I hated it when it first came out. I think most professionals started using it too early. I started using it because my clients wanted me to go digital because of the fast transfer speeds. Nowadays I wouldn't even consider using film.

**Irish Grand National,
Fairyhouse Racecourse**
"I photographed the Irish Grand National in 2002 to illustrate a story on Irish horse racing and the million-dollar business of horse breeding in Ireland. I used a remote camera to obtain an unusual angle from under the fence—the picture was actually fired by radio from 100 meters [328 feet] away, at the next obstacle."

CAMERA: Canon EOS 1N
LENS: 24mm
ISO: 200
APERTURE: f/4
SHUTTER SPEED: 1/2000 sec
LIGHT CONDITIONS: natural
WEATHER CONDITIONS: bright
 and sunny

Bob Martin

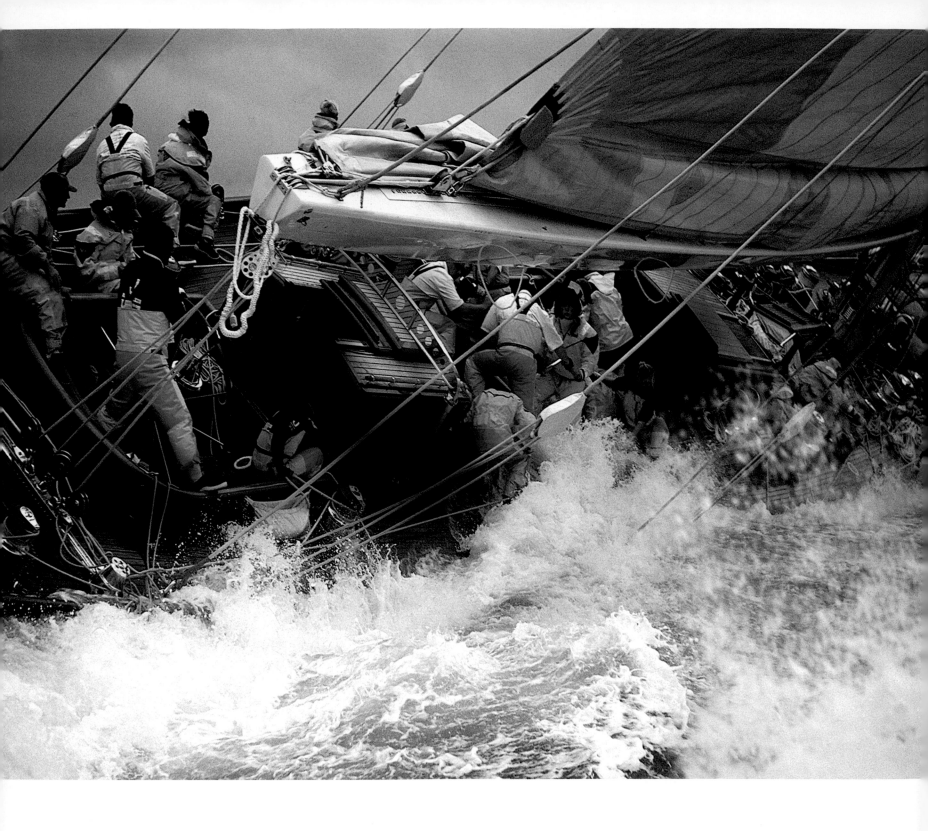

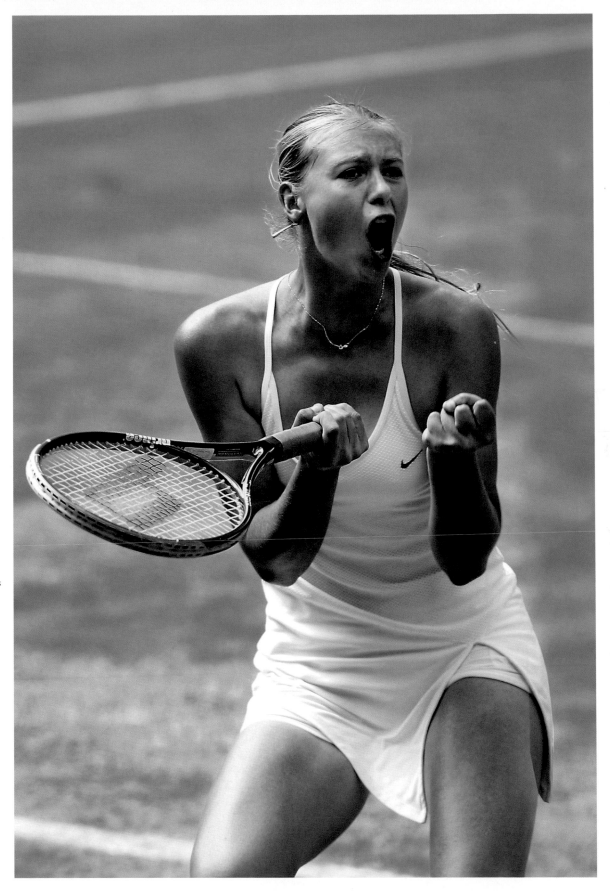

Left: **J-Class Challenge, Isle of Wight**
"Yachting is one of the most beautiful sports to photograph, but as this shot shows, it is not all about sunny days! I took this on a miserable rainy day and it illustrates how important teamwork is at sea. The driver of the boat I was shooting from is really the star of the day, however, because time after time he positioned us perfectly without affecting the racing yachts, to get the best pictures."

CAMERA: Canon EOS 1N
LENS: 300mm
ISO: 200
APERTURE: f/2.8
SHUTTER SPEED: 1/1000 sec
LIGHT CONDITIONS: natural
WEATHER CONDITIONS: stormy

Right: **Maria Sharapova, Ladies' Final, Wimbledon**
"Maria Sharapova reacts after winning the point that gave her the lead against Serena Williams in the second set at the 2004 Wimbledon Ladies' Final. She went on to win the match and her first Wimbledon title. I used a 300mm f/2.8 lens—a little bold, perhaps, but sometimes risk can reap rewards."

CAMERA: Canon EOS 1D
LENS: 300mm
ISO: 200
APERTURE: f/4
SHUTTER SPEED: 1/1000 sec
LIGHT CONDITIONS: natural
WEATHER CONDITIONS: sunny

Bob Martin

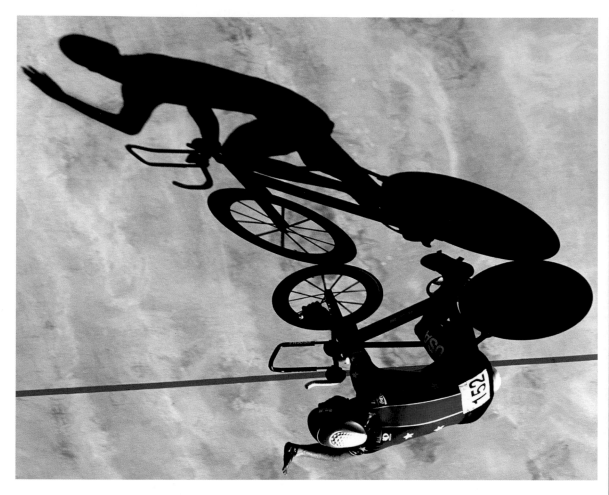

AS: How much of your work is manipulated using imaging software?

BM: I'm a reportage photographer and I do not touch my pictures, apart from very fundamental Photoshop techniques I would otherwise use in any darkroom, such as curves, dust, contrast, color balance, and slight cropping. This is all basic and acceptable. If my commercial pictures are frequently manipulated, however, that's up to the client. But as an editorial photographer I think it is ethically incorrect to change them beyond what they should be. What you see in the frame is what the finished product should be.

AS: Where do your ideas for innovative pictures come from?

BM: Creativity: experience means I have a good idea of what can be done; and individuality: I always ask myself "what can I do that's different?" I really don't like sitting next to 50 other guys because I know I can achieve more if I stand on my own.

AS: What does the future hold for you?

BM: I want to slowly but surely stop shooting action and shoot more commercial stuff as I get older. Running up and down pitchside is for young guys and not for me. But my commercial work will always have a sports or action twist!

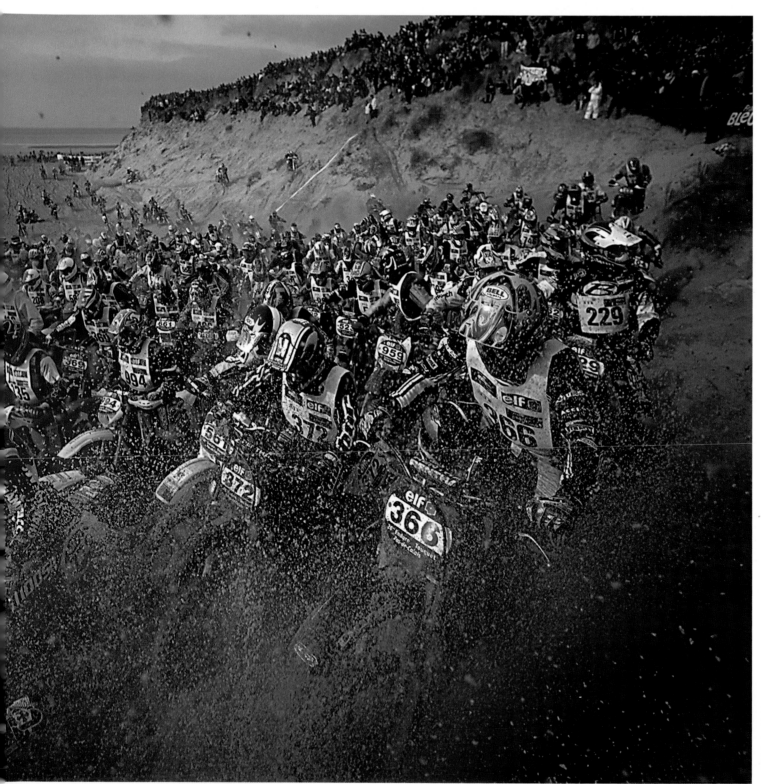

Left: **Le Touquet Motorcycle Enduro, Le Touquet**

"Le Touquet Motorcycle Enduro is held each year in January on the sand dunes just outside Le Touquet, near Calais in France. After walking the course, I decided that the bottle neck at the first bend should provide the best position for a picture. I was rewarded with this remarkable image shot on a 24mm lens, with bikes passing in front and behind me. The adrenalin of shooting such a picture prevented me from thinking about the safety aspect. I did however ponder on my stupidity after the race, while editing the pictures."

CAMERA: Canon EOS 1N
LENS: 24mm
ISO: 100
APERTURE: f/4
SHUTTER SPEED: $^{1}/_{1000}$ sec
LIGHT CONDITIONS: natural
WEATHER CONDITIONS: cloudy

Far left: **Pan American Games, Mar del Platta**

"This graphic shot of a cyclist really is one of my favorites, captured from the top of a very steep staircase. It's one of the few pictures I've taken that have made it on to the walls of my home. It was shot during the Pan American games in Mar del Platta in Argentina. I love the harsh evening light because it allowed me to use the shadows creatively."

CAMERA: Nikon F5
LENS: 80–200mm
ISO: 200
APERTURE: f/5.6
SHUTTER SPEED: $^{1}/_{1000}$ sec
LIGHT CONDITIONS: natural
WEATHER CONDITIONS: dry/ evening sunlight

Bob Martin

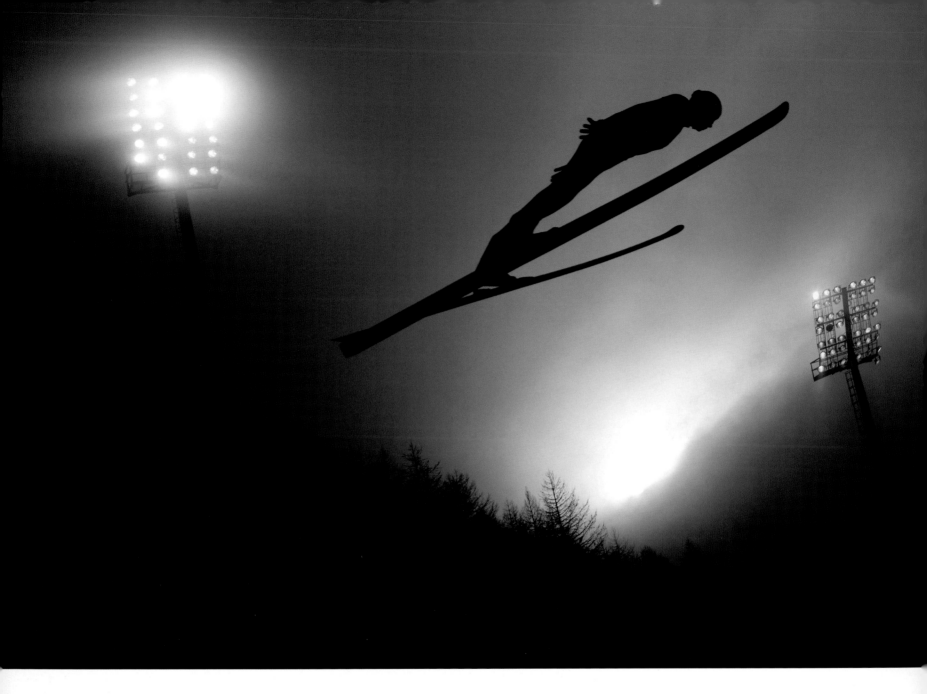

Individual Men's Ski Jump, Winter Olympics, Turin
"The Winter Olympics in Turin produced many great pictures and this silhouette of a ski jumper is one of my favorites. As the sun set, the light was just right for only a few minutes at dusk, in the evening fog, using the flood lights to aid composition. This picture was the result of two days of looking and experimenting."

CAMERA: Canon EOS 1Dn MKII
LENS: 85mm
ISO: 200
APERTURE: f/2.8
SHUTTER SPEED: 1/1000 sec
LIGHT CONDITIONS: floodlit tungsten
WEATHER CONDITIONS: ice/snow

Top 10 Tips for Success

1) Think like a professional
Shoot as many pictures as you can, using different angles, as well as experimenting with settings and composition. Most cameras today are digital so it doesn't cost anything to shoot. This really is the very best thing about digital photography. Shoot masses of pictures and, afterward, delete your mistakes.

2) Try a different viewpoint
A picture can be more interesting if it's taken from an unusual angle. Don't be afraid to lie down and look up at your subject. Equally, you could try climbing up to a higher viewpoint, so that you're looking down on your subject. Try both and keep the best result.

3) Composition
I like to look through my viewfinder and mentally divide the screen into three horizontal and three vertical sections, appearing as a "tic-tac-toe" grid. Where the lines intersect are the points which your eye naturally seeks out when looking at a photograph. It's logical, therefore, that you should try to position your subject around one of these focal points. It's also important to keep your horizon straight. Failing to do so is the most common mistake when starting out—and there is nothing worse than seeing a photograph in which the skyline and subject run downhill!

4) Shoot pictures with a good background
One of the most important elements I consider is what the background of my picture is going to look like—no picture can be great without a complementary background. It's worth stressing the background should not distract from the main subject in the picture; it should be used to complement or add content to it. Sometimes, when there isn't a great background to work with, a good trick is to use a telephoto lens and shoot at the widest possible aperture. This puts your background out of focus and helps your subject to stand out.

5) Use a higher shutter speed
For instance, if children are playing in the park, running directly toward you, try to use a shutter speed no longer than $1/500$ sec. Where they're running across the frame, you'll need a little bit more stopping power, so try to shorten your shutter speed to about $1/1000$ sec. In this case, remember to move your camera, following the action as you take the picture, and press the shutter button as gently as possible, to capture the peak of the action. If you're using a wide-angle lens and your subject is filling the frame, you will need to use a really fast shutter speed, of at least $1/2000$ sec, for example.

6) Illustrate movement by experimenting with slow shutter speed
Don't be afraid to try $1/15$ sec or less—you can always delete the bad shots. One technique often used by sports photographers is to follow their subject and pan. Using a shutter speed of $1/60$ sec or similar will enable you to freeze the main subject but it will add motion blur into the background.

7) Don't be afraid to shoot backlit into the sun
It can produce far more interesting pictures than you might think. I often make an extra-long lens hood for my camera out of black cardboard, especially if the sun is really low. It is amazing how the manufacturers do not make the lens hoods long enough for their telephoto lenses.

8) Get a good camera bag
I use a backpack that doesn't hurt my back. Most sports photography requires patience and a camera bag that hurts your back will not help you to produce good results, especially if you feel uncomfortable.

9) Use the LCD screen as a Polaroid substitute
Professional photographers have for years used Polaroid backs to check their pictures. On most digital cameras you have an LCD screen to check the pictures. Use it all the time to check your timing to see if you caught the action. It really is the best gadget of the lot for shooting fast action images.

10) Try using flash with blur
My favorite trick is to shoot with a long shutter speed (approximately $1/8$ sec), and a little bit of light from a flashgun. Second-curtain synchronization is an extension of this technique. Normally, the flash fires in synchronization with the first shutter curtain, when the shutter is fully open. With second-curtain synchronization, however, the flash fires immediately before the second curtain closes, at the end of the exposure. This means the flash fires at exactly the right moment to create blur behind the moving subject. This can work really well for action pictures, with the blur behind the flash to accentuate movement.

Greyhound racing, Hackney Dog Track
If the background of an image is dull
and uninteresting, as here, Martin uses
a telephoto lens and shoots at the widest
possible aperture to put the background
out of focus and make the subject stand
out in sharp focus. He explains, "I like
the contrast between the young and
fit animal on the left, and the tired old
mutt on the right! I chose to photograph
at this bend as it had the only good
background on the track. It was really
difficult to capture the moment—even
old dogs fly like the wind!"

Specification

CAMERA: Nikon F5

LENS: 500mm

ISO: 400

APERTURE: f/4

SHUTTER SPEED: ¹/1000 sec

LIGHT CONDITIONS: natural

WEATHER CONDITIONS: cloudy

Essential Equipment

- Three 35mm Canon EOS 1D MKII camera bodies

- Two 35mm Canon EOS 1Ds MKII camera bodies

- Four 35mm Canon EOS 1Dn MKII bodies

- Lenses ranging from 14 to 600mm

- Lens hoods for all lenses (some homemade)

- Two 1.4x teleconvertors

- One 2x teleconvertor

- Canon 580-EX flashgun

- Spare Lithium-ion batteries

- Eight 2–4GB CF cards

- Waterproof jacket

- Comfortable backpack

Bob Martin

Dave Rogers

Rugby

Dave Rogers is firmly established as stock photography giant Getty Images' premier rugby specialist, having been responsible for a huge amount of progress for the sport. Rogers' love of both rugby and photography came to fruition when he was employed by West Midlands Press, after graduating with a National Council Press Photography Certificate from Wednesbury College in 1974. He had been singled out for a career as an accountant, but his complete lack of interest in the vocation and love of sport guided him in the right direction. "I packed in my accountancy job after a week because it was boring and I hated it. I was already on Wednesbury College's waiting list, and when someone pulled out on the Friday, I started my photography course on the Monday."

After graduation, Rogers landed a solid role at the *Sutton Coldfield News*, where he realized his dream of photographing his beloved soccer team, Wolverhampton Wanderers. It was during this period in the late 1970s that Rogers met Bob Thomas, a respected sports photography agent. Rogers never looked back and joined prestigious sports photography agency Allsport in 1992, now part of Getty Images. When it comes to top-class rugby shooting, Rogers is never far from the action, with an uncanny knack of being in the right place—and at the right time.

Dave Rogers

Interview

AS: What was your first ever camera?

DR: A Pentax Spotmatic SP-500. I bought it in a frenzied state shortly before I was due to start my photography course at college, the day after I resigned from my week-long accountancy job.

AS: Is it fair to say that, like many successful photographers, you had a "lucky break" at some stage?

DR: Meeting Bob Thomas, who ran his own sports picture agency. This gave me the chance to travel and take pictures at top sporting events. I also owe much to Colin Elsey, arguably rugby's most influential photographer. He took the sport's most famous shot—England and Lions player Fran Cotton covered in mud—and I learned much from the camaraderie we developed. Colin passed away just before the Rugby World Cup in 2003 and, sadly, never got to see England lift the trophy.

AS: Why did you decide not to pursue other types of photography, such as portraits or fashion, for example?

DR: Why sit behind a desk when you can meet some of the world's most interesting people, travel, and feel as though you are part of one of sport's most intense games?

AS: Do you shoot what you want or do others generally define what's required of you?

DR: I can't just shoot anything—like all the best photographers I have to plan ahead. I shoot what I feel best reflects the particular game, but there is far more planning than most people imagine. I'm sufficiently experienced to know what the newspapers want.

AS: Where are you mostly based? Where are your most popular locations to work?

DR: I travel all over the world to cover high-profile rugby tournaments and matches. I have photographed in South Africa, Argentina, Scotland, Italy, Ireland, Wales, Romania, France, Australia, New Zealand, and of course, England. I go wherever rugby takes me.

AS: Which places do you like traveling to the most?

DR: All the Tri Nations venues, comprising New Zealand, Australia, and South Africa, the latter being my favorite.

AS: What things do you enjoy most about your job?

DR: The travel and the adrenaline rush I get from meeting the photographic needs of a fast-paced game.

AS: From a technical aspect, what are the most difficult things about your job?

DR: With today's digital technology there are some camera controls that can be aesthetically difficult. However, meeting newspaper deadlines—my pictures start to be wired as soon as three minutes after the game kicks off—can be stressful, as can post-game editing. There is very little relaxation when I'm shooting in stadium conditions. I am always competing with photographers from other top agencies such as Reuters and Associated Press, which means that it often becomes a frenzied race.

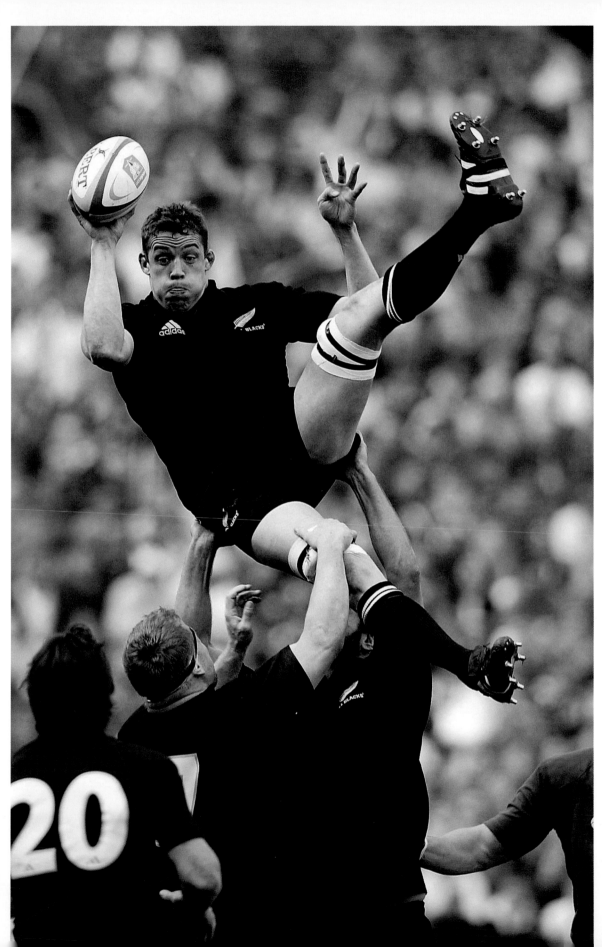

**South Africa vs New Zealand,
Ellis Park**
Jono Gibbes, the New Zealand
All Black flanker, jumps for the
ball in the line-out during a
tense Tri Nations game. The
height of the shot captures
the dangers of being a jumper
in line-out play, with Gibbes
losing his balance and falling
backward, despite the assistance
of his teammates.

CAMERA: Canon EOS 1Ds MKII
LENS: 400mm with 1.4x
 converter
ISO: 500
APERTURE: f/2.8 (f/4)
SHUTTER SPEED: ¹⁄640 sec
LIGHT CONDITIONS: natural
WEATHER CONDITIONS: bright

Dave Rogers

Leicester Tigers vs Northampton Saints, Welford Road
Lewis Moody, the Leicester flanker, leaps in line-out action with Andrew Blowers of Northampton. The limited depth of field set on the camera highlights the action in front of the crowd, bringing into focus the beads of rain, while the wide aperture of the lens allows more light into the camera sensor and helps to isolate the action in front of an otherwise messy background.

CAMERA: Canon EOS 1Ds MKII
LENS: 400mm
ISO: 800
APERTURE: f/2.8
SHUTTER SPEED: 1/500 sec
LIGHT CONDITIONS: natural mixed with floodlit tungsten
WEATHER CONDITIONS: rain

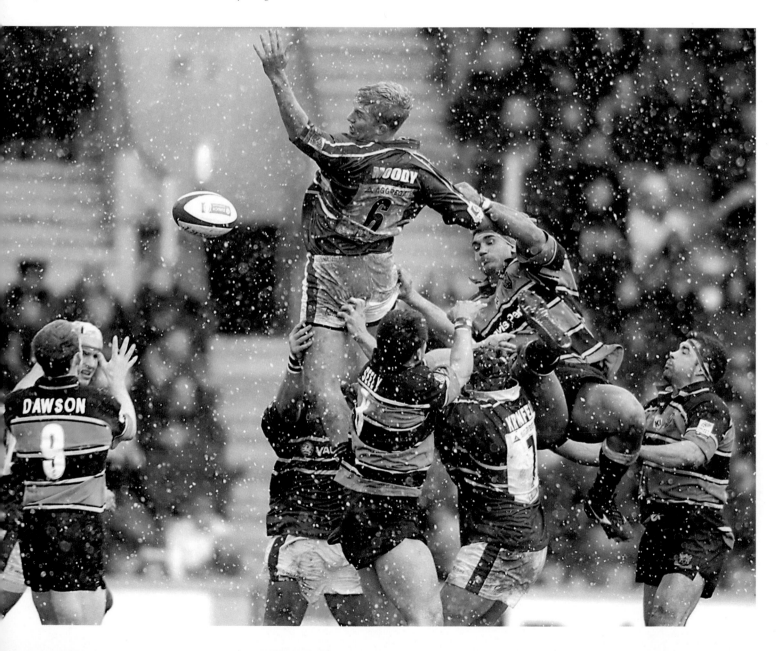

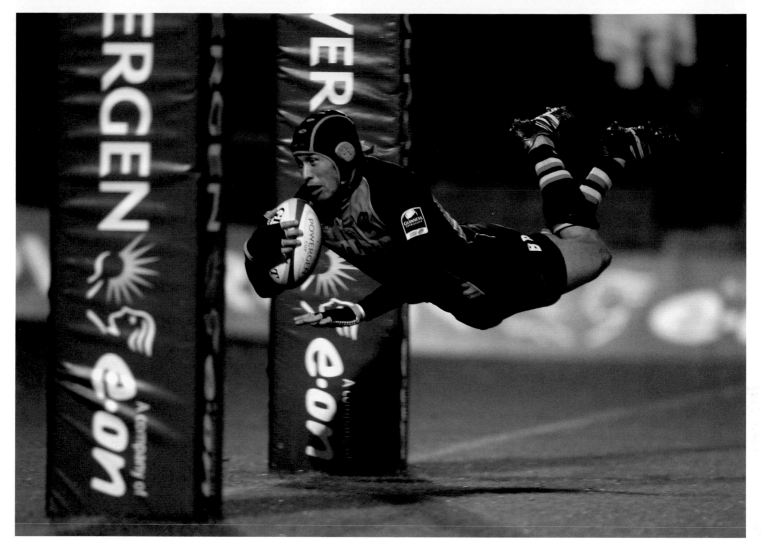

Northampton Saints vs Newport Gwent Dragons, Franklin's Gardens
Bruce Reihana, the Northampton Saints team captain, throws himself over the try line to score during a match against Newport Gwent Dragons. Rogers used a fast shutter speed in artificial light to crisply capture the player in full flight, demonstrating his amazing athleticism.

CAMERA: Canon EOS 1Ds MKII
LENS: 400mm
ISO: 1200
APERTURE: f/2.8
SHUTTER SPEED: 1/400 sec
LIGHT CONDITIONS: floodlit tungsten
WEATHER CONDITIONS: dry

AS: When are the busiest times of the year for you?

DR: Rugby is a worldwide sport and it is always busy, but I tend to follow more rugby in winter.

AS: How would you describe your personal technique or style of photography?

DR: When my camera is pointed where it should be, full concentration is needed to get the job done, so you might say my style is one of concentration. I get nervous for England before a big game but I've learned to blank it out, switch off, and focus on the job at hand. You can't scream your head off just because you want to.

AS: What's in your kit bag? What camera system do you use and why?

DR: Two Canon EOS 1Ds MKII camera bodies; a couple of flashguns (always loaded with fresh batteries—essential for pitchside laps of honor); and lenses comprising 16–24mm, 35–70mm, and 70–200mm, some attached to a spare camera body so I don't have to waste time swapping lenses during games. But my workhorse is a large 400mm f/2.8 lens, sometimes used with teleconverter. My system is quick and it suits the way I like to shoot. If I can't react quickly I risk missing the biggest and best shots.

AS: What are your favorite and most used lenses/focal lengths?

DR: My 400mm f/2.8 is my standard lens, but I also use the 70–200mm for action near the try-line.

Dave Rogers

Jonny Wilkinson, Kingston Park
A beautiful silhouette of England fly-half Jonny Wilkinson as he practises his kicking at dusk. A powerful and artistic image, it was achieved by Rogers lying horizontally on the ground and asking Wilkinson to keep his leg up after releasing the ball, for effect. Rogers' position and use of a short focal length from 17mm lens, adds character to the sky and emphasizes its darkening mood.

CAMERA: Canon EOS 1Ds MKII
LENS: 17mm
ISO: 400
APERTURE: f/8
SHUTTER SPEED: 1/500 sec
LIGHT CONDITIONS: natural/dusk
WEATHER CONDITIONS: cloudy

Dave Rogers

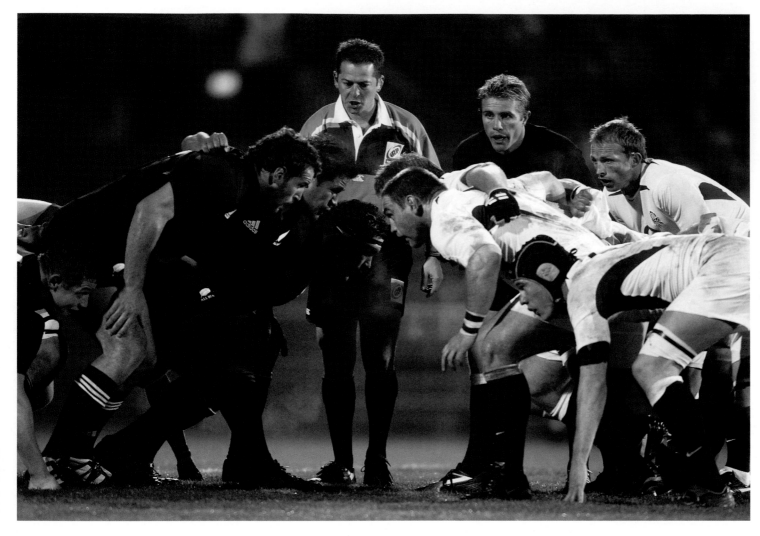

New Zealand vs England, Carisbrook Stadium
The New Zealand All Blacks and England front rows prepare to scrum down against each other, the concentration of the players is clearly visible on their faces. The central placement of the referee and the steam rising from the players on a cold night reveals the intense atmosphere of the game.

CAMERA: Canon EOS 1Ds MKII
LENS: 400mm
ISO: 1200
APERTURE: f/2.8
SHUTTER SPEED: ¹/500 sec
LIGHT CONDITIONS: floodlit tungsten
WEATHER CONDITIONS: damp

AS: What types of pictures do you find the most difficult to take?

DR: Nighttime photos can be difficult if the grounds are floodlit with tungsten. Most rugby grounds are notorious for this.

AS: Which do you prefer, digital or film, and why?

DR: Advances in digital gear are significant, but I don't think the pace of today's sports photography is detrimental to the quality of the pictures. I always do my best to keep my standards up. Pressure in any environment brings results and it's exactly the same in a sports arena. I spent much of my early career processing film in toilets and in other confined spaces all over the world. I will never use film again!

AS: How much of your work is manipulated using imaging software?

DR: Just the basics, such as cleaning up dust. Retaining photo integrity with today's manipulative technology is imperative.

AS: Where do your ideas for innovative pictures come from?

DR: I'm always on the look out for other people's work and I am always willing to learn.

AS: What does the future hold for you?

DR: I would like to try different challenges, for example, being based in a country other than the UK. With a worldwide agency like Getty Images, there is always an opportunity.

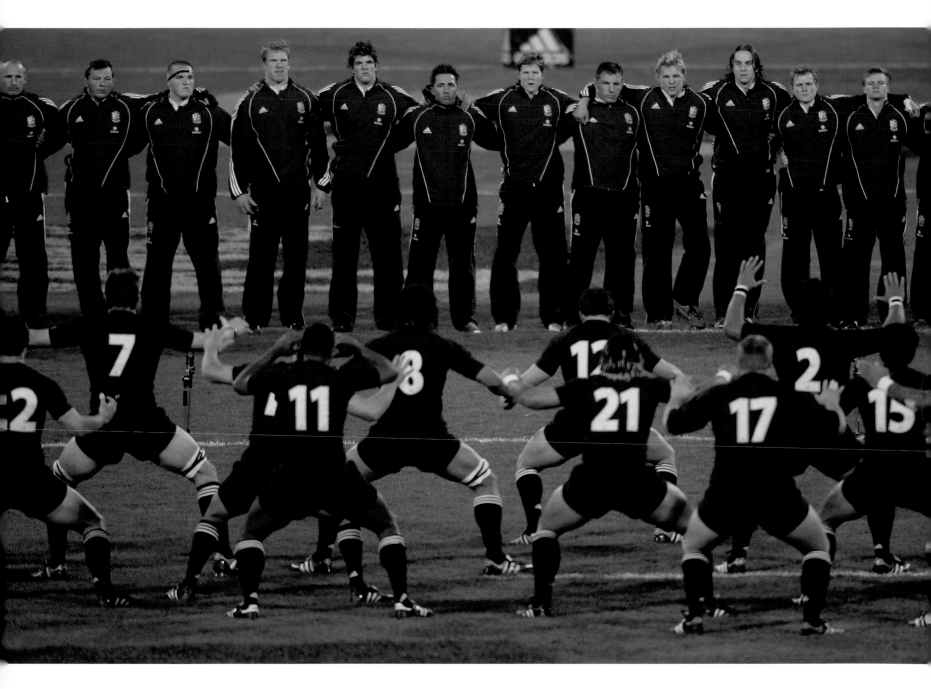

New Zealand vs British & Irish Lions, Westpac Stadium
The Lions face the illustrious All Blacks "Haka" before the second game between the teams during the Lions' 2005 tour. Face-to-face, the almost symmetrical composition of the image conveys the feeling of tension during the build-up to the game. Taken behind the goal at one end of the stadium, Rogers used a long 400mm lens with 1.4x converter to make the image look more compact.

CAMERA: Canon EOS 1Ds MKII
LENS: 400mm with 1.4x converter
ISO: 1000
APERTURE: f/2.8
SHUTTER SPEED: ¹⁄₂₅₀ sec
LIGHT CONDITIONS: tungsten floodlit
WEATHER CONDITIONS: dry

Dave Rogers

Leicester Tigers vs Bath Rugby, Welford Road
Sam Vesty of Leicester (left) is tackled by Andy Higgins of Bath. Both players are caught with their feet off the ground as Dave Rogers perfectly captures the force of the hit. One of Rogers' favorites, this photograph was used in most of the newspaper reports on the following day.

CAMERA: Canon EOS 1Ds MKII
LENS: 400mm with 1.4x
 converter
ISO: 400
APERTURE: f/2.8 (f/4 with
 converter)
SHUTTER SPEED: $^1/_{500}$ sec
LIGHT CONDITIONS: natural
WEATHER CONDITIONS: cloudy

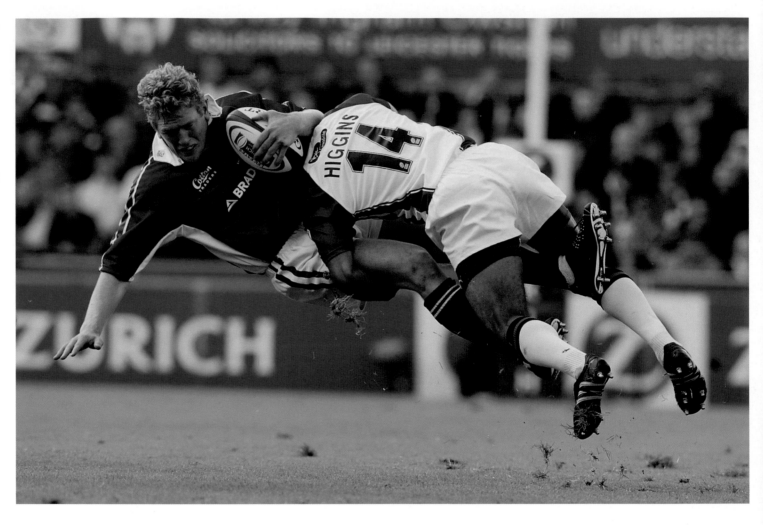

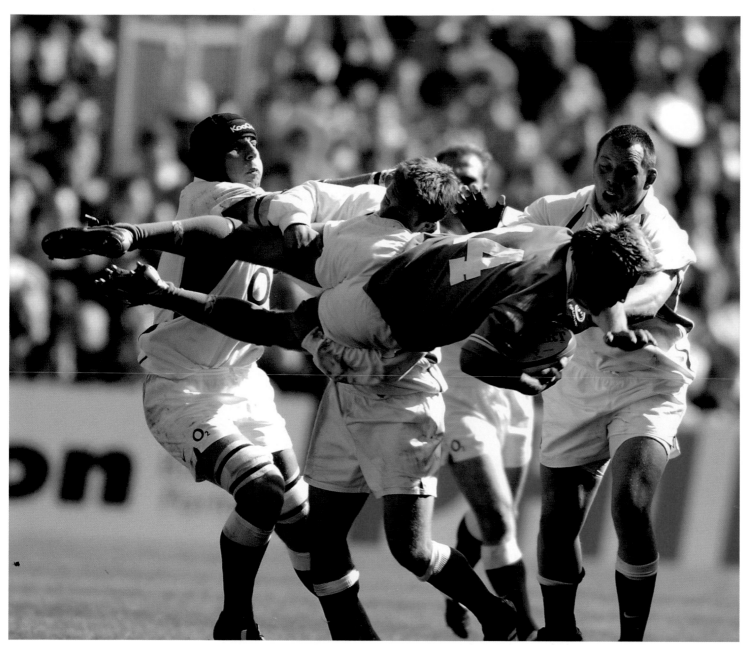

Ireland vs England, Lansdowne Road
Justin Bishop of Ireland is upended by Jonny Wilkinson of England during the Six Nations Championship Grand Slam decider. The horizontal stance of the player receiving the tackle adds a nice contrast to the rest of the frame. "This was a really difficult shot to pull off," remembers Rogers, "because I was operating in the shade, but the action took place in bright sunshine."

CAMERA: Canon EOS 1Ds MKII
LENS: 400mm
ISO: 200
APERTURE: f/4
SHUTTER SPEED: $^{1}/_{100}$ sec
LIGHT CONDITIONS: natural/ shade
WEATHER CONDITIONS: part- cloudy/sunshine

Dave Rogers

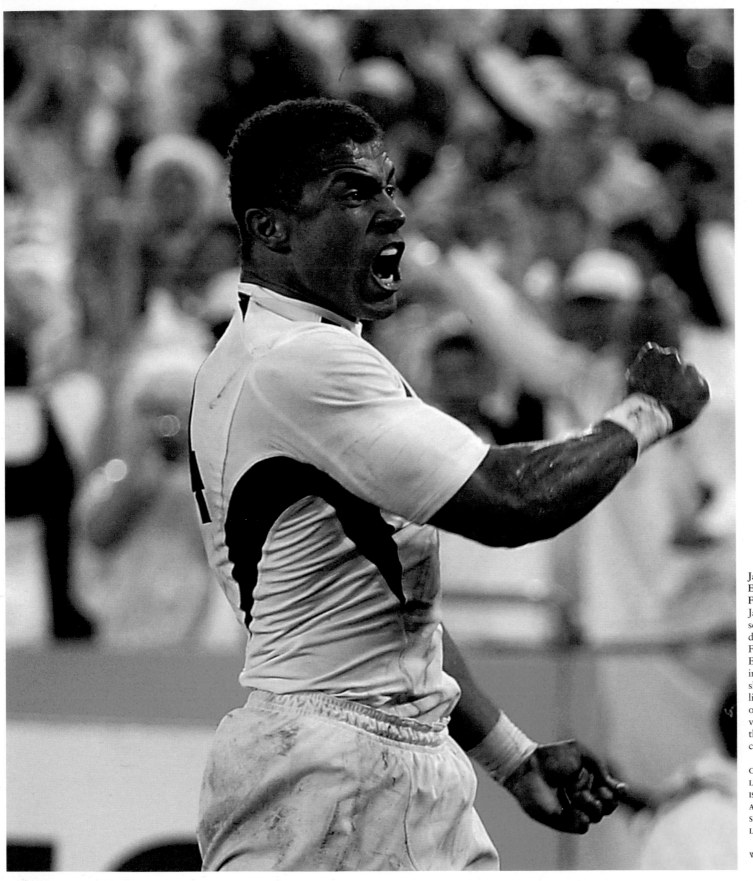

Jason Robinson, Australia vs England, Rugby World Cup Final, Telstra Dome
Jason Robinson of England screams with joy after scoring during the Rugby World Cup Final between Australia and England. Rogers captures the intense emotion of the player shortly after he dived across the line to score England's only try of the game. The stadium was very bright with tungsten lights that often play havoc with a camera's metering system.

CAMERA: Canon EOS 1Ds MKII
LENS: 70–200mm
ISO: 800
APERTURE: f/2.8
SHUTTER SPEED: 1/500 sec
LIGHT CONDITIONS: tungsten floodlit
WEATHER CONDITIONS: damp/ drizzle

Top 10 Tips for Success

1) Build up technique slowly
Don't expect to start shooting at a top game in a top stadium. Go to your local rugby club where you'll be able to get closer to the action and you can avoid having to use a long lens. Short lenses are easier to grasp.

2) Look out for anything unusual
Rugby is not just about 30 people running around the pitch. Sometimes the emotions of the fans, for example, can make the best possible pictures.

3)Take an umbrella
Mostly a winter sport, rugby requires you to have full weather protection for astoundingly cold conditions. I often shove a large golf umbrella down my jacket and bring it down close to the top of my head, allowing me to have both hands free to operate my camera, while keeping me dry. Simple but very effective.

4) Get to the venue early
Often there is more than one match at the same venue, such as a junior rugby game before the main event, which makes for great photography. Getting a good seat is vital for your range of photographs.

5) Familiarize yourself with your gear
Don't be afraid to fire off practice shots and make mistakes—capturing sport is often down to instinctive reactions. The more you practice, the better you will get.

6) Know the laws of the game
This is imperative for good pictures because you are able to predict the flow of the game. Understanding the rules gives you a better range of pictures and more time to get them.

7)Try different angles
If possible, try an elevated position; looking down on the field can give a much better viewpoint, especially with line-outs and scrums.

8) Make sure you carry spare gear
Spare batteries are an absolute must; rugby is mainly a winter sport and spare power is essential as they drain so quickly in cold conditions. Unless you are downloading images on-site, you can never have enough digital media cards, too.

9) Don't be afraid to experiment
Try a slow shutter speed for motion blur; panning your subjects with the action can work quite well to demonstrate the speed of players, especially the faster runners, such as the backs. If it's sunny, try to shoot looking into the light. This can darken the background and avoid messy advertising boards. It also softens the shadows on the faces of players, and makes them stand out from the crowd.

10) Enjoy the game
I can't emphasize this enough; the best tip I can give is to enjoy photographing the game. If you don't, you might lose interest, which is detrimental to the pictures you take. You will notice the difference.

South Africa vs Australia, Newlands Stadium

South Africa scrum-half Joost van der Westhuizen quickly dives to pass the ball during a hard-fought Tri Nations game. The clean background, produced by pointing the lens against the sun, makes the players' facial expressions stand out from the crowd.

Specification

CAMERA: Canon EOS 1Ds MKII

LENS: 400mm

ISO: 200

APERTURE: f/2.8

SHUTTER SPEED: 1/1000 sec

LIGHT CONDITIONS: natural

WEATHER CONDITIONS: bright and sunny

Essential Equipment

- Two 35mm Canon EOS 1Ds MKII camera bodies
- 16–35mm f/2.8 lens
- 24–70mm f/2.8 lens
- 70–200mm f/2.8 lens
- 300mm f/2.8 lens
- 400mm f/2.8 lens
- Lens hoods for all lenses

- Two flashguns
- Two spare Lithium-ion batteries
- Ten 1GB CF cards
- Chamois leather cloth
- Laptop computer
- Sunscreen laptop visor

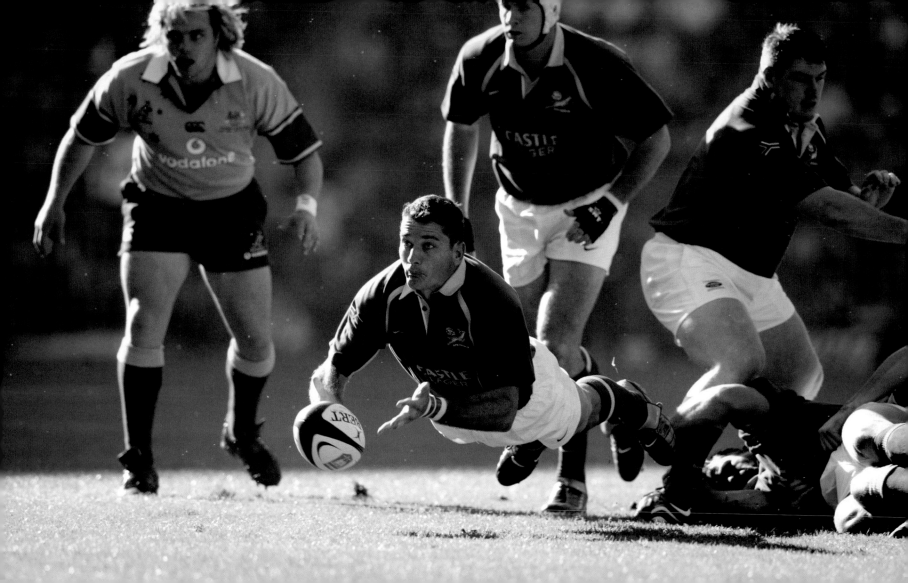

Seb Rogers

Cycling

Seb Rogers has been riding mountain bikes for almost two decades. In that time, he's left tire tracks all over the world, from Borneo in Malaysia to Moab in the US, and Chamonix in France. But it is his camera that has captured some truly awe-inspiring records of the world's most skilled mountain bikers—a vocation he literally pedaled his way into. Although he's been lucky to ride through and take photographs in some spectacular scenery, often in the company of talented riders, his favorite trails are on his doorstep, in rural Somerset. "Watching the effect of the changing seasons always feels like a special privilege," he says. "I wouldn't swap it for anywhere."

Even though sport has become a popular vocation among photographers in recent years, very few have the experience and expertise to interpret a brief with flair and originality, or to produce inspiring action shots when the pressure is on. Rogers' renowned photography has brought him commissions from best-selling magazines and industry-leading manufacturers, allowing him to share his unique vision with a worldwide audience.

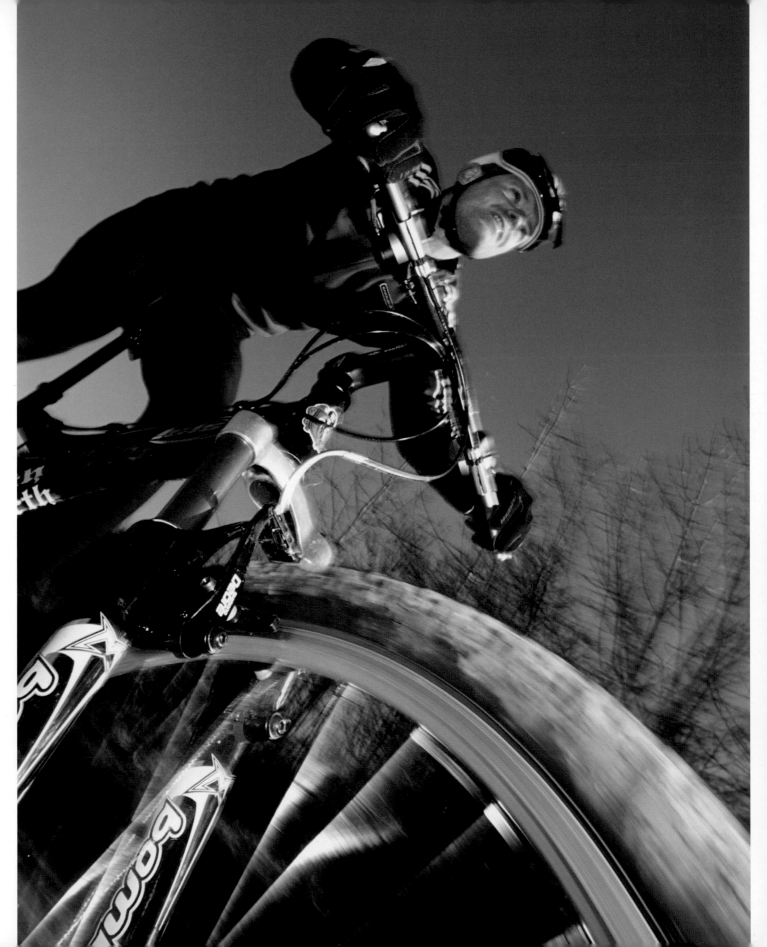

AS: What was your first-ever camera?

SR: A vintage Olympus Trip 35 film camera. By the time I got an SLR I was using it to shoot still-life with two flashguns.

AS: What have been your greatest photographic achievements to date?

SR: Paying the bills doing something I love! The industry has become hugely competitive and being a successful photographer is an achievement in itself. When I was in my teens I had success in various competitions, which enabled me to get properly kitted out just by spending money on film and processing.

AS: Is it fair to say that, like many successful photographers, you had a "lucky break" at some stage?

SR: I think you make your own luck in this business. I spent the better part of a year pestering magazine editors in my spare time and bombarding them with ideas for features. I made a nuisance of myself, basically, and eventually I got a call offering me some photographic work. Once I had my toe in the door there was no looking back.

AS: Why did you decide not to pursue other types of photography, such as portraits or fashion, for example?

SR: Mountain biking is my other love, after photography. It seemed natural to combine the two. The world probably doesn't need any more portrait or fashion photographers.

AS: Do you shoot what you want or do others generally define what's required of you?

SR: I've been shooting long enough to pick and choose what I photograph, and for whom I shoot, to some degree. This is a very nice position to be in. Having said that, I always shoot with the market in mind. Great pictures in their own right are all very well, but my first priority has to be to sell. I always ask my clients what they're looking for and discuss any particular needs they have—that way there are no nasty surprises. Most people are really happy if you deliver what they want to see.

AS: Where are you mostly based? Where are your most popular locations?

SR: I'm based near Bristol in southwest England. I have great riding on my doorstep and the Mendip Hills—literally 10 minutes away—have featured in many of my shoots. But I also have easy access to south Wales, the Quantock Hills, and Exmoor. I also love the Lake District National Park and the riding in and around Chamonix in the French Alps. And British Columbia in Canada comprises some of the most amazing photography—and some of the most talented riders—in the world.

AS: What things do you enjoy most about your job?

SR: The feeling of independence, the ability to set my own timetable, and the variety of jobs and locations.

Front-of-bike view
Attaching the camera to the bottom of the bike's fork leg with a studio lighting clamp gives this unusual view of bike and rider. It also makes the bike's steering extremely unwieldy and unstable—to be attempted by experienced riders only!

CAMERA: Nikon F801
LENS: 17–35mm
FILM: Fuji Provia 100 transparency
APERTURE: f/16
SHUTTER SPEED: 1/30 sec
LIGHT CONDITIONS: single on-camera, set to TTL auto
WEATHER CONDITIONS: low winter sun

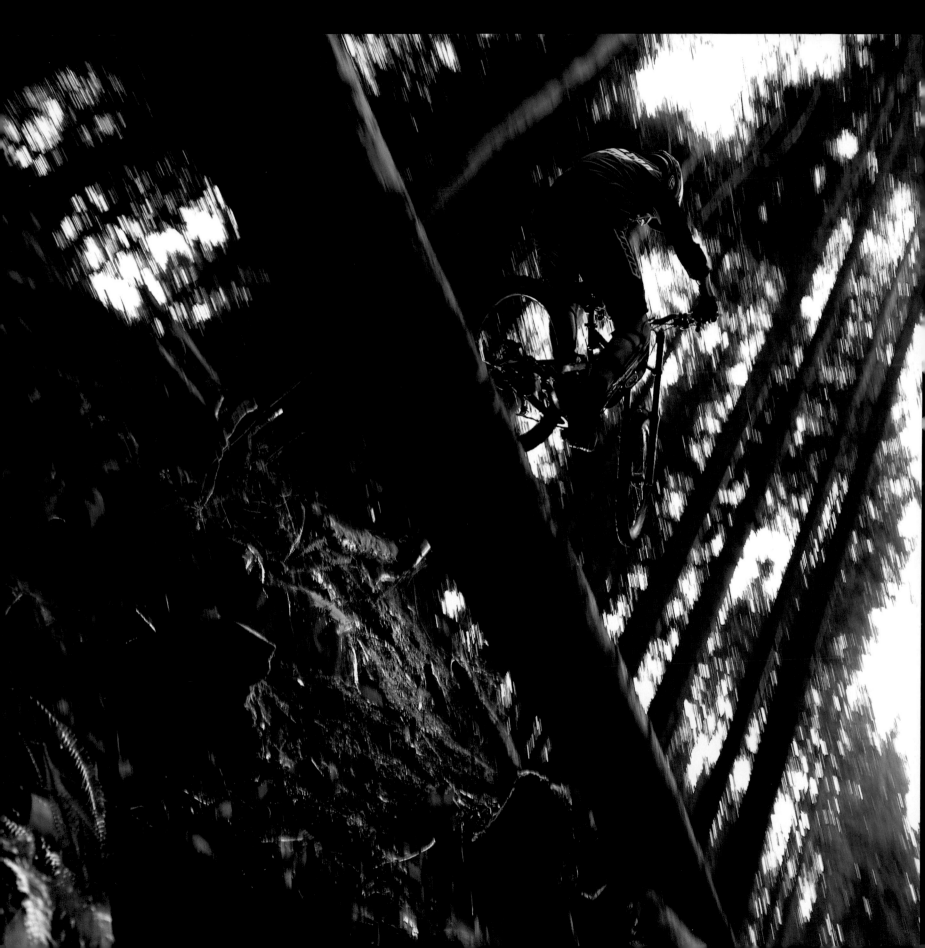

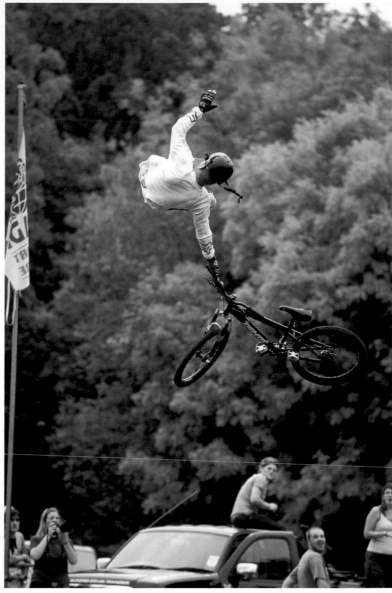

Left: **Freeriders**
Using natural obstacles as part of the trail is becoming more popular with skilled freeriders. Here, Rogers emphasizes the length and height of this fallen tree with a wide lens and low angle, and the rider's unexpected wheely added the finishing touch to the shot.

CAMERA: Nikon D2X
LENS: 12–24mm
ISO: 400
APERTURE: f/5.6
SHUTTER SPEED: ¹⁄60 sec
LIGHT CONDITIONS: single remote flash, radio triggered, set to TTL auto -1 stop
WEATHER CONDITIONS: cloudy

Above: **Stunt rider**
This rider had been attempting a backflip but aborted mid-jump and ditched his bike to lessen his chances of injury. The surprised faces of the onlookers tell the story, although Rogers wishes he'd been able to crop a bit lower, to get more of them in.

CAMERA: Nikon F5
LENS: 80–200mm
FILM: Fuji Provia 100 transparency (camera set at ISO 200)
APERTURE: f/4
SHUTTER SPEED: ¹⁄500 sec
LIGHT CONDITIONS: no flash, set to TTL auto -1 stop
WEATHER CONDITIONS: cloudy

Seb Rogers

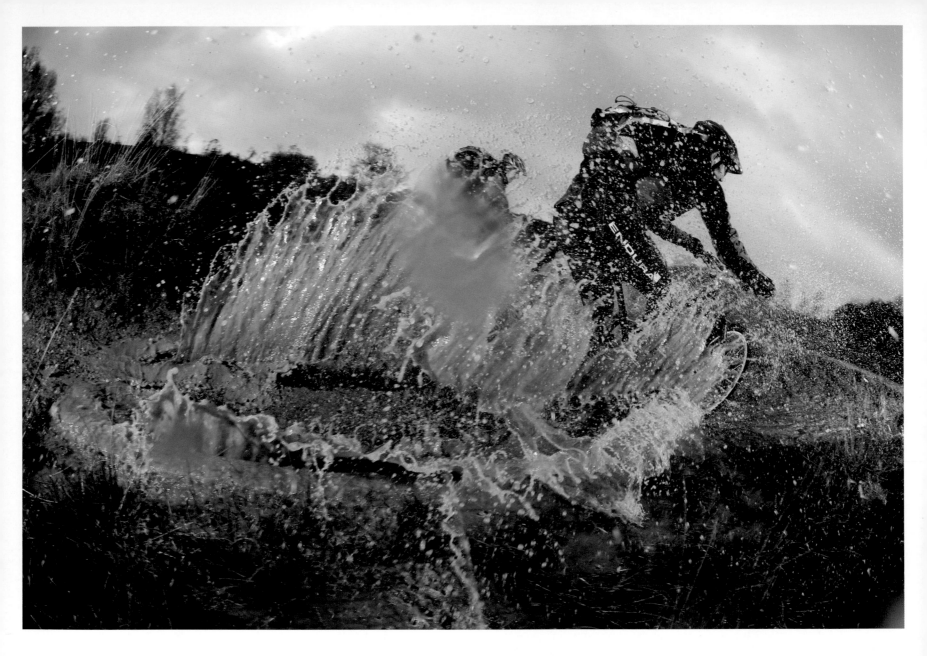

Winter riders
These riders had been splashing through a deep puddle on a magazine shoot to illustrate winter riding, and Rogers noticed how effective the spray was as they passed. He explains, "I got in close with my fisheye, took the shot a little later... and got a lensful!"

CAMERA: Nikon D2X
LENS: 10.5mm fisheye
ISO: 200
APERTURE: f/7.1
SHUTTER SPEED: ½50 sec
LIGHT CONDITIONS: two remote flashguns, radio triggered, set to TTL auto -1 stop
WEATHER CONDITIONS: cloudy

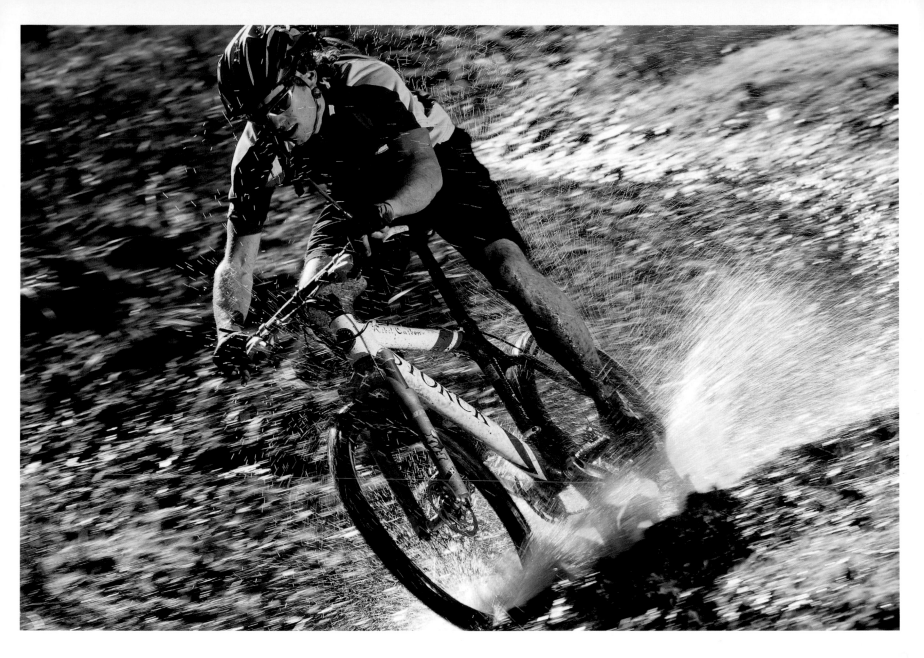

Mountain biker on wet trail
Rogers was under strict instructions not to get this very expensive, one-off custom bike dirty. "But the backlit trail with water running down it was far too good to resist. Lots of spray and plenty of concentration on the rider's face add to the impact."

CAMERA: Nikon D2X
LENS: 80–200mm
ISO: 100
APERTURE: f/7.1
SHUTTER SPEED: 1/125 sec
LIGHT CONDITIONS: single remote flash, radio triggered, set to TTL auto -1 stop
WEATHER CONDITIONS: sunny

AS: From a technical aspect, what are the most difficult things about your job?

SR: Carrying photo gear on a bike is one of the logistical hurdles that has to be overcome and, partly for this reason, I prefer to work on foot wherever possible. There's also the issue of keeping mud, water, and dust away from expensive camera bodies and lenses. As far as moving subjects go, mountain bikes aren't that hard to shoot. They mostly follow a predictable path over the ground, while moving at relatively modest speeds. The challenge is to portray them in a way that makes the sport look as exciting as it feels.

Seb Rogers

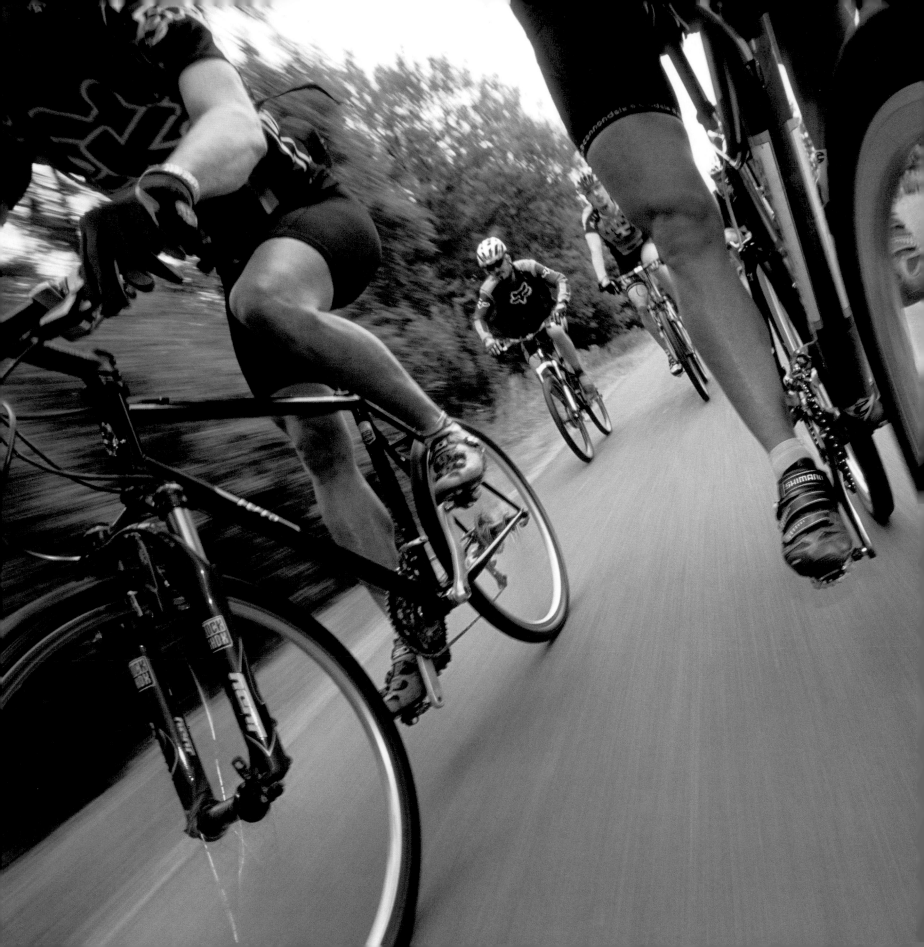

AS: Which location or venue do you like to photograph the most? Why?

SR: I'm always awestruck by both the scenery and the riding around Chamonix. Technically the riding is very tough; photographically it's a visual overload, so coming back with something worthwhile takes some thought. I doubt I'll ever tire of going back there.

AS: How would you describe your personal technique or style of photography?

SR: I try to keep things simple and keep clutter to a minimum. I tend to shoot either quite wide or quite long, and lately I've been enjoying using two flashguns to throw directional light at the parts of the picture that need a bit of emphasis.

AS: What's in your kit bag? Which camera system do you use and why?

SR: I switched to Nikon in 1989 when it became obvious that Olympus was abandoning serious photographers. The F801 [N8008 in North America] impressed me with its glasses-friendly viewfinder, intuitive control layout, and manual metering mode that clearly wasn't an afterthought. Every Nikon I have owned since has been a logical evolutionary step forward, so I can pick up any of my bodies and feel instantly at home. When you need to react quickly to get a shot, this sort of thing is important.

AS: What are your favorite and most used lenses/focal lengths?

SR: My 12–24mm is usually attached to one camera body and it spends most of its time at the wide end of the focal scale. The 10.5mm fisheye is also a useful lens for getting me out of a tight spot—literally. When I'm not shooting wide, I'll often reach for the 50–150mm or 85mm. I don't have much need for anything longer, and the fast telezooms are mostly too big and cumbersome for me to cart around anyway.

Road bikes
Lying flat on the floor of a friend's truck, strapped in with climbing harness and a system of ropes, Rogers was able to get within inches of these mountain bikers at speed, to illustrate a magazine feature about training on the road.

CAMERA: Nikon F5
LENS: 17–35mm
FILM: Fuji Provia 100 transparency (camera set at ISO 200)
APERTURE: f/16
SHUTTER SPEED: 1/30 sec
LIGHT CONDITIONS: single on-camera, set to TTL auto -1 stop
WEATHER CONDITIONS: cloudy

Seb Rogers

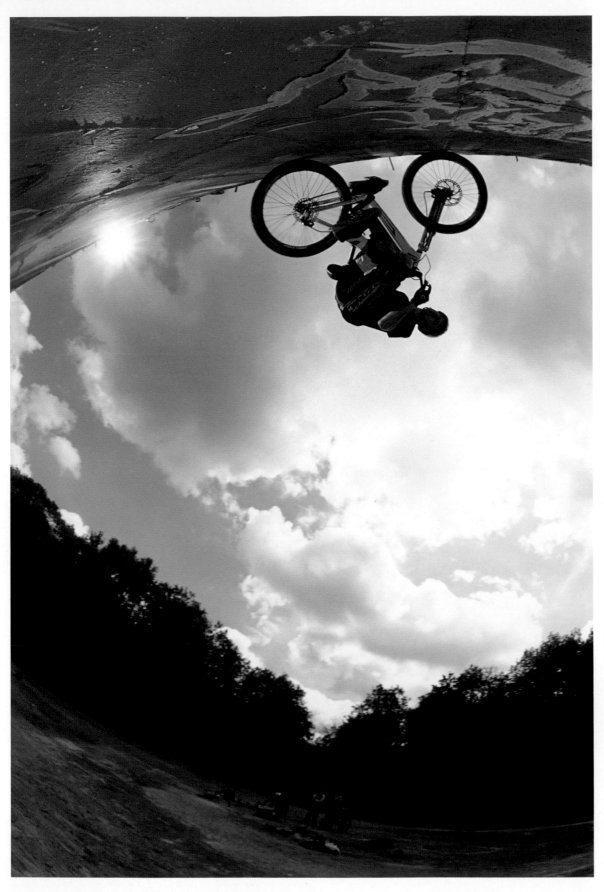

Fisheye view of a wall ride
Shooting standing at the bottom of this wall ride and looking up with a fisheye lens captures the rider's height, while including his friends watching from a distance adds a sense of scale. A single remote flash on top of the wall brings some fill-in light and a bit of extra contrast.

CAMERA: Nikon F5
LENS: 16mm fisheye
FILM: Fuji Provia 100 transparency
APERTURE: f/8
SHUTTER SPEED: 1/250 sec
LIGHT CONDITIONS: single remote flash, radio-triggered
WEATHER CONDITIONS: sunshine and cloud

Low-angle trail view
Sometimes a detailed or close-cropped shot is enough to convey your message. Here, shooting while running alongside the bike with the camera and wide-angle lens held at ground level hints at the speed of the bike on this dusty, sunlit trail.

CAMERA: Nikon F5
LENS: 17–35mm
FILM: Fuji Provia 100 transparency
APERTURE: f/14
SHUTTER SPEED: 1/40 sec
LIGHT CONDITIONS: single on-camera, set to TTL auto
WEATHER CONDITIONS: low sun

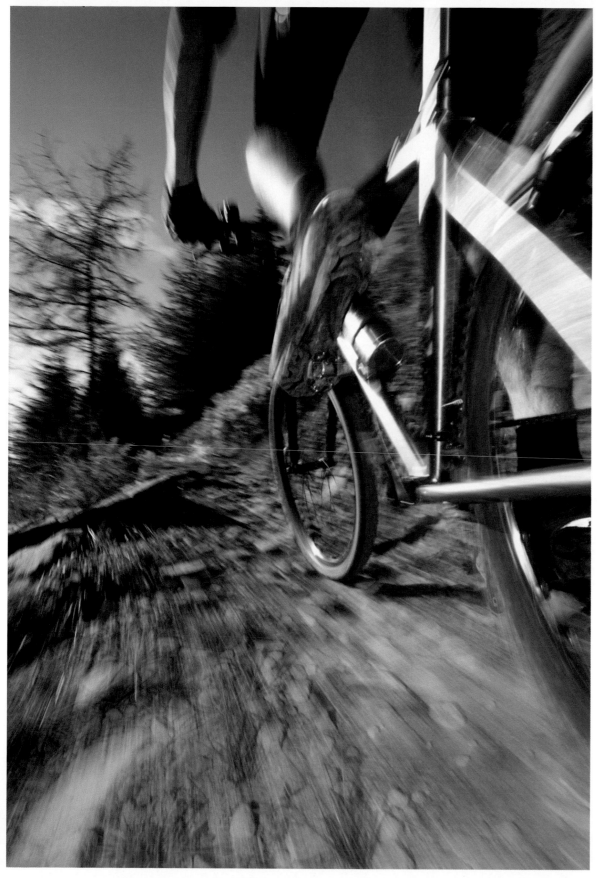

AS: What types of pictures do you find the most difficult to take?

SR: Magazine cover shots, because publishers have become extremely specific about their needs. Once I've sorted the location, background, rider, clothing, and bike, I often end up having to compose an action shot in one corner of the frame, to meet the needs of coverlines and covermounts. And the whole thing has to look spontaneous and natural—despite having been set up from scratch and shot dozens of times.

AS: Which do you prefer, digital or film, and why?

SR: I was a film stalwart for as long as I felt able to hold out. I couldn't see why I needed digital, partly because years of shooting slides meant I was confident about film exposure. The ludicrous expense of pro gear also made me reluctant to change. But having made the switch I've had huge amounts of fun. Digital enables me to be more creative with lighting and composition, and to be certain that I've got a result before I go home—even then I can fine-tune results by processing RAW files. It's rather like having a Polaroid for every shot. If I had to go back to film tomorrow I'd be fine, but I'd certainly miss the total control that digital gives me.

AS: How much of your work is manipulated using imaging software?

SR: It depends what you mean by manipulated. I only shoot in RAW format—never JPEG—so every single shot that goes to a client has been individually tweaked for white balance, curves, contrast, saturation, and so on. I like my images to have a fairly film-like look, with plenty of punch, so that's the way I process them. But heavy Photoshop work, such as the occasional insertion of a blue sky into a cover shot, for example, is up to the client.

AS: Where do your ideas for innovative pictures come from?

SR: A fellow photographer once said to me, "There are only about six different ways to shoot a mountain bike." He's right of course and that's where the challenge lies. I know how it feels to be weaving down a narrow trail at what seems like warp speed. This is precisely what I try to capture in my pictures.

AS: What does the future hold for you?

SR: More of the same. I want to be riding bikes and taking pictures for as long as there are bikes to ride and trails to explore.

Seb Rogers

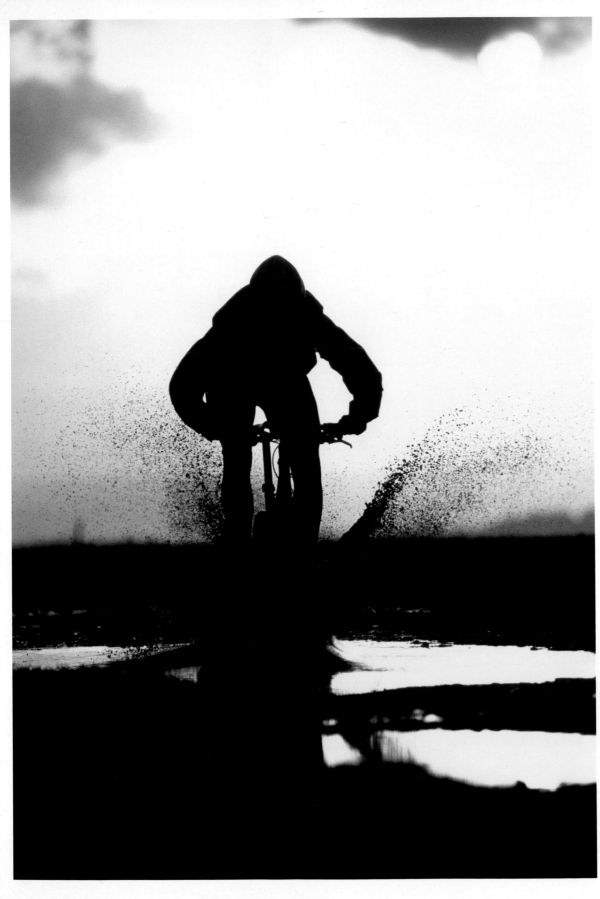

Silhouetted rider
A mountain biker splashes
through a deep puddle in front
of the setting sun. It can be hard
to judge the best moment for a
splash, so Rogers shot a quick
8fps (frames per second) burst
and chose the best shot out of
the set.

CAMERA: Nikon F5
LENS: 80–200mm
FILM: Fuji Provia 100
 transparency
APERTURE: f/4
SHUTTER SPEED: 1/2000 sec
LIGHT CONDITIONS: no flash,
 set to TTL auto -1 stop
WEATHER CONDITIONS: late
 evening sun/cloud

Top 10 Tips for Success

1) Don't get hung up on gear
Although gear can make the difference between getting the shot and missing it, most of the time it doesn't make nearly as much difference as some of the hype suggests. It's far more important that you are comfortable and familiar with the setup that you prefer to use. Before you upgrade, ensure you're squeezing the maximum possible performance out of the equipment you currently own.

2) Take control of your camera
Camera manufacturers place huge emphasis on complex autofocus and exposure systems, but even the best of them can't get it right all of the time. To get results, you need to work out under what circumstances the automatic systems are likely to fail and have a strategy for dealing with them. Like many photographers my camera controls are set manually. In constant light conditions this brings the best results because one quickly learns to judge when the light has changed, without even consulting the camera's meter system.

3) Keep your finger off the button
This is going to sound strange in an age of high capacity memory cards and cheap hard drives, but one of the best ways to improve your results is to be more selective at the capture stage. Sometimes less can be more. Think, plan, anticipate… and don't rely on hosing a scene down to choose just one single shot. For me it's not a numbers game.

4) Anticipate the moment
It can be useful sometimes to capture a high speed sequence of a moving subject, but even with a high frame rate of 8fps (eight frames per second), it's possible that the peak action will occur between two frames. It's often better to watch, anticipate, and squeeze off a careful shot at precisely the right moment.

5) Track the action
Shooting a moving subject? Move the camera with it—always. If you've planned your shot in advance you can position the subject under an imaginary focus point in the viewfinder, as a reference point, and keep it there as you track it, take the shot, and follow through.

6) Get in close
Two ways to grab a viewer's attention: crop close or get in close with a wide lens. It takes practice and confidence to capture a moving subject in a very tight frame, but it guarantees impact.

7) Plan ahead
Understanding your subject is a vital process of planning how a picture will look. If you're not familiar with any given sport, spend a bit of time watching before you shoot, so that you can anticipate likely peaks in action as well as good vantage points. Time spent thinking about your shots isn't time wasted—it is an important step in getting the exacting photographs you and your clients want.

8) Get high—or low
Most people view the world around them from a height of between five and six feet. Show them an image that's captured from a different perspective and you'll immediately grab their attention. I hardly ever shoot standing up, unless I'm standing on a wall or in a tree. Most of the time you'll find me crouched, kneeling, or even lying flat on the floor.

9) Don't follow the crowd
Most sports events have certain areas crammed with photographers, and often for good reasons—it may be that these are the best vantage points, or that they are the only ones available for safety reasons. But whenever I see a crowd of photographers I head in the opposite direction, to see if there's a different angle. Why take the same shot as everyone else? Use your own head, trust your instincts, and go for the unexpected. It'll help make your work stand out.

10) Be critical of results
It's a mistake not to be critical enough of the technical quality of your pictures. Don't let digital lull you into a false sense of Photoshop-enhanced security. You can fix some things postcapture, but a photo that is right in-camera will always look better than one that's been rescued. Nail your exposure and white balance; you'll save time in front of the computer and improve the quality of your photos. And check that your focus and panning technique are up to scratch—a shot that isn't quite sharp in the right places is not worth keeping, no matter how well composed.

Seb Rogers

Peak District National Park
This rider's eye view of a narrow, single track trail was captured by attaching the camera to the bike's seatpost with Rogers running behind with a button-release cable, being careful to make sure that his shadow wasn't visible in the shot.

Specification

CAMERA: Nikon F801

LENS: 16mm fisheye

FILM: Fuji Provia 100 transparency

APERTURE: f/16

SHUTTER SPEED: 1/30 sec

LIGHT CONDITIONS: single on-camera, set to TTL auto

WEATHER CONDITIONS: late evening sun

Essential Equipment

- Nikon D200 camera body
- Nikon D2X camera body
- 10.5mm f/2.8 fisheye lens
- 12–24mm f/4 lens
- 50mm f/1.8 lens
- 85mm f/1.4 lens
- 50–150mm f/2.8 lens
- Two Nikon SB800 flashguns
- Quantum 4i radio slave

- Two 2GB CF cards
- Spare batteries
- Ten rechargeable AA batteries for flashguns
- Lens cleaning cloth and blower brush
- Two mini tripods for mounting flashguns
- Apple Macintosh Pro laptop with RAW processing software and CF card reader

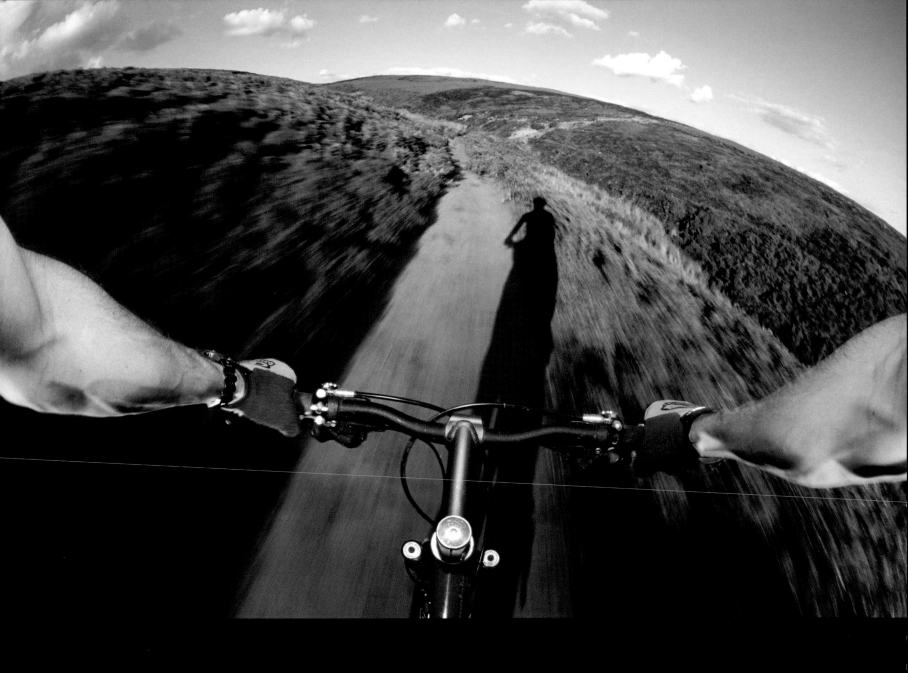

Seb Rogers

Andy Rouse

Wildlife

World-renowned wildlife photographer Andy Rouse has long had a passion for wild things. He has built his reputation on getting in close to his subjects, enabling him to chronicle some of the world's largest and most dangerous animals. In doing so, he has captured the most exciting and evocative action images of wildlife found today. With a style all his own, Rouse is equally passionate about the message his photography conveys and sees his work as contributing to the general appreciation of our precious wildlife, hopefully stimulating others to act on their behalf.

With a camera always by his side, Rouse has also starred in his own TV series and made numerous TV appearances, including two series of *Wildlife Photographer* and *Animal Planet* for UK-based Channel 5, which he presented and directed. In addition, he writes regular monthly columns for photographic and internet magazines worldwide, plus a monthly equipment review column. His work is published through various agents, including Corbis and Getty Images, in a variety of forms. Throughout his illustrious career he has lectured at festivals in France, Finland, New Zealand, and Germany. He is a multi-award winning photographer and continued success in the annual BBC Wildlife Photographer of the Year competition has become part of his career.

Andy Rouse

AS: What was your first-ever camera?

AR: A Canon AE1 Program SLR film camera, before upgrading to a Canon A1 in 1987.

AS: What have been your greatest photographic achievements to date?

AR: Staying competitive in my field of business and becoming known worldwide as a brand name. It's a big achievement for a British photographer because most UK-based companies tend to buy images from foreign photographers. Those who have tried their hand at it will know just how hard it is to succeed.

AS: Is it fair to say that, like many successful photographers, you had a "lucky break" at some stage?

AR: Yes, the first image I took which generated some attention was of a fox chewing a garden gnome which won me an award in the BBC Wildlife Photographer of the Year competition. Of course I've been able to demonstrate some strong technical skills when it matters but, more than that, I've met the right people at the right time.

AS: Why did you decide not to pursue other types of photography, such as portraits or fashion, for example?

AR: Wildlife is in my soul and I love the empathy I create with my subjects. I'm also not very good at other types of photography: I've tried all kinds of things, but it seems as though I'm just taking pictures, rather than doing something I enjoy that is worthwhile and carries an important message. Photographing animals is very hard but it enables me to work to the limit of my ability every single day I do it. I also enjoy the photographic challenge of it and I have risked my life on several occasions, in which I have had to think clearly under pressure to get myself out of sticky situations.

AS: Do you shoot what you want or do others generally define what's required of you?

AR: I don't get commissioned very often because in wildlife photography that just doesn't happen. Mine is a stock-driven business and I go on assignment, shoot the pictures, and find a market for them upon my return. Some trips can cost up to $19,500 US (£10,000), so I have to justify why I can go away and come back to make a profit. It is this, among other motivations, that drives me to take great photographs.

Verreaux's sifaka, Madagascar
"Using a very high shutter speed will automatically dictate a very wide aperture. This also gives a very low depth of field, while using a decent fixed focal length lens will blur the background and ensure focus is firmly on the subject."

CAMERA: Canon EOS 1V HS
LENS: 300mm
ISO: Fuji Provia 100
APERTURE: f/2.8
SHUTTER SPEED: $\frac{1}{750}$ sec
LIGHT CONDITIONS: sunny
WEATHER CONDITIONS: dry

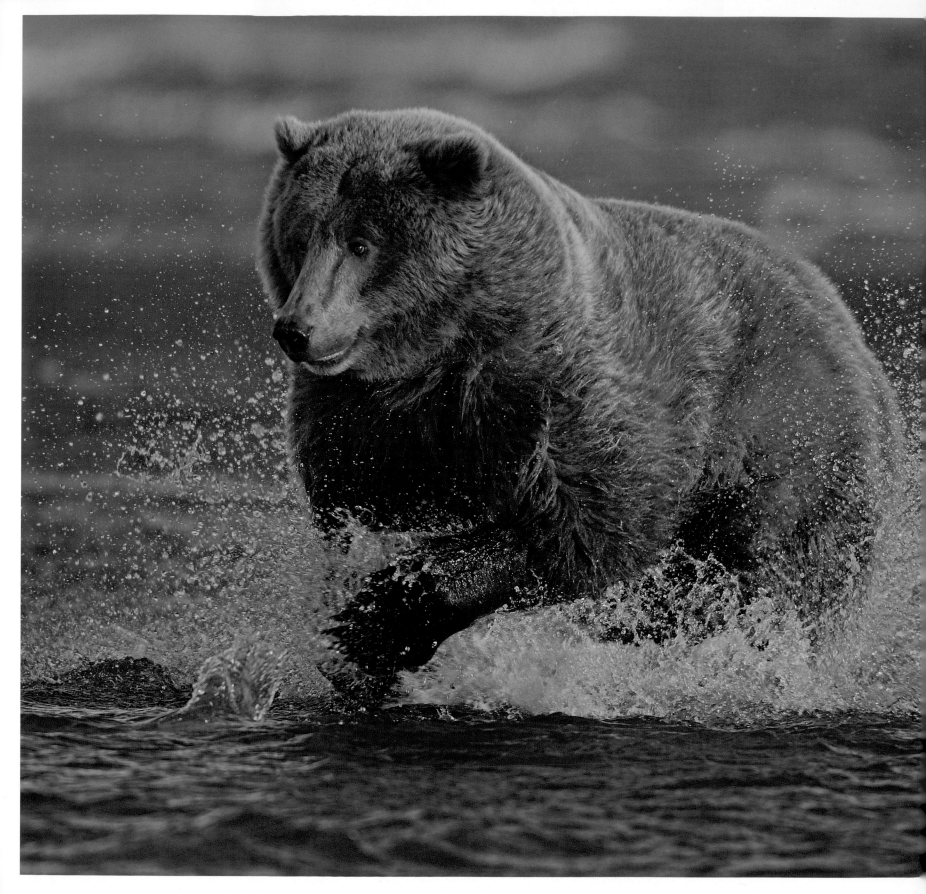

Grizzly Bear, US
"Moments like this are so
unpredictable and it pays to
be well prepared. When I am
photographing bears fishing I
know how fast they can erupt
into the water, so I always set
my camera's autofocus to AI
Servo, working hard to keep
the focusing point right between
the eyes. Then, when they run,
you hope the autofocus can
keep up."

CAMERA: Canon EOS 1Ds MKII
LENS: 500mm
ISO: 100
APERTURE: f/4
SHUTTER SPEED: ¹⁄₅₀₀ sec
LIGHT CONDITIONS: sunshine
WEATHER CONDITIONS: dry

AS: Where are you mostly based? Where are your most
popular locations?

AR: Around 50 percent of my work is of UK species: hares,
foxes, owls, deer—these animals are responsible for building
the foundations of my career. Much of my time is also spent in
Africa, where I return each year, mainly to Kenya, Botswana,
and Zambia. But I often travel to Antarctica and the Falkland
Islands to photograph penguins. They can make me smile in the
most atrocious conditions and I seem to have very good
empathy with them. People are harder to photograph.

AS: What things do you enjoy most about your job?

AR: Being with animals. Conservation is important and
unfortunately I have seen so many climate change effects that
are irreversible. In my opinion it's now too late and I frequently
ask myself whether it's the human race or the natural cycle of
the world that's changing the environment. Many species are
now, and will continue to go, extinct, whether we like it or not.
I do what I do with my camera but there are better people in the
world than me to portray what's happening. I'm a photographer
and not a spokesperson for climatic affairs.

AS: From a technical aspect, what are the most difficult things
about your job?

AR: The processing side of photography gets me down; I take
a prolific amount of pictures which leads to lots of editing, as
well as an enormous backlog of work, talks, seminars, and tours.
When these add up they can detract from the time I need to
spend editing my work. I try to make sure my photography
doesn't take over my life and I have few close friends who work
in the photographic industry.

Andy Rouse

**Gentoo penguins,
Falkland Islands**
"When motion is predictable
and the camera has enough time
to track a subject before I want
to fire off the shot, I put the
camera in total control. For this
image I set my Canon to AI
Servo and selected all the
focusing points, thus allowing
the camera to be in control of
predicting where the penguin
would be in focus, at any one
point. Then all I had to do was
to keep the penguin in the center
of the viewfinder and try to stop
laughing because its antics were
just so brilliant."

CAMERA: Canon EOS 1Ds MKII
LENS: 300mm
ISO: 100
APERTURE: f/2.8
SHUTTER SPEED: 1/2000 sec
LIGHT CONDITIONS: bright
WEATHER CONDITIONS: dry

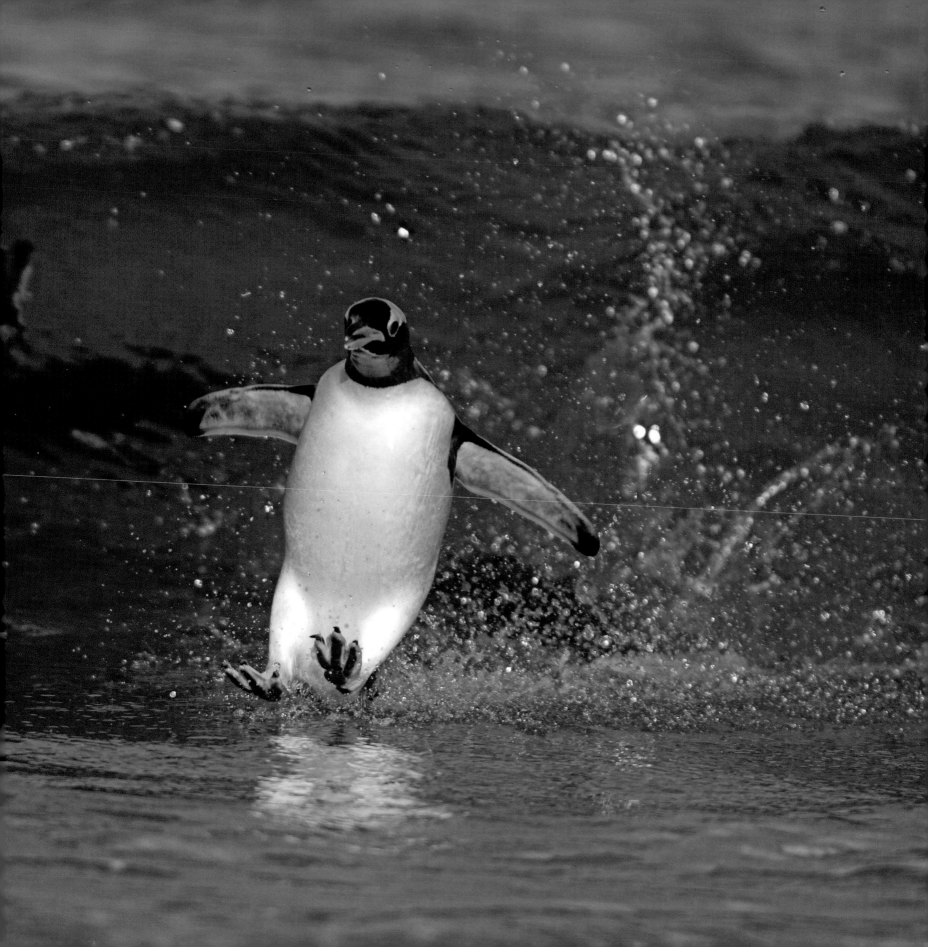

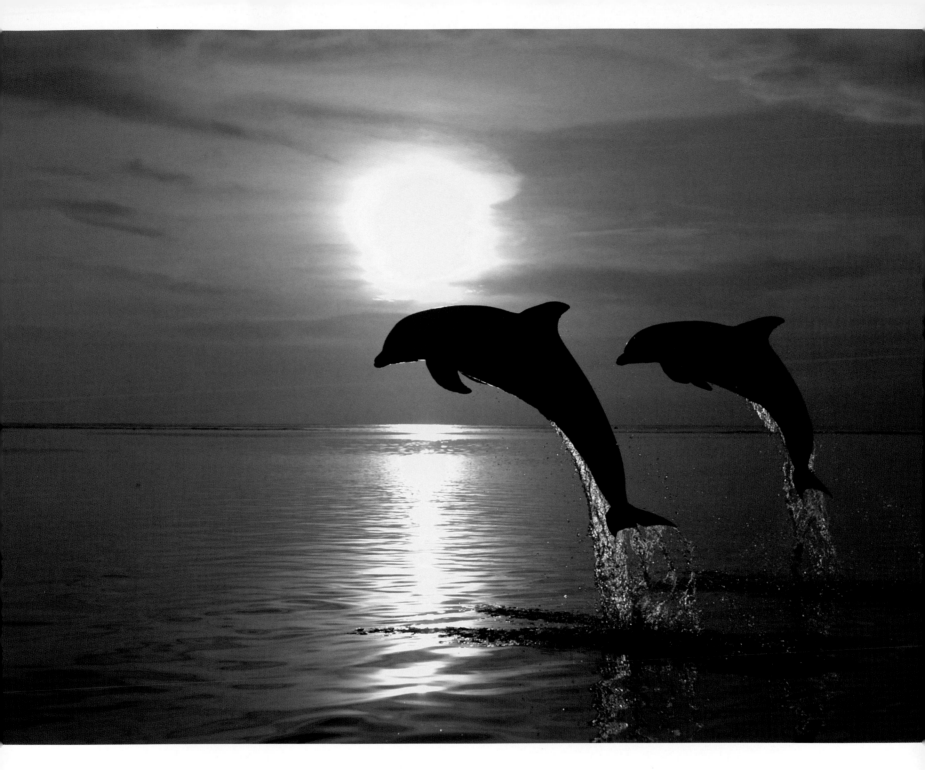

Bottlenose dolphins, Caribbean
"It's sometimes hard to forget that motion is not all about getting the subject full in the frame. Often the environment of the shot is just as beautiful, as you can see here. The problem was my camera's autofocus, and, since I didn't know where the dolphins would jump, I couldn't set the autofocus beforehand. So I relied on the fact that since there was little distraction in the background, and the dolphins provided a good contrast against it, the autofocus would lock on. Luckily it did."

CAMERA: Canon EOS D30
LENS: 24–70mm
ISO: 100
APERTURE: f/4
SHUTTER SPEED: 1/500 sec
LIGHT CONDITIONS: flash/natural

AS: How would you describe your personal technique or style of photography?

AR: This changes a lot as I evolve my style; I know of few professionals whose style has remained the same throughout the last 10 years. However, you could say that I like to get in really close more than ever, and nowadays I tend to shoot with wide-angle lenses more than long lenses. Storms really turn me on, especially when I see the way some animals react to them. It's hard because I have to take pictures of what I think will sell. But I'm known throughout the industry and clients know I'm not going to send them any bad pictures. I like to take shots hand-held with as much natural light as possible—if a photographer can't do this without flash or a tripod in dark conditions then they shouldn't be in the game. It's basic skill and technique to push up your camera's ISO setting to around 200 and shoot with an aperture of f/8.

AS: What's in your kit bag? Which camera system do you use and why?

AR: Mainly a Canon EOS 1Ds MKII, though recently I have begun to use my Canon EOS 5D more, which has a better dynamic range and less noise on the image. Canon's digital cameras have the best image sensors and I have always used their gear.

AS: What are your favorite and most used lenses/focal lengths?

AR: Mostly a 70–200mm f/2.8, sometimes with 1.4x teleconverter, because I like to travel light and move around freely. But it also depends on the type of animals I photograph, so a 500mm lens comes in handy if I have a shy, quick subject. It's very important for me to fill the frame naturally and take a picture as I see it, rather than blow it up in Photoshop.

AS: What types of pictures do you find the most difficult to take?

AR: I don't like shooting macro. You can either see pictures or you can't, and with macro lenses, I can't. There's no art in my pictures when I use macro.

AS: Which do you prefer, digital or film, and why?

AR: Digital. It's allowed me to be more creative, reduce my production costs, and shoot without having to rewind film. Rewind noise on film cameras has frightened off more animals throughout my career than I can shake a stick at. Nowadays digital has reached the stage where the quality is amazing and I can blow them up to a much bigger size. Having said that, I've used a Pentax 645 medium-format film camera—and the quality is very good—but it's noisy and not suitable for wildlife work. If someone produced a fully digital medium-format camera I would consider using it.

AS: How much of your work is manipulated using imaging software?

AR: I retouch, not manipulate, and I feel very strongly about this. I think it's OK to change colors to bring back exactly what I saw when I was in the field, and to sometimes increase the saturation a little, so long as all the basic elements of the picture remain. Wildlife is what you see because it has already been created, hence manipulation would be misleading.

AS: Where do your ideas for innovative pictures come from?

AR: I never prethink before I shoot. If I suddenly see an animal running quickly then I will shoot what I see, from the hip. I'm not a photographer that goes out each day taking pictures; I get immersed in a project when I am doing it. Good pictures come from exploiting opportunities and making the most of what happens in the right place, at the right time. There are no rules to getting a winning picture.

AS: What does the future hold for you?

AR: I continually find myself becoming more involved in conservation and as a photographer I hope my work can effect change because it is seen by a worldwide audience. I want people to understand the changes that are happening right now, and I can see my career following this path a little bit more than it used to. I'm also planning to exhibit my work more in future, I have a forthcoming exhibition at the UK's Natural History Museum.

Bull elephant, South Africa
"Sometimes you can create different images of much-photographed subjects by combining an abstract composition with slow motion. Here I used a very slow shutter speed to capture a large bull elephant to blur the bush as he shook it for food."

CAMERA: Canon EOS 1Ds MKII
LENS: 70–200mm
ISO: 100
APERTURE: f/11
SHUTTER SPEED: 1/15 sec
LIGHT CONDITIONS: bright
WEATHER CONDITIONS: dry

Cheetahs, Kenya
"In low-light conditions the decision about whether to opt for frozen-frame or motion blur is effectively made for you. A lot of photographers choose not to shoot at all, which is always a mistake. You should always try to shoot motion blur, no matter what the light conditions are, as you never know how the image is going to turn out. If it is rubbish then you can simply delete it, but if it is good then you get something a little bit like this."

CAMERA: Canon EOS 1Ds MKII
LENS: 70–200mm
ISO: 200
APERTURE: f/5.6
SHUTTER SPEED: ¹⁄₁₅ sec
LIGHT CONDITIONS: cloudy
WEATHER CONDITIONS: dry

Andy Rouse

Thomson's gazelle, Kenya
"Using a slow shutter speed is sometimes not enough; you have to move the camera while the shutter is still open to enhance the feeling of motion. This is called panning and is an action technique I often use to create the impression of how fast a subject is running. These Thomson's gazelle were fleeing from a cheetah, so this shot was a spur-of-the-moment decision to shoot something with a very slow shutter speed. Luckily it worked."

CAMERA: Canon EOS 1Ds MKII
LENS: 70–200mm
ISO: 100
APERTURE: f/11
SHUTTER SPEED: 1/10 sec
LIGHT CONDITIONS: bright sunshine
WEATHER CONDITIONS: dry

Barn owl, UK
"While on a job for an advertising client I used my friend's barn owl to simulate how it might look to a mouse on the ground. It was pointless blurring the shot with a slow shutter speed, as it would have looked odd against the blue sky, so instead I set the camera to autofocus tracking and a very high shutter speed to freeze the motion of the owl in mid-attack."

CAMERA: Canon EOS 1Ds MKII
LENS: 27–70mm
ISO: 200
APERTURE: f/2.8
SHUTTER SPEED: 1/1500 sec
LIGHT CONDITIONS: bright sunshine
WEATHER CONDITIONS: dry

Andy Rouse

Pheasant, UK
"This is a useful trick when photographing birds, where the technique is often to freeze the motion of the wings. I wanted to show how powerfully the pheasant flaps its wings when displaying to a potential mate, so I focused dead-center on its chest and deliberately set the camera with a slower shutter speed than I would usually do to introduce the element of blur."

CAMERA: Canon EOS 1Ds MKII
LENS: 300mm
ISO: 100
APERTURE: f/5.6
SHUTTER SPEED: ⅟60 sec
LIGHT CONDITIONS: bright
WEATHER CONDITIONS: dry

Osprey, Finland
"Smash-and-grab merchants like the osprey give virtually no notice of when they are going to crash down into the water on unsuspecting prey. When I work in conditions like this, I set my autofocus to tracking and prefocus it in the center of the lake, so that the lens hasn't got to travel so far to get the focus right."

CAMERA: Canon EOS 1V HS
LENS: 300mm
ISO: Fuji Provia 100
APERTURE: f/2.8
SHUTTER SPEED: $1/500$ sec
LIGHT CONDITIONS: sunny
WEATHER CONDITIONS: dry

Andy Rouse

Siberian tiger, US
"I was on an advertising shoot and my client needed a shot of a tiger hunting. Luckily I knew of an animal trainer whose cats worked in all the big movies and could get it to run straight down the barrel of my lens. I set the camera to AI Servo autofocus tracking and lit up all the focusing points, as I knew the autofocus could not go wrong and would always pick up the tiger's head. It may have been a captive tiger, but when it was pounding toward me through the snow, it certainly gave me a huge adrenaline rush and I was very glad when it was over."

CAMERA: Canon EOS 1Ds MKII
LENS: 500mm
ISO: 200
APERTURE: f/5.6
SHUTTER SPEED: $\frac{1}{500}$ sec
LIGHT CONDITIONS: bright/
 cloudy
WEATHER CONDITIONS: snow

Top 10 Tips for Succe

1) Take a wider view

It's always a great temptation when photographing wildlife to fill the frame as the subject is invariably beautiful. This is a great starting point, of course, but often this will not be the best shot, so take a wider view and look at the context of the subject in its habitat. Showing how and where your subject lives can make a much more compelling image than the usual head and shoulders shot.

2) Focus on the eyes

Getting the eyes in sharp focus is the number one requirement for any wildlife picture; if you do this then it will forgive and hide many other mistakes in the frame. I focus exactly on the eyes, selecting a focusing point that is always right over the top of them and wait until I can see the eyes fully open before taking the shot.

3) Get up early

It may sound crass, but most action-packed shots in the wild happen in the hours shortly after dawn; if you are working in a hot climate this is especially true as the predators will be out hunting and everything else will be relaxed before the heat of the day starts to intensify.

4) Be motivated by light

Light can make or break an image; it controls the image and the message that it gives the viewer. Good light usually means shooting in the soft morning and evening glow, but it can also mean shooting in really evocative, stormy conditions. Try to vary your exposures to make the most of the light, and when you process your images, don't lose the mood by over-brightening an image; try to enhance the mood by underexposing your shutter speed and aperture combination.

5) Shoot RAW not JPEG

We all make mistakes and by shooting RAW you will ensure that it will be relatively easily to correct them using RAW software. Shooting RAW is not really an issue of quality, although RAW files do exhibit less noise and banding than JPEGs; it's more an issue of flexibility. Shooting RAW also allows you to experiment and be confident in making color corrections, without having to be an imaging expert.

6) Shoot in aperture priority mode

Most wildlife shoots happen in very low-light conditions and require a fast shutter speed to capture the action, or use a low depth of field to blur the background. This means your primary goal will be to control the aperture at which you shoot and for this reason you should always shoot in aperture priority. Setting the fastest shutter speed your camera can shoot at, in a certain light condition, is also simplicity itself when using aperture priority. My advice is to set the dial to the lowest possible aperture setting that the camera will allow you to (usually f/4–f/5.6). This will, by definition, automatically select the fastest shutter speed.

7) Backup everything twice

It's very easy to lose your precious digital images, whether by an accidental delete or a hard disk crash. Therefore I suggest you back up everything twice; when in the field I use a portable 80GB download device, connected to a backup hard drive, to save my RAW file images. At home I use a stack of external USB 250GB hard drives, all in mirrored pairs, so if one fails I still have a copy.

8) Use stabilized lenses

Stabilized lenses are a godsend for action photographers as they allow us to shoot in low-light conditions and get good results. I regularly shoot at shutter speeds below 1/60 sec and trust my Canon IS (Image Stabilize) system to give me a great chance of getting a sharp image in such conditions. I always adopt a very rigid, braced position when shooting, pulling my arms into my chest and minimizing all movement during the shoot. It has paid off in bad light more times than I can count.

9) Think about how your subject sees you

Most wild animals are scared of human contact and this can be exacerbated by how you stare when they see you. If you are wearing brightly colored clothing then not only will it make your subject more wary of you (or make it run away), it might also make it more aggressive. Smell counts too as most members of the animal kingdom have a highly developed sense of smell and will avoid you before you even see them. I always wear dark clothing when photographing wildlife, sometimes camouflage if it is necessary, and I never wear any kind of scent.

10) Be respectful

Remember it is their world and whatever animal you are photographing has a bigger struggle for survival than you. Be mindful of getting too close or overstaying your welcome, particularly if you are working with a female animal and her young. At all times watch for stress in your subject and back off as soon as you sense it; if you do not know the signs of stress then find out before you put yourself in the situation as it may save your life.

Andy Rouse

**Black browed albatross,
Falkland Islands**

"To get this artistic shot I combined the slow shutter speed of my SLR with the syncronized speed of my flash. I tracked the albatross as it was flying across me, and when I pressed the shutter, I kept moving and followed it while the shutter was still open. The flash lit up the albatross and the panning motion created the streaks, producing a nice shot of a wonderful bird."

Specification

CAMERA: Canon EOS 1Ds

LENS: 70–200mm

ISO: 100

APERTURE: f/5.6

SHUTTER SPEED: 1/15 sec

LIGHT CONDITIONS: flash/natural

Essential Equipment

- One 35mm Canon EOS 5D camera body

- One 35mm Canon EOS 1D camera body

- One 35mm Canon EOS 1Ds MKII camera body

- 24–70mm f/2.8 lens

- 70–200mm f/2.8 lens

- 300mm f/2.8 lens

- 500mm f/4 lens

- Canon 580-EX Speedlite flashgun

- Kata waterproof rucksack

- Gitzo 15–48 tripod

- Manfrotto 501 tripod

- Kirk tripod ballhead

- Jobo GigaVu PRO Evolution 80GB portable downloader

- 10x 4GB CF cards

- Aquatech waterproof camera covers

- Paramo outdoor Gore-Tex clothing

- Camera image sensor cleaner

- 105mm circular polarizer

- Canon drop-in polarizer for long lenses

Basketball and general sports

Having recently relocated to Australia, New Yorker Shaw has traveled the globe shooting the most high-profile sports events, although his first love remains basketball. Soon after he joined Allsport Photography in 1998, the company was taken over by Getty Images, and Shaw is now a senior staff photographer for the company. His assignments have included the Winter and Summer Olympics, the baseball World Series, the NBA Basketball Finals, and the Super Bowl.

In addition to day-to-day games coverage, Shaw has recently been working closely with the Getty Images features department, to develop and produce human interest stories in the sports arena, from kickboxing in Bangkok to the Iditarod Great Sled Race in Alaska.

Ezra Shaw

Interview

AS: What was your first-ever camera?

ES: A Konica that I got when I was just eight and that was stolen during a family trip to Washington DC shortly after I got it. After that, my father bought me a second-hand Nikon FE2 film camera from someone outside a photographic store in New York City.

AS: What have been your greatest photographic achievements to date?

ES: Just as I was finishing university, I was awarded first place in the Alexia Foundation Competition, a foundation dedicated to helping photographers produce photographs that promote world peace and cultural understanding. I was able to work on a story about children affected by the Chernobyl disaster that would have otherwise never been possible. This has recently come full circle as I was able to go back to Belarus and document the changes that have taken place 20 years after the nuclear disaster.

AS: Is it fair to say that, like many successful photographers, you had a "lucky break" at some stage?

ES: During my final year at university a friend introduced me to someone who worked at *Sports Illustrated*, who in turn introduced me to more people at the magazine. This opened up many doors and I started assisting some of the *Sports Illustrated* photographers—an invaluable experience and a definite stepping stone in my career.

AS: Why did you decide not to pursue other types of photography, such as portraits or fashion, for example?

ES: While growing up I was always into sports. When I realized I was never going to make it to Wimbledon playing tennis, I had to figure out another way to get there. And, although I have yet to photograph Wimbledon, I've been able to shoot amazing sporting events around the world.

AS: Do you shoot what you want or do others generally define what's required of you?

ES: Generally I get to shoot what I want. Although there are always commitments going into assignments, Getty Images is very good at encouraging its photographers to try different things. This can make a typically boring assignment more interesting because I'm always looking for different angles and going for interesting shots that no other photographer has done.

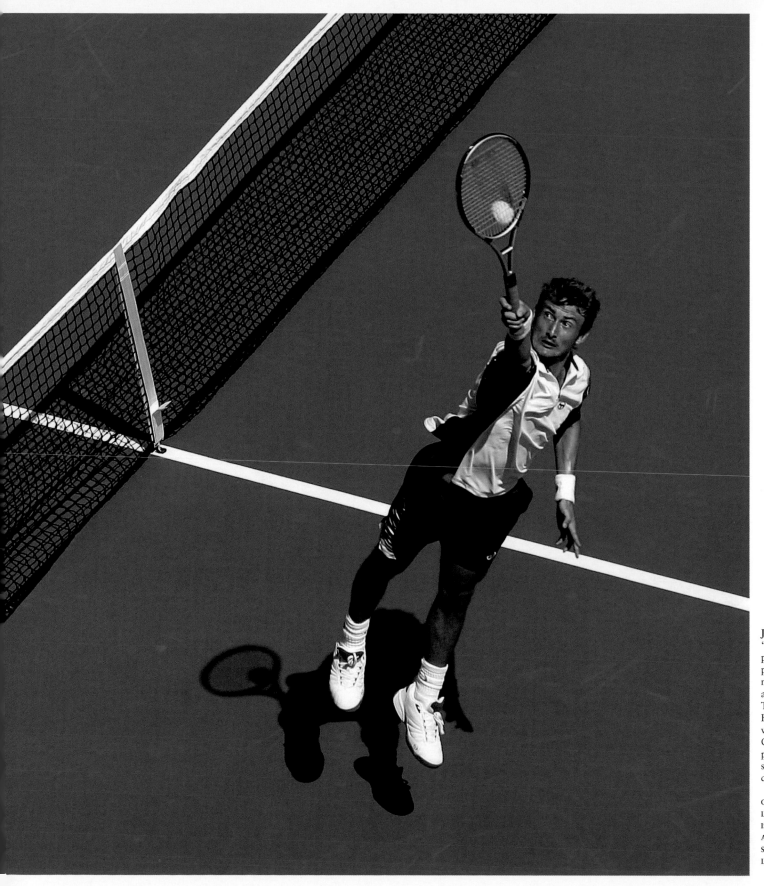

Juan Carlos Ferrero, US Open
"Tennis is a great sport to photograph because it's never played in the rain and I can move around and work from a variety of different angles." This picture of Juan Carlos Ferrero leaping to return a shot was taken in the Grandstand Court, a favorite among the photographers because they can shoot from a walkway almost directly above the action.

CAMERA: Canon EOS 1D MKII
LENS: 70–200mm
ISO: 200
APERTURE: f/7.1
SHUTTER SPEED: $^1/1600$ sec
LIGHT CONDITIONS: bright sunlight

Ezra Shaw

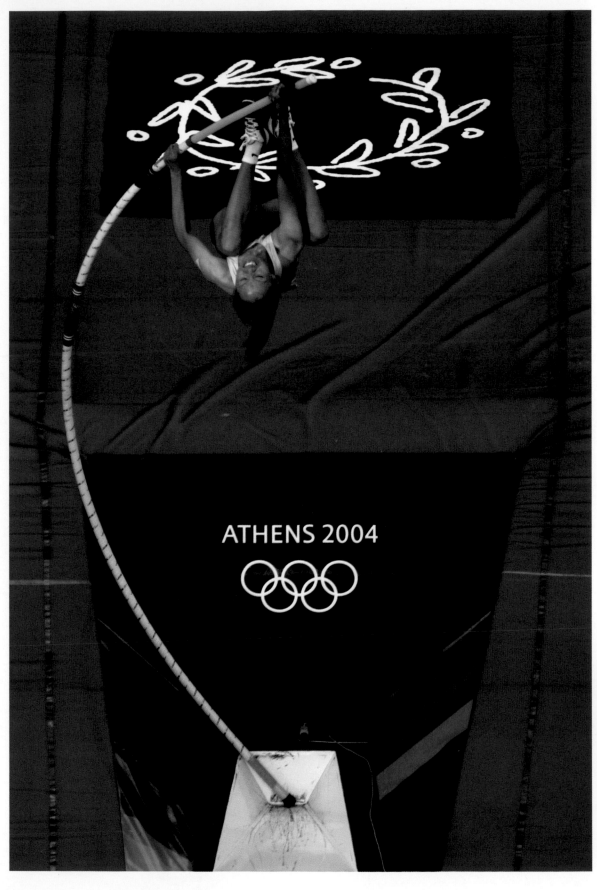

ATHENS 2004

Shuying Gao, Women's Pole Vault qualifying round, Summer Olympics, Athens
"I took this shot from the catwalk in the stadium and I remember having to climb through numerous tunnels and up many ladders to reach it. It was worth it because it gave me a different angle to the hundreds of other photographers at the event. The sun was going down when I got to the catwalk; this picture was one of the first frames I fired when I got up there. It worked the best because the light completely disappeared soon after."

CAMERA: Canon EOS 1D MKII
LENS: 400mm with 1.4x
 teleconverter
ISO: 500
APERTURE: f/6.3
SHUTTER SPEED: ¹⁄640 sec
LIGHT CONDITIONS: tungsten

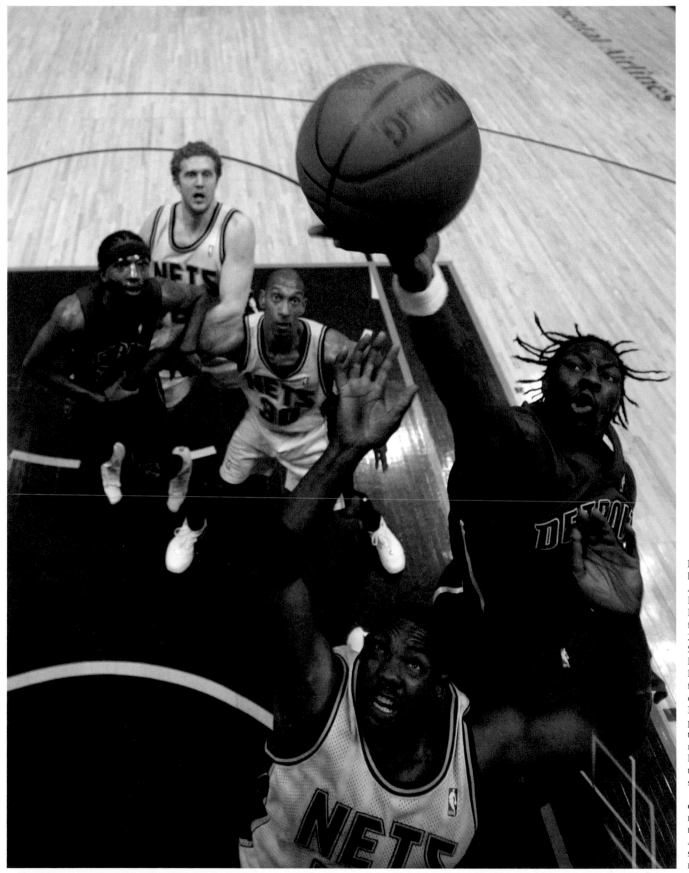

New Jersey Nets vs Detroit Pistons, Continental Airlines Arena
Ben Wallace leaps over Rodney Rogers of the New Jersey Nets for a rebound in game six of the 2004 Eastern Conference Semifinals. "Ben Wallace of the Detroit Pistons has been named Defensive Player of the Year four times and is always one of the top rebounders in the NBA league. Going in to this particular game, I was looking to capture him getting one of the rebounds he is so famous for, so I set up a remote camera behind the backboard to capture the shot in all its intensity."

CAMERA: Canon EOS 1D
LENS: 16–35mm
ISO: 1,000
APERTURE: f/3.5
SHUTTER SPEED: 1/400 sec
LIGHT CONDITIONS: tungsten

Ezra Shaw

AS: Where are you mostly based? Where are your most popular locations?

ES: I'm based in Sydney after recently moving to Australia. For the past 10 years, however, I've been working out of New York City. One of my favorite locations is Cuba—it makes me feel as though time has stood still for the past 40 years. It's an amazing place to take my camera.

AS: What things do you enjoy most about your job?

ES: Getting to meet people and see things most others never get the chance to do. Every day I meet someone new. If I was working in an office, I definitely wouldn't have that opportunity.

AS: From a technical aspect, what are the most difficult things about your job?

ES: For me, the most difficult thing technically is lighting. It amazes me sometimes how some photographers are able to light certain subjects and make the photograph look so natural and beautiful.

AS: How would you describe your personal technique or style of photography?

ES: I always think about the assignment and the big picture. For me, trying to incorporate the atmosphere and crowd into the final product is an absolute must. This is especially important for the larger events with bigger crowds and a more definitive moment at the outcome, such as a celebration at the end of a major tournament like the NBA Finals.

San Antonio Spurs vs New Jersey Nets, NBA Finals, SBC Center
"From a photographer's point of view, I always hope the championship game is won on home turf. The excitement of both fans and players reaches extreme levels, making for some great shots." Here, Malik Rose and Kevin Willis of the San Antonio Spurs celebrate with fans in their home arena, after defeating the New Jersey Nets in game six of the 2003 NBA Finals.

CAMERA: Canon EOS 1D
LENS: 16–35mm
ISO: 1000
APERTURE: f/2.8
SHUTTER SPEED: 1/125 sec
LIGHT CONDITIONS: tungsten with flash

Ezra Shaw

Left: **NBA All-Star Game, Dwyane Wade vs Dirk Nowitzki, Pepsi Center**
"There's no other active player that can fly through the air like Dwyane Wade. Here he is under pressure from Dirk Nowitzki during the 2005 NBA All-Star game. Even though it seems he is in an impossible place from which to score, he was still able to make the basket."

CAMERA: Canon EOS 1D MKII
LENS: 24–70mm
ISO: 1000
APERTURE: f/2.8
SHUTTER SPEED: 1/500 sec
LIGHT CONDITIONS: tungsten

Above: **Josh Smith, NBA Slam Dunk Contest, Pepsi Center**
"I remember seeing pictures of Michael Jordan flying from the foul line when he won the Slam Dunk Contest in 1988. When I saw Kenyon Martin taking a seat on the floor for Josh Smith's dunk, I knew that something special was about to happen. I wanted to take a picture that showed not only the difficulty of the dunk, but also how far and how high he had to jump to win."

CAMERA: Canon EOS 1D MKII
LENS: 16–35mm
ISO: 1000
APERTURE: f/3.2
SHUTTER SPEED: 1/500 sec
LIGHT CONDITIONS: tungsten

Ezra Shaw

New Jersey Nets vs LA Lakers, NBA Finals, Continental Airlines Arena

Shaquille O'Neal and the rest of the LA Lakers celebrate after defeating the New Jersey Nets in the 2002 NBA Finals, making it the Lakers' third title in a row. "Sometimes I have just as much fun in the locker room as the players do after winning a championship game. Only a few photographers are allowed here at the start of the celebration, so it's always special to be one of the lucky few. As a photographer, I'm looking to capture the players' joy and excitement, but at the same time, trying to keep my camera from getting completely covered with champagne!"

CAMERA: Nikon D1H
LENS: 17–35mm
ISO: 1000
APERTURE: f/8
SHUTTER SPEED: ¹⁄₆₀ sec
LIGHT CONDITIONS: rear-curtain flash

AS: What's in your kit bag? Which camera system do you use and why?

ES: I use Canon cameras for two reasons: the first is that I find most of Canon's equipment very reliable, the second because Getty supplies its photographers across the board with Canon gear.

AS: What are your favorite and most used lenses/focal lengths?

ES: For most assignments I use my 400mm lens, but I always like to have my 16–35mm zoom with me at all times, in case something interesting happens right in front of me.

AS: What types of pictures do you find the most difficult to take?

ES: Portrait shots. I think this is because I just haven't taken enough portraits throughout my career and I always find it difficult to come up with new and interesting portraits. I find it even harder to light them correctly.

AS: Which do you prefer, digital or film, and why?

ES: Both have advantages. In most cases, I still don't think color is as good on digital as it is on film, but for what I do on a day-to-day basis, digital is perfect. In addition, with digital, I get to see what I'm shooting immediately, so I am able to experiment and try different techniques throughout an event.

AS: How much of your work is manipulated using imaging software?

ES: Very little of my work is done with imaging software. Getty Images has very strict guidelines as to what can be done to a picture by the photographer.

AS: Where do your ideas for innovative pictures come from?

ES: I look through as many newspapers and magazines as possible and I use these to get ideas for new stories and subjects that I want to photograph. From there, I try to come up with new and exciting pictures.

AS: What does the future hold for you?

ES: You never know what the future holds, but I would like to work on more long-term feature projects, where I become more involved with the subject, and less on daily games coverage. I have an urge to work on projects that show the importance sport has within certain communities, as well as the impact it can have on children while they develop.

Ezra Shaw

New York Jets vs Tennessee Titans, Giants Stadium
"When I'm shooting American football, I always have a wide-angle lens around my neck, in case something happens right in front of me. This picture of Curtis Conway of the New York Jets making a catch for a touchdown against the Tennessee Titans is the reason why I always have the wide-angle lens—to capture play such as this when it happens."

CAMERA: Canon EOS 1D
LENS: 24–70mm
ISO: 1,000
APERTURE: f/2.8
SHUTTER SPEED: 1/500 sec
LIGHT CONDITIONS: tungsten

Top 10 Tips for Success

1) Consider your aims

Before you leave for your assignment, think about your aims and the types of shots you want. There is a big difference in going to a game to shoot general action and get a series of pictures that tell a story, as opposed to coming away with one stellar picture that newspapers or magazines will want to run as a double-page spread.

2) Learn the environment

By learning rules and researching the big stars of each team, I have found it is much easier to come away with meaningful pictures. In basketball, for example, if the clock is counting down with only a few seconds left, I need to know who the team's most valuable players are and who is most likely to take the last shot of the game. Otherwise it is easy to focus on the wrong players and miss the most significant part of the event.

3) Get there early

At bigger games such as the NBA Finals or All-Star competitions, shooting positions are preassigned. However, for most regular season games, it is first come, first served. Early birds have the advantage of being able to choose the spot they want to shoot from. There's no sense arriving late and having to take a position that nobody else wants.

4) Backgrounds are vital

Backgrounds are one of the most important factors to think about when picking a position to shoot from. It is sometimes difficult at basketball arenas, but if at all possible, avoid shooting into bright red or yellow signs. Another way to control your background is to set your camera with shallow depth of field: this way the background is out of focus and less important, thus bringing the viewer's attention to a sharp foreground.

5) Try different angles

Making your way upstairs in an arena will eliminate some of the unwanted advertising signage that is now a fixture at most venues. Importantly, moving into different areas can give you a unique approach, avoiding duplicating other photographers' work. For me, it is important to produce distinctive images through creativity.

6) Use remote cameras

This is especially important when photographing sports such as basketball, where photographer positions are often fixed and limited. Remote cameras give me an angle that I would otherwise not be allowed to shoot from during the game. Popular places are on the basket post and behind the glass of the backboard. Another place that makes for interesting pictures is directly above the basket—accessible only from the catwalks of the arena.

7) Use the light to your advantage

Indoor tungsten light gives different results from natural, outdoor light. If I am shooting outdoors, however, I always notice which way the sun is going so I can use it to my advantage. I pay particular attention to the movement of light and shadow: if one side of the stadium is in shadow, this might be a perfect opportunity to shoot a backlit subject. By shooting into the shadow, the background will go dark, thus making the subject stand out. Also, use the light to your advantage when shooting from different angles. I always try to shoot from the top of the stands late in the afternoon and work with the shadows as they go across the field.

8) Be prepared

It is likely that nothing remarkable will happen at most games you go to photograph. That is why I always prepare for special moments and I am ready to capture them at any given split-second.

9) Experiment with your photography

Try to develop your own style. Every photographer is always learning from their peers and co-workers. It is important to ask questions as well as to give advice to other photographers. Your shooting skills will get better if you learn from one another.

10) Practice

Nothing can make you a better photographer other than getting out there and taking more pictures. If you can't get a credential to the Super Bowl, NBA Finals, or any other big sports event, go out and shoot sport at any level you can get access to. It's obvious, but you have to be out there, shooting, in order to improve.

Ivan Karaulov, Normal Hill Individual Ski Jumping Final, Winter Olympics, Turin

This amazing action shot of Ivan Karaulov competing in the Normal Hill Individual Ski Jumping Final was taken on the second day of the Winter Olympics in Turin, Italy. Shaw explains, "I spent most of the night trying to get this picture of the skier coming through the center of the rings, setting my camera with a slow shutter speed, to show speed, movement, and drama."

Specification

CAMERA: Canon EOS 1D MKII

LENS: 500mm

ISO: 50

APERTURE: f/4

SHUTTER SPEED: 1/30 sec

LIGHT CONDITIONS: bright sunlight

Essential Equipment

- Three 35mm Canon EOS 1D MKII camera bodies
- 16–35mm f/2.8 lens
- 24–70mm f/2.8 lens
- 70–200mm f/2.8 lens
- 300 mm f/2.8 lens
- 1.4x converter
- Monopod

- Lens hoods for all lenses (some arenas require you to use rubber lens hoods)
- Flashgun
- Three spare Lithium-ion batteries
- Eight 1–2GB CF cards
- Clamp and Magic Arm to hang remote camera
- Safety cable to secure remote camera

- Two PocketWizard transceivers (preferably with custom channels built in) and all cables and triggers needed for remote camera
- Roll of gaffer tape
- Pocket knife
- Laptop computer to transmit pictures electronically
- Folding seat

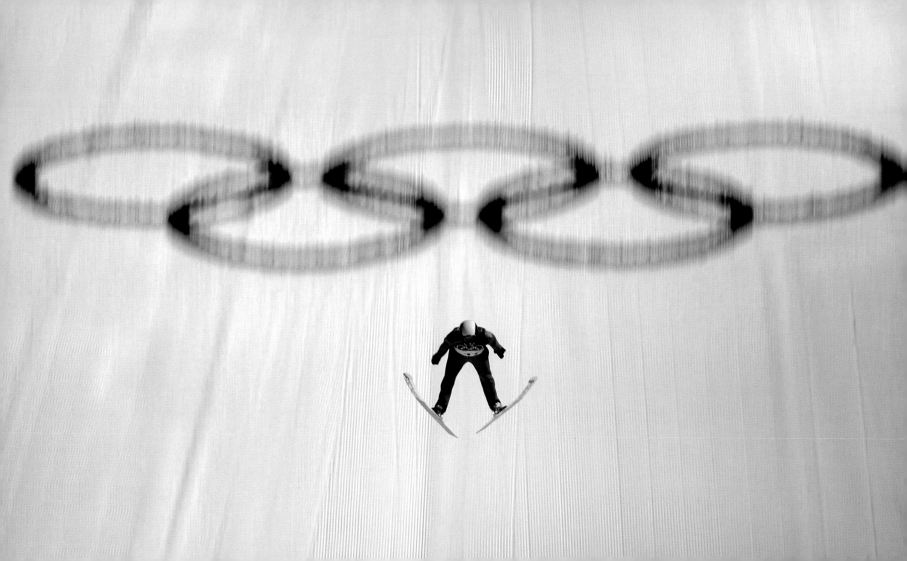

Adventure sports

Walking, rock climbing, mountaineering, kayaking, mountain biking, and windsurfing are all activities where Dave Willis has found a market for the fast-paced action pictures he loves to shoot—which begs the question: which comes first, the sport or the photography? Willis didn't study photography at college, instead learning to fine-tune his skills while treading a fine line between life and death, in the midst of spectacular activities that come under the banner of adventure sports.

As a prolific adventure photographer, he provides advertising and brochure photography for several outdoor clothing companies and undertakes PR work and stock photography for organizations such as the National Trust, as well as the world's leading tourist boards. He is also respected for his photo shoots for many outdoor magazines and provides stock images through several specialist picture libraries. His own library, mountainsportphoto.com, is expanding and adventure travel photography is fast becoming his niche field. He explores every avenue to maximize the potential of his photography.

Dave Willis

Interview

AS: What was your first-ever camera?

DW: My first SLR camera was a Nikon EM when I was 17 years old; then, later, when I had saved enough money, a Nikon FM. I soon discovered I wanted to shoot up close and I initially purchased a 50mm lens, later joined by a 28mm and 105mm.

AS: Is it fair to say that, like many successful photographers, you had a "lucky break" at some stage?

DW: When I started I knew exactly what I wanted to do, but I had no idea how to do it. My ambitions lay with mountaineering photography, yet I had no knowledge of mountains or photography. But I was just 17 and could not conceive of failure. Ignorance is bliss.

AS: Why did you decide not to pursue other types of photography, such as portraits or fashion, for example?

DW: I'm a born risk-taker. I soon found that all successful outdoor sports photographers are outdoor people first and photographers second. You cannot work in potentially hostile mountainous environments unless you are reasonably comfortable being there. Over the years my outdoor skills improved to where I was able to qualify as an outdoor instructor, and this allows me to take the photographs I need—whatever the lighting conditions.

AS: Do you shoot what you want or do others generally define what's required of you?

DW: It's a bit of both, but mostly I take the lead. If I see something that attracts me, then I'll place myself in that situation if I think there's a market for the photographs. For example, I haven't really pursued caving photography because I don't enjoy being stuck underground for long periods.

AS: Where are you mostly based? Where are your most popular locations?

DW: The Lake District in the UK. One reason I live there is because the whole place is a fantastic outdoor photographic studio—right on my doorstep. I also get commissions throughout many mountainous regions around the world, in particular the Swiss, French, and Italian Alps. I also photographed the first-ever indoor World Climbing Championships in Lyon, France, during the late 1980s, which I have fond memories of.

AS: Which places do you like traveling to the most?

DW: Anywhere I haven't been to before. I love traveling and I've spent lots of time in South America, the US, and Canada. I have trekked in the Grand Canyon, which aesthetically is an absolutely stunning location, and I also enjoy taking my camera to the Rocky Mountains in British Columbia.

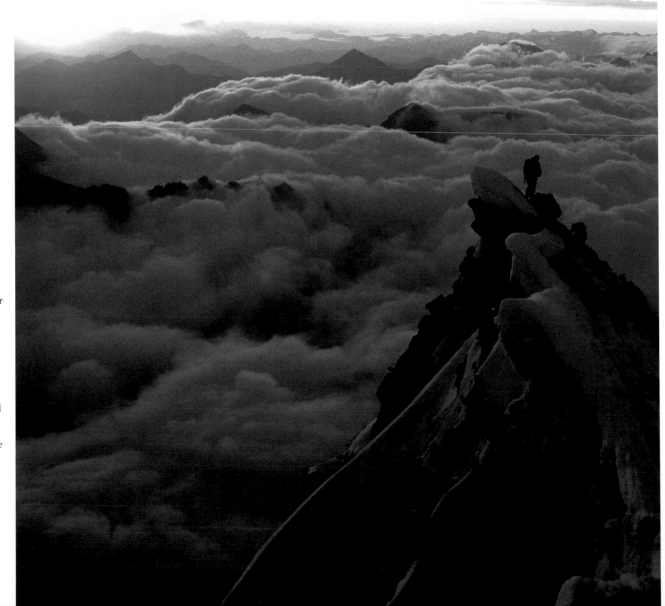

Alpine dawn on Gross Glockner
"Alpin-glow situations like this are not as uncommon as you might suppose, and all alpinists are only too familiar with the dreaded 3am departure from the hut—essential to complete a summit attempt and descend safely in one day. The alpine climber in the scene, silhouetted against the backdrop, brings a sense of scale, human interest, and drama that might otherwise be missing."

CAMERA: Nikon FM
LENS: 25–35mm
ISO: Fuji Provia 100
APERTURE: f/8
SHUTTER SPEED: ¹⁄125 sec
LIGHT CONDITIONS: bright sky and deep shadows

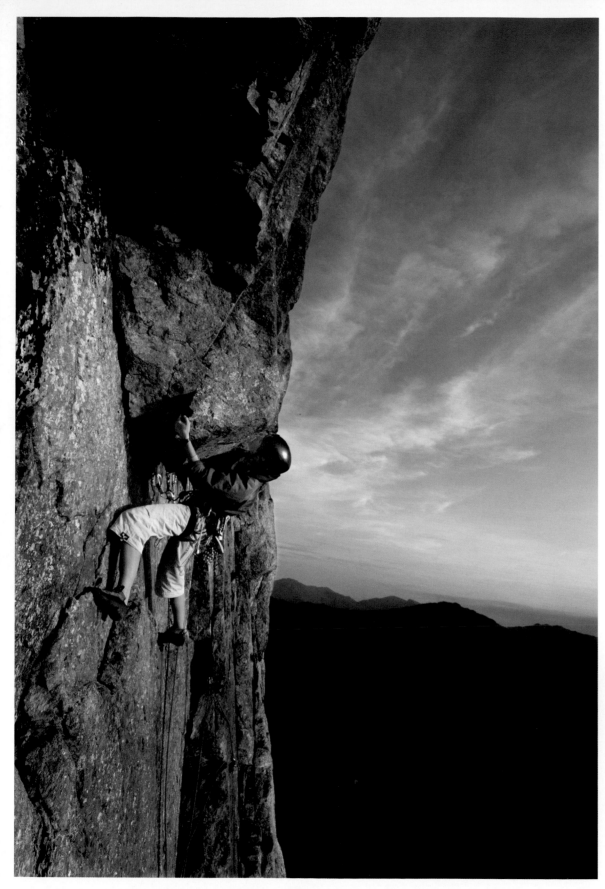

AS: What things do you enjoy most about your job?

DW: The freedom and being able to let myself go. I love my job because it allows me to do what I want, rather than what someone else wants me to do. I get to play for a living, as opposed to working for a living.

AS: From a technical aspect, what are the most difficult things about your job?

DW: The weather: getting myself into dynamic camera positions is a constant struggle. Sometimes I make myself into a "human tripod" against a rock to give me a stable position; the rope I'm hanging from is the first point of the tripod, and then I brace both feet against the rock face to create a stable position. These days, with modern photographic equipment, I can push the camera's ISO setting to get the right exposure even in darker conditions.

AS: When are the busiest times of the year for you?

DW: Autumn months because colors lend a tremendous amount of atmosphere to outdoor pictures. Spring is always a busy time, too, while snow and ice have their own appeal. Rain is my least favorite condition in which to photograph.

Kipling Groove, Gimmer Crag, Great Langdale
"I climbed the route ahead of the rock climber and set up a hanging belay from anchors and ropes that I hauled up, to photograph the model leading the pitch only a few feet from my camera position. The clouds in the sky help to lead the eye toward the climber, a fact that I was aware of and used to my advantage. A wide lens allowed me to get very close to the climber and still include plenty of background, otherwise the image would be too cramped and lack any sense of depth or space. The final touch was added back at my desk—I desaturated the image to drain color from the rock."

CAMERA: Nikon D70
LENS: 10–20mm
ISO: 200
APERTURE: f/11
SHUTTER SPEED: $1/200$ sec
LIGHT CONDITIONS: sunset

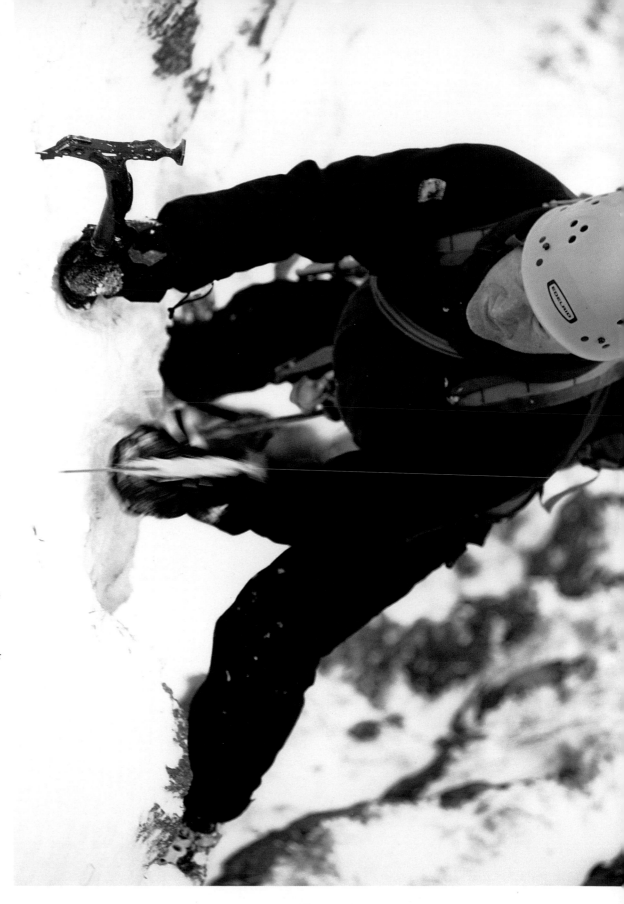

Climbing in Nethermost Gully, Lake District

"Winter climbing poses a number of unique problems for photographers and for camera equipment. For this shot I used a fast aperture telephoto zoom to fill the frame, autofocus to save time, a fast shutter speed to prevent camera shake, and a wide aperture to minimize the background and eliminate distractions. Looking down on the subject is a key technique for emphasizing height, exposure, and the feeling of commitment. Using a slower shutter speed than I might usually do results in a little motion blur that reinforces the swing of the ice axe. Color is important here, too. The landscape is a monotone of white and gray so a splash of color really stands out."

CAMERA: Nikon F4
LENS: 80–200mm
FILM: Fuji Provia 100
APERTURE: f/2.8
SHUTTER SPEED: $^1\!/_{125}$ sec
LIGHT CONDITIONS: overcast with light-reflective snow

Dave Willis

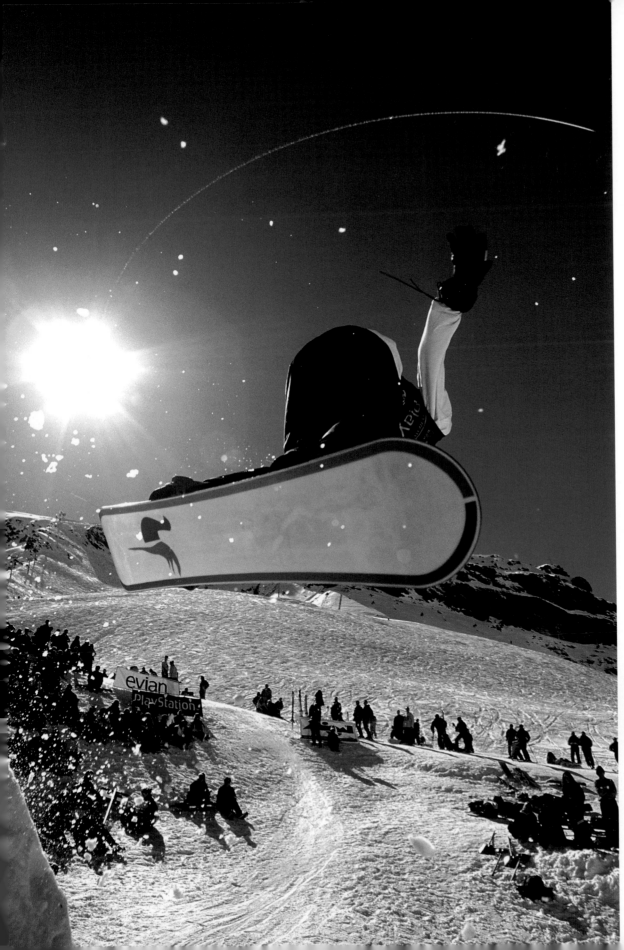

Half-pipe snowboarding at the British Championships, Meribel
"The half-pipe is a great location for snowboarding action and is relatively easy to shoot. Photographers can easily gain access to the rim and use extreme wide-angle lenses to great effect. Here the riders soared off a steep ramp, executed a number of gymnastic aerials, and hoped to land safely. At the apex of the jump, as the rider begins to descend, the board has lost its momentum and slower shutter speeds will produce sharp images. Shooting directly into the sun produces a silhouette effect, so a burst of flash is required to illuminate the rider, hence the need to use a shutter speed of only 1/250 sec—the sync speed of the camera."

CAMERA: Nikon F4
LENS: 20–35mm
FILM: Fuji Provia 100
APERTURE: f/11
SHUTTER SPEED: 1/250 sec
LIGHT CONDITIONS: sunshine
 and blue sky

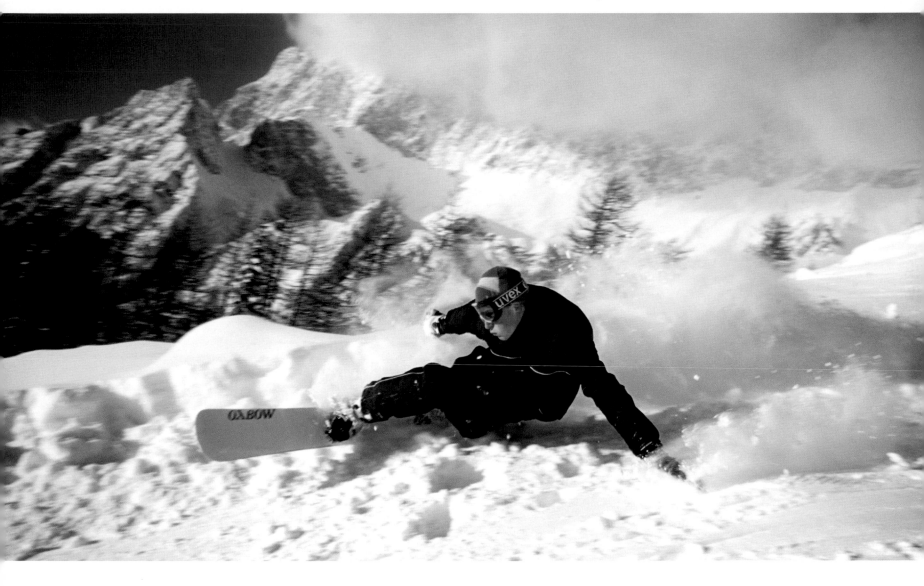

Border-X snowboarding, Austria
"I'd been working with this
professional snowboarder all
day and I had a number of good,
sharp images in perfect blue-sky
conditions. The weather began
to deteriorate with low
mountain cloud gathering
around the slopes. So I realized
how much more dramatic and
atmospheric this light had
become and worked hard to get

a great action shot before it
faded. The impression of speed
is created by the relatively slow
shutter speed and panning the
lens, with subject, showing
plumes of snow billowing from
the edge of the rider's hand.
Positioning the camera on the
inside of the curve allows the
rider to lean toward the camera,
enhancing the dynamic sense
of speed. Using a wide-angle

20mm focal length enabled
me to be extremely close to the
action and distort the perspective
to enhance the drama."

CAMERA: Nikon F4
LENS: 20–35mm
ISO: Fuji Provia 100
APERTURE: f/8
SHUTTER SPEED: ¹⁄125 sec
LIGHT CONDITIONS: low cloud
 gathering on mountain slopes

Dave Willis

AS: How would you describe your personal technique or style of photography?

DW: I produce simple and graphic images that show atmosphere. Although it is important to produce technically accurate photographs, it is important for me to show the atmosphere of the location, the weather conditions, or the sport itself. I consciously try to keep my pictures as simple as possible because that way they are easier to understand and have more impact.

AS: What's in your kit bag? What camera system do you use and why?

DW: The Nikon D200 is my main camera but I also use a Nikon D70, which is a great backup model. Each produces the standard both I and picture editors require. Surprisingly, given the types of activities I photograph, I'm not a big user of telephoto lenses, although I do own 80–200mm and 100–300mm lenses. Often I end up being slightly farther away from where I had first anticipated, so zoom lenses with these ranges are ideal. A major consideration for me is the weight I carry. My photographic gear, in addition to clothing, comprises weatherproofs, climbing rack, rope, first aid kit, food and drink, and navigation gear.

AS: What are your favorite and most used lenses/focal lengths?

DW: I like to shoot up close and the lens I rely on most is a Sigma 10–20mm f/4-5.6 EX, followed by my Nikon 18–70mm f/3.5-4.5G lens, as well as a Nikon 35–70mm f/2.8.

AS: What types of pictures do you find the most difficult to take?

DW: Sailing and windsurfing are the most difficult because quite often I'm stuck on the beach and I'm forced to use a big lens to fill the frame. Dark conditions can also be tough—I like to shoot in manual mode with tripod. I also prefer to shoot from a boat and be close to the subject with a wider lens, because I seldom have any technical problems at all. The biggest problem is filling the frame.

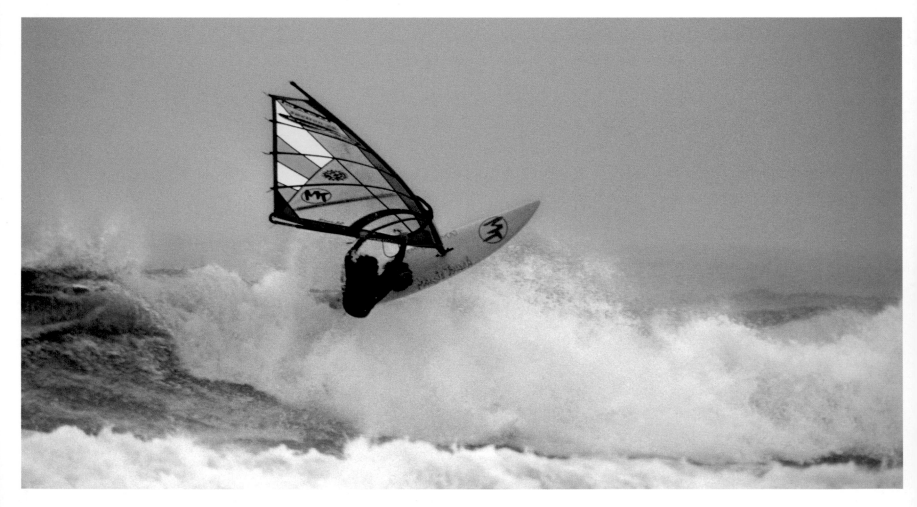

Windsurfer at Gwithian Sands, Cornwall
"The storm-battered, windswept coasts of Cornwall offer a unique atmosphere in which to sail and photograph. It's essential to keep the monopod steady, otherwise camera shake will ruin the shot, particularly with a strong cross-wind hammering you. Shutter speeds need to be as high as possible, but in murky light this could be as low as 1/250 sec, so I often push the ISO to 200 or 400 to get the speed up to around 1/500 sec. Focusing on a moving target with this setup takes time to master. Sometimes autofocus will work and sometimes it won't, so you have to be able to manually follow focus or track the sailor."

CAMERA: Nikon F4
LENS: 300mm with 2x teleconverter
FILM: Fuji Provia 100 rated at ISO400
APERTURE: f/5.6
SHUTTER SPEED: 1/500 sec
LIGHT CONDITIONS: overcast with rain

Kayaking on the River Caldew
"This is a portrait of a sportsman in action. It's not about the river or how big the water is, it's about the concentration and commitment of someone in the water, staying alive and having fun! The spray is caught frozen in motion to emphasize the river's power and force. The paddler is in the center of the frame to exclude distractions from the portrait, while the background is dark for the same reason. The shot is not too tightly framed. However, I still wanted to give it a sense of scale and location."

CAMERA: Nikon F4
LENS: 80–200mm with tele-zoom
ISO: Fuji Provia 100
APERTURE: f/5.6
SHUTTER SPEED: 1/500 sec
LIGHT CONDITIONS: bright and overcast

Dave Willis

C2 slalom racing, River Marple
"To create the impression of speed and power with the canoeists in this image, I used fill-in flash and a slow shutter speed. The effect can be difficult to predict but shooting digital allows me to preview the shot on the back of the camera. The real skill with this kind of image lies with panning the camera to keep the subject in frame and to include all the elements that are important. The situation is fast-moving and it's easy to end up with a composition that doesn't quite work."

CAMERA: Nikon D70
LENS: 18–70mm
ISO: 400
APERTURE: f/3.5 with fill-in flash
SHUTTER SPEED: 1/15 sec
LIGHT CONDITIONS: overcast evening

AS: Which do you prefer, digital or film, and why?

DW: Digital imaging is becoming more accessible for photographers like me, but—and it's a big but—will digital equipment survive the great outdoors? The kind of extreme conditions I encounter can kill delicate electronics and batteries stone dead. I prefer a temperature-resistant, waterproof system that costs less than my mortgage! Digital gives me instant feedback, which I love. Economically it makes more sense because I don't have to develop film, and nowadays, my Nikon D200 offers at least as good if not better quality than film. Most picture editors prefer to deal with digital files than scan film, too.

AS: How much of your work is manipulated using imaging software?

DW: Every picture I submit for publication has been tweaked in Photoshop, but only with minor adjustments to levels, curves, and color balance. I rarely send out images that haven't had a quick tweak. But I manipulate as little as possible and I don't like to push or pull pictures beyond what should be there. I am attracted to images which have become slightly desaturated and I calibrate my monitor to a certain percentage each time.

AS: Where do your ideas for innovative pictures come from?

DW: I spend a lot of time gaining motivation from other photographers. A man called John Cleare got me interested in mountaineering photography—he had an amazing portfolio of Mount Everest, while in more sporting terms, Tony Duffy of Allsport has been my motivation. He has a simple and graphic way of capturing situations, while Philipe Plisson's shots are instantly recognizable. He is a master at cutting out clutter.

AS: What does the future hold for you?

DW: While I love taking pictures for myself, my work has to be geared toward what the general public wants. Many people—all around the world—are becoming more adventurous and like to take more risks than any other generation. In future I'm open to anything—the Himalayas, the Antarctic Pole, and the desert. The world has plenty of untamed frontiers which appeal to me.

Downhill mountain bike racing
"Speed blur and wide-angle panning are techniques I used for this image of a mountain biker at full tilt, coupled with fill-in flash. I use fill-in flash a lot for fast action sports because it allows me to use motion blur to full effect. The image is shot from a low angle to place the mountain bike high in the frame and increase drama. The lens is very wide and very close to the action—so close in fact that I couldn't get my eye to the viewfinder! A shutter speed of 1/15 sec is slow enough to produce lots of blur, but the flash, set to underexpose by about -1 stop, is enough to produce a sharp ghost image over the top and reveal the detail of the action."

CAMERA: Nikon F4
LENS: 20–35mm
ISO: Fuji Provia 100
APERTURE: f/16
SHUTTER SPEED: 1/15 sec
LIGHT CONDITIONS: high, overhead midday sun

Dave Willis

**Cycling the Hardknott Pass,
Lake District**
"The Fred Whitton Challenge
is a cycling tradition that throws
down the gauntlet to roadies
in the Lake District; I was
immediately drawn to the
serpentine hairpins behind this
rider so I composed the frame to
take advantage of the dynamic
flow of tarmac. A wide-angle
lens helps to expand the
landscape treatment and the
low-angled sun creates a useful
shadow from the rider, giving an
extra dimension. Capturing the
rider as he exits the hairpin also
creates an additional element
of tension and expectation in
the picture."

CAMERA: Nikon F4
LENS: 20–35mm
FILM: Fuji Provia 100
APERTURE: f/8
SHUTTER SPEED: 1/250 sec
LIGHT CONDITIONS: strong and
 low-angled evening sunshine

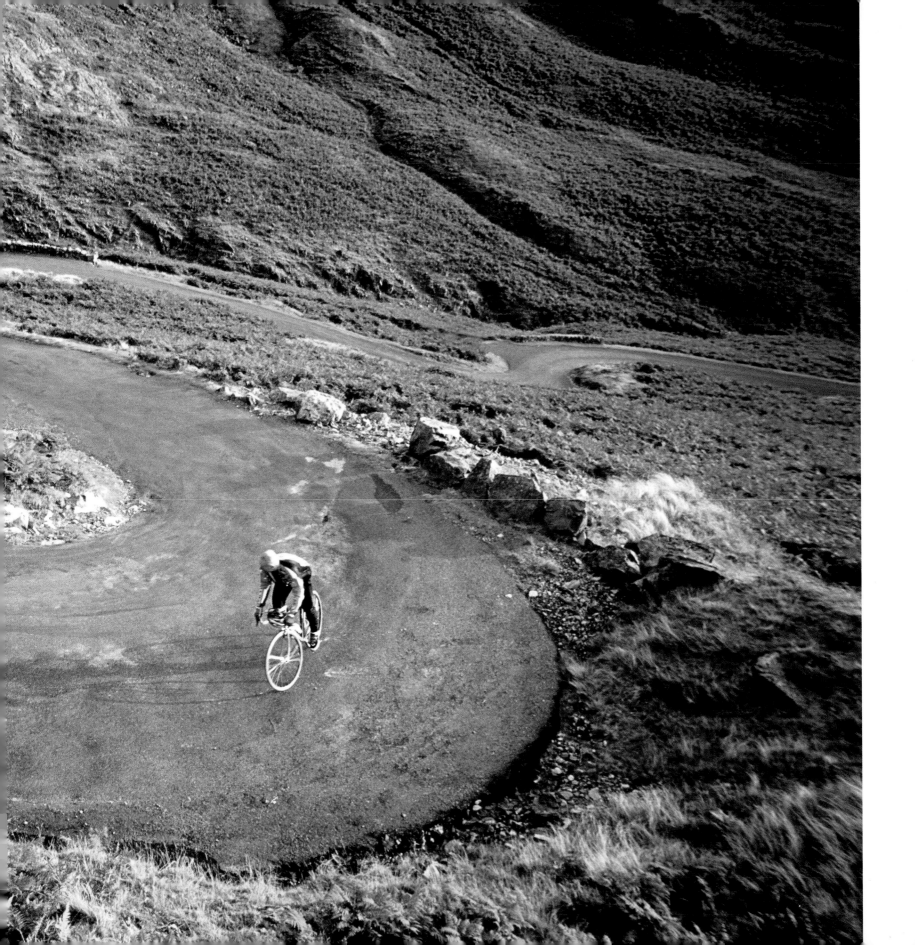

Kentmere Horseshoe, Lake District

"I made my companion jump up onto a nearby boulder and assume a relaxed pose that made a clean, outlined body shape against the sky. The camera viewpoint places the sun directly behind to create a rim-lit effect, just like a studio portrait. It also highlights his frozen breath to emphasize the cold air. I then adjusted exposure for the sky, to make a crisp, black silhouette. The classic rule-of-thirds composition is used here to create a natural balance and rhythm in the image."

CAMERA: Nikon F4
LENS: 3570 mm with tele-zoom
FILM: Fuji Provia 100
APERTURE: f/8
SHUTTER SPEED: $^1/_{125}$ sec
LIGHT CONDITIONS: clear sunset

Top 10 Tips for Success

1) Travel light

Everything you use has to be hauled on your back. If you arrive at your location exhausted from carrying around too much camera kit, you're not going to be motivated to start shooting creative pictures. Remember that you might also be carrying climbing kit, waterproofs, spare clothing, food, drink, and emergency kit—maybe even camping equipment.

2) Keep your camera handy

Hiking or mountaineering picture opportunities present themselves at every turn so you have to be an opportunist. If you can't reach your camera at short notice, you'll lose a lot of pictures. Try using a waist bag fastened around your front with just a camera body and medium-to-short zoom. You'll be amazed how often you find yourself reaching into your bag and pulling out the camera for a grabbed opportunity—the list of possible shots is endless.

3) Use big pockets for your gear

Many adventure sports professionals don't use camera bags. They prefer to have everything to hand, either in a photographer's vest or in big jacket pockets. One criteria for me when I choose an outdoor jacket is whether I can fit a lens and flashgun into the pockets and carry the weight comfortably. These days I generally settle for a combination of a large capacity bag fastened around my front, coupled with a jacket crammed with one or two lenses and accessories.

4) Know your gear inside out

Ask yourself this—can you change a lens, turn your camera on, set an f/8 aperture at 1/250 sec shutter speed, and select manual mode to focus in the dark? With modern electronic cameras it's not that hard—often everything is illuminated so long as you know where the on/off switch and lens release button is. Wasting time trying to remember which button does what is a sure recipe for missed pictures and frustration.

5) Waterproof your camera kit

In the great outdoors the weather is both your friend and your enemy. Water, particularly rain, can be the greatest threat. It gets into everything. It short-circuits batteries, corrodes electronics, mists up your lens, and generally wreaks havoc with your carefully laid plans. Plastic wrap and plastic bags work well for keeping the rain off when I am setting up. Particularly useful is a big plastic bag that will drop over my camera and biggest lens, to cover them while I wait for the downpour to stop. Take a chamois leather cloth to wipe down lens elements—I've found it to be the only sure way to dry lens glass after rain.

6) Keep batteries warm in the cold

The winter season offers skiing, snowboarding, ice climbing, and alpine mountaineering, all at minus temperatures! Batteries can last for barely an hour, so keep them warm inside your jacket until you need them. Modern digital cameras cope remarkably well with low temperatures but their essential power supply does not. So take spare batteries and keep those warm too.

7) Learn about the sports you want to photograph

I'm sometimes asked whether I consider myself to be a photographer or a climber. The answer is climber first, because without the knowledge and skill that I have as a climber and mountaineer I could not get the images that I do. You have to know what is going to happen next, and why, in order to anticipate the picture and figure out how to be in the right place at the right time. Imagine trying to do skiing photography without being able to ski—it's just not going to happen.

8) Use fill-in flash

A flashgun is one of the most underrated pieces of kit that photographers own. Many don't use outdoor flash simply because they don't understand how to benefit from it. But used in a subtle way, daylight-balanced flash can transform pictures by intensifying colors and adding dramatic backlight and side-lighting effects, to really make images stand out. Effective motion-blur images depend on balanced flash for most of their impact. The idea is really very simple. Set your flashgun to around -1 exposure value, depending on the effect you want and the strength of the ambient light, then use a slow shutter speed to record motion while the flash records a sharp "ghost image" over the top.

9) Fill the frame

If you want plenty of impact, you need to get in close or at least use a long lens to fill the frame with action. Outdoor adventure sports take place in stunning landscapes and dramatic scenery and this will always offer the photographer a chance to be creative with landscape-inspired images.

10) Keep it simple

Simplicity is the key to great photographs. Simple pictures contain only the essential elements needed to tell the story. No distractions, no wasted space, and nothing that doesn't need to be there. If you look at a picture and think "maybe I could crop that a bit, and perhaps remove that distracting tree or splash of unnecessary color," then you haven't quite pared the image down enough. Only press the shutter release when you can honestly say there is nothing in the frame that shouldn't be there.

Workshop

Big leap into Beaver Canyon, Grand Canyon

"I was a little shocked when our guide offered to jump into Beaver Canyon for my camera—it was a 75 foot (22.8m) fall but I was assured he had done it many times before. The lighting in the canyon is extremely harsh with contrast at midday, but this helped to isolate the action against a clean and uncluttered background. The sunlit area of water is crucial to show scale and location, and I prefocused on where I thought the guy would be as he left the cliff edge. The image works because of the sense of anticipation of what could happen and the tension created by the fact there is no going back."

Specification

CAMERA: Nikon F4

LENS: 20–35mm

ISO: Fuji Provia 100

APERTURE: f/8

SHUTTER SPEED: 1/500 sec

LIGHT CONDITIONS: very bright natural light with blue sky

Essential Equipment

- Nikon D200 35mm digital SLR camera

- Nikon D70 35mm digital SLR camera

- 10–20mm wide-angle zoom lens

- 18–70mm medium zoom lens

- 100–300mm telephoto zoom lens

- Nikon-mount SB800 flashgun

- Spare Lithium-ion batteries

- 512MB/1GB memory cards

- 30GB portable hard drive

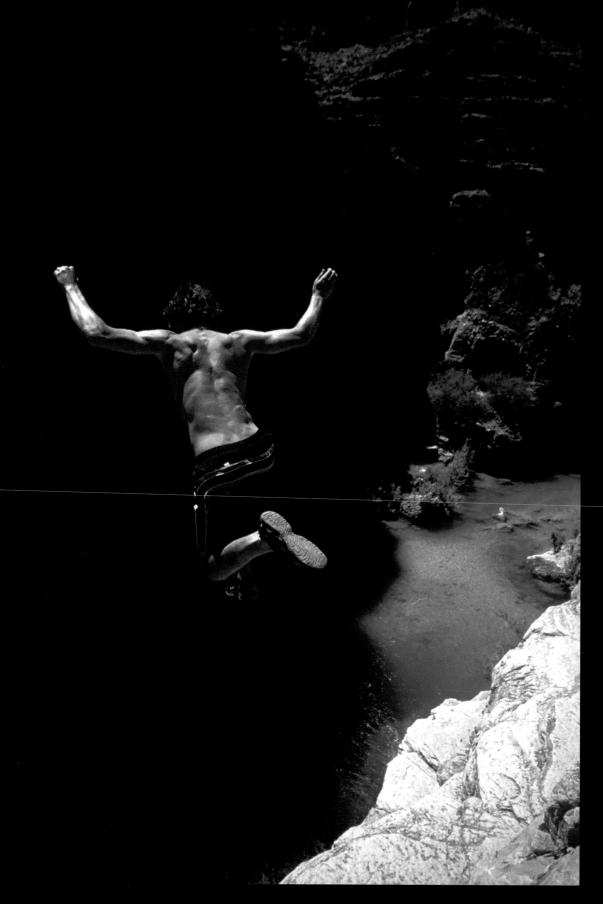

Dave Willis

Directory

Photographs by

Charles Coates

© LAT Photographic
www.latphoto.com
© Sutton Motorsport Images (page 17)

Photographs by

Jed Jacobsohn

© Jed Jacobsohn/Getty Images
www.jedjacobsohn.com

Photographs by

Bob Martin

© Bob Martin
www.bobmartin.com

Photographs by

John Gichigi

© John Gichigi/Getty Images
www.gettyimages.com

Photographs by

Tom Jenkins

©Tom Jenkins
tom.jenkins@guardian.co.uk

Photographs by

Dave Rogers

© Dave Rogers/Getty Images
www.gettyimages.com

Index

 Index

Acknowledgments

I have always been a sports-mad individual. Whether it's boxing, rugby, or motorsport, the TV has always been turned on—often at the most unsociable hour.

On this basis, therefore, it is an absolute privilege for me to have authored this book, bringing together my love of sport and my love for action photography.

My sincere gratitude to Alison Crombie of Getty Images, who always lends a hand whenever I ask. I owe you one.

Special thanks to Jane Roe for her sensitive interpretation of my words, and to the RotoVision design department and JC Lanaway Design for their appreciation of the wonderful photography and for their attractive page design.

Particular thanks to Tom Jenkins, who, while suffering pneumonia, showed considerable patience to meet my deadlines.

Last and by no means least, my thanks and love to family and friends who always back me up—whether right or wrong.

Andy Steel